SEE

L O W L Y

L O O K I N G A T M O D E R N A R T

Michael Findlay

Prestel

MUNICH · LONDON · NEW YORK

CONTENTS

ACKNOWLEDGMENTS

Seeing Slowly was two decades in the making. In 1995, Sandra Joys, the founding director of Christie's Education in New York, recklessly delivered her students to me for a daylong seminar I called "Trusting Your Eye." We looked at modern art together and discussed what we saw but deliberately avoided the use of identifiers such as the names of artists and movements. I thank Sandra, and give much gratitude to her dynamic successor, Véronique Chagnon-Burke, who has allowed me to refine and continue these occasional dialogues.

My greatest debt is to the countless curators, collectors, and fellow art dealers who throughout my fifty-plus years in the business brought me to hundreds of thousands of works of art in museums, private collections, and galleries. This ongoing daily pleasure has been, and continues to be, my education.

I am very grateful and fortunate that my wife, the talented contemporary quilt artist Victoria Findlay Wolfe, shares with me the enthusiasms and working insights of her practice. I thank our daughter, Beatrice, for her cameo in Chapter Five, as well as my son, Bob, and granddaughter, Nikita, for the very happy hours we have spent together in museums.

I am indebted to my first reader and editor, Christopher Lyon, who patiently guided me to clarify, shuffle, trim, and discard. John Long admirably managed all my illustrations and Efren Olivares compiled the endnotes. Celine Cunha provided invaluable research assistance, as did my gallery colleagues Emily Crowley, Jean Edmonson, and Maeve Lawler.

Thanks indeed go to Michael Steger, my friend and agent at Janklow & Nesbit Associates; the good team at Prestel, including my editor Holly La Due and Stephen Hulburt; copy editor John Son; and designer Mark Melnick.

For my wife, Victoria; daughter, Beatrice; son, Bob;

and granddaughter, Nikita

INTRODUCTION

⌄

And still deeper the meaning of that story of Narcissus,

who because he could not grasp the tormenting, mild image he

saw in the fountain, plunged into it and was drowned.

But that same image, we ourselves see in all rivers and oceans.

It is the image of the ungraspable phantom of life,

and this is the key to it all.

—

HERMAN MELVILLE

Narcissus

Until the camera took over the job in the late nineteenth century, artists were mostly preoccupied by people, places, and things. Modern art has vastly expanded the artist's mandate, and today virtually any creation, action, or even proposition is accepted as art so long as we encounter it in a context we regard as suitably credentialed, such as a museum or art gallery. Does this mean that "anything goes"? And if so, how are we to judge or understand it? How many lectures must we attend? How many books must we read?

My belief is that great art, ancient or modern, reaches out to us and has the capacity to move us so profoundly that we are, for a moment or a lifetime, changed. This will only happen if we are prepared to engage with it on an emotional level with an active mind. Art is *sensational*; interacting with it to the fullest requires in the first place the practice of our senses and an open mind. Only if our senses have been fully engaged can we enjoy the secondary benefit that is the education of our intellect.

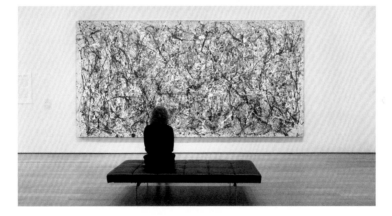

Jackson Pollock
One: Number 31, 1950, 1950
Oil and enamel paint
on canvas
106⅛ × 209 in.
(269.5 × 530.8 cm)
Installation view,
The Museum of Modern
Art, New York (2017)
The Museum of Modern
Art, New York. Sidney and
Harriet Janis Collection
Fund (by exchange)

Art is that which enables us to reach for Herman Melville's "ungraspable phantom of life," and regardless of what form it takes, or even when it is seemingly formless, we can accept and enjoy it, or find it uninteresting and reject it, to the extent that our feelings are affected by what we experience. For you, it might be the passion of Jackson Pollock's *One: Number 31, 1950* (1950). For me, it is Salvador Dalí's fantastic vision of Narcissus himself.

Salvador Dalí
*Metamorphosis of
Narcissus*, 1937
Oil on canvas
20 ⅛ × 30 ¾ in.
(51.1 × 78.1 cm)
Tate, London.
Purchased 1979

Some approach modern art asking, "Is it art?" That is beside the point. The question we must ask is, "Does it work for me?" By "work," I mean "act on your senses and engage your mind," not "test your knowledge of art history."

Aided by the media, ever ready to exploit the celebrity of a small group of artists and sensationalize high prices, modern art provides hooks on which those with the means to collect can attach their social identities to wealth and prestige. In my book *The Value of Art*, I examine three motives

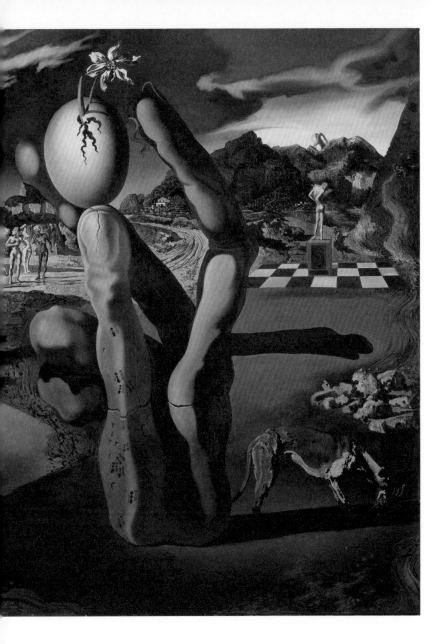

for collecting art: investment potential, social reward, and what I call the "essential" value—art for its own sake. This book is about how we can engage that "essential" value for *our* own sake, leaving the investment potential and social rewards safely in the hands of the great art world lions and their attendant lionizers.

You and I are interested in art, and so when we encounter it, we do not turn away but look at it, right? But do we really *see* it? For me, there is a difference between "looking" and "seeing," which is that the former is passive.

If my eyes are open, I look where I am going, but most of the time I am simply navigating. I am not *seeing* what is all around me, whether it is the people on the Lexington Avenue 6 train in New York or the leaves on the Japanese maple tree in my garden. This book is about seeing with all your senses and with an open and inquiring mind. Such seeing does not require any knowledge of facts about works of art. Sufficiently moved by a work of art that you are truly seeing, you will inevitably become curious about those facts, which is when your intellect comes into play.

This book is for everyone willing to join me on a journey to unlock the full power of that *essential* value of modern art. This book is for those of us who think we cannot possibly comprehend any of the exciting movements in modern art that have taken place in the last hundred years or so without lessons, lectures, and audio guides.

I am going to ask you to ignore a lot of what you may already know and everything you may think you need to learn. I will introduce concepts like mindfulness and intimacy that are possibly more apt for a self-help book than an introduction to seeing art, but a self-help book is exactly what you are holding in your hands. Together we will aim, at the very least, to achieve a moment or two of genuine engagement with works of modern art—of your choice, not mine.

While the possibilities of total enthrallment may stop short of the sudden enlightenment that Zen adepts call *satori*, we will have stepped off the information highway and allowed ourselves to enjoy a wide variety of authentic responses to modern art. The "Aha!" moments that await may include, but are by no means limited to, a peaceful moment, a fleeting smile, a taste of mellow sadness, even a frisson of shock and agitation.

Modern art comes in many mediums and sizes, among them painting, sculpture, drawing, print, video, and installation art. Engaging with it requires neither reading nor listening, whether before, during, or after we see a work. We can find out who made it and when it was made so that we may refer to it, and we can enjoy agreeing or disagreeing with what other people may say or write about it, but reading about the artist's sex life in a popular biography or what a critic, or what someone with a doctorate in art history thinks the work of art means, is not as important as

your experience of the work; in fact, the less you know *about* the work, the easier it may be for you to really enjoy it.

I will lose my stripes and be drummed out of the art world for saying this, but modern art is not about secret ingredients or puzzle solving. There are no codes to crack. This book is for people who enjoy music and novels and theater and movies. Those require no inside information or special training, and neither does modern art.

To get to the starting line, we may have to remove layers of misinformation. These will be replaced by what you bring to the table, not what I say. Famous or obscure, the work of art that you allow to grab your attention will deliver stronger sensation and greater pleasure than the work of art you are directed to by your audio-guided tour. It may be the smallest painting in the room or the biggest or the darkest or even (apparently) the ugliest. Let your eyes choose.

Great artists take great risks, and risk is a key ingredient of modern art. From Paul Cézanne to Barnett Newman to Andy Warhol, artists who are now heralded as pioneers broke the rules. We must do the same. If the rules of engaging with modern art today consist of knowing how art critics (or curators or dealers) label art, what they say about it, or, God forbid, what a work is worth in dollars, then I am asking you to break those rules and take the risk of *seeing only the art*, and *making up your own mind*.

Our destination is an encounter with a specific work of art, a very real painting or sculpture or installation, or even a performance event, in which all our senses are operational and we are fully engaged, offering the promise of an emotional response that can make that object part of your life. The goal of this process is restoring the integrity of the object, an integrity increasingly eroded by our culture, in which an artwork often becomes a mere prop, standing in for anything and everything, from investment asset to high fashion accessory.

The journey I urge you to take in this book has been and continues to be the voyage of my life as an art lover, one full of wonders and surprises. For most of us this costs little more than museum admission (art galleries are free), so let's get to the starting line.

PEELING THE ONION

⌄

For art comes to you proposing frankly to give nothing

but the highest quality to your moments as they pass,

and simply for those moments' sake.

—

WALTER PATER

For most journeys in life, internal or external, we must learn things. Learned information is often equated with wisdom, but sadly, wisdom and information are not the same. Information is valuable only if tempered by wisdom, and wisdom comes from experience, not learning.

Our systems of education stress the accumulation of information, often at the expense of experience. You may believe that you know a lot, some, or a little, about modern art, but our journey begins with jettisoning what you think you know. This is what I mean by peeling the onion. If you know nothing at all, you may have nothing to peel. This is unlikely because most of us approach adulthood with set attitudes and opinions about art, mostly not based on experience.

On this journey I will ask you to discard all manner of theories, learned behaviors, preconceptions, and props, which manifest themselves as ways to access, understand, and enjoy art, but which instead serve the opposite end, increasing our repertoire of ideas and language while decreasing our engagement with art. Part of what we are going to do is examine those attitudes and opinions and remove them, layer by layer, until we reach a place of clarity, receptivity, and honest judgment. Only in that place can true connoisseurship be practiced; only in that place can judgments of quality have meaning.

I am speaking from my experiences as an art dealer. I cannot *make* a client like a work of art, let alone fall in love with it. All I can do is display the painting, drawing, or sculpture and create the optimum conditions for my client to experience it. Because my living depends on some people liking a work of art well enough to buy it, I need to be able to answer questions about its authorship, history, physical condition, and commercial value. The client's decision about whether or not to buy a work may be influenced by my answers, but a positive or negative response to the work of art can only be decided by his or her engagement with the piece itself.

I could tell her why I like it or tell him what other people have said or written about it—but would that make them like it? Surely you have

experienced being told by a knowledgeable friend about a book or a movie that you simply *must* read or see. Everyone is raving about it! And then you read the book or see the movie and say to yourself, "What? I didn't think much of that!"

There is nothing wrong with listening to advice so long as, diplomacy aside, your conclusive opinion is genuinely your own.

Others may lead us to new cultural experiences. Sometimes a client will ask me to locate a work of art by an artist whose work is perhaps not my favorite. I do find a piece by him, and when I show it to them, their excitement and enthusiasm may be so palpable that, even without much conversation, I begin seeing it more clearly than I would have otherwise. This is not so much being influenced by their opinion as being impressed by their level of engagement.

This book encourages you to see a broad array of works of modern art and be receptive to those that reach into the core of your being. There is no reason why you should not be able to see a work of art as if you were its first viewer, in the artist's studio, the day it was finished.

I am asking you to abandon the multitude of distractions, which our culture places between us and the objects of our experience, and engage works of art with a naked eye and mind. Only then can we meet the art on its own terms, and only after that has happened can we trust our taste, have confidence in our judgments, and, if we wish, add information to our insights.

I am a baby boomer. We are fast approaching our past-due dates. When young, some of us engaged in a search for spiritual enlightenment or transformation, and I am perplexed by the extent to which many of us now approach old age seemingly afraid of spiritual elevation. I am not talking about pleasure or happiness but about experiences that shift our soul slightly upward, for a minute or two, or sometimes even for life.

If we spent so much effort in the 1960s getting high, why are we so earthbound now (we and the generations that followed us)? Outside of spiritual communities, society seems to consider discussion of transcendence as impolite as the mention of money used to be among the English upper classes. Why are we afraid of opening ourselves up to the possibility

of experiencing the spiritual and emotional elevation that can happen, easily and harmlessly (and inexpensively), if we know how to see art?

One of the clichés of our culture is that men suppress their feelings while women more freely accept them. In fact, men may talk less about their feelings, but both genders have the same capacity for experiencing states of emotion. Since I am advocating *seeing* art, not gushing about it, however, my male readers may still keep upper lips stiff and jaws clenched when they are in public museums and galleries.

In the final chapter, I detail three transformative encounters I have had with art objects. These occurred decades apart (the first when I was twenty-two, the most recent when I was sixty-two), but the impact of each created within me the same sense of breathtaking awe, combined with the piercing sensation of being in a state of extra-reality. Whatever your spiritual beliefs and practices (or lack of them), I assure you that if you follow my path you will experience similar moments.

The Uses of Art

It is the most important function of art and science to awaken
this [cosmic religious] feeling and keep it alive.
 —ALBERT EINSTEIN

"Why is it art?" Gerald asked, shocked, resentful.
"It conveys a complete truth," said Birkin. "It contains the
whole truth of that state, whatever you feel about it."
 —D.H. LAWRENCE, *WOMEN IN LOVE*

The impulse to make marks as a basic declaration of existence predates virtually every other known aspect of human culture. In 2008, tools and ochre pigment, dating from between one hundred thousand and seventy thousand years before the present, were found in the Blombos Cave in South Africa. A number of pieces of ochre are incised with seemingly abstract patterns. These predate comparable objects found in Europe by at least thirty thousand years. After the need for food and shelter, making

forms is a basic instinct, and many believe it emerged long before spoken language, although for obvious reasons it is unlikely the birthday of the latter will ever be determined.

In my previous book, *The Value of Art*, I argued that today art possesses three values: potentially maintaining or increasing its commercial value; enhancing social interaction, for example, in the company of fellow art lovers; and providing the opportunity for private contemplation of, and engagement with, the object. The value of art seventy thousand years ago was unlikely to have been monetary, but it was most certainly social, though possibly never entirely private. Susan Sontag aptly described prehistoric art as "incantatory, magical . . . an instrument of ritual."[1]

Great art may be inspired by divinities, but all art is made, used, and abused by imperfect humans. The history of art, from the beginning of recorded history to today's screaming headlines, is replete with tales of squalor, theft, forgery, fraud, and riches beyond imagining. The cast includes evil potentates, acquisitive prelates, robber barons, and hedge-fund billionaires, and it is salted liberally with mad starving geniuses. Every age has put art to a great variety of both good and bad uses.

American culture, which is despised and emulated (often simultaneously) in many other countries, is highly goal oriented. Regardless of how many generations of immigrants have brought with them diverse beliefs, the Protestant ethic still rules. The purpose of our children's education is to get a job, build a career, and move on up the ladder of success. To enjoy this success we have to stay alive. To stay alive as long as possible we have to eat right and get plenty of exercise.

But to attain what goal are fifty million people per year visiting American museums, hunting for visual excitement? Many are tourists, domestic or international; others are supporting their local institutions. One way or another, they may simply enjoy art—and some might admit it makes them feel better.

The real issue is that because we are a profoundly goal-oriented society, most of us need practical reasons for studying art: to teach (recycling information), to get a job (as artist or art businessperson), to collect (invest?), or

even to further the eternal quest for self-improvement (be more socially desirable).

This "outcome orientation," as Harvard University professor of psychology Ellen Langer has called it (more about her further on), is one of our most fundamental mind-sets. Among the difficulties generated by this pervasive goal orientation is an inability to engage in a process of seeing art for its own sake; the child thinks he or she must learn something, must have an "answer."

Art is no panacea. It cannot cure disease, feed the hungry, or eliminate war. In every culture, however, there is a reverence for images and objects, which seem to have no purpose except to be experienced, and which can take us to a better place or make us aware of the better part of the place where we exist.

Sadly, when fine art is part of the discussion in our culture (public or private), its function as a spiritual elevator plays second fiddle to its roles as:

Financial Instrument (Wealth)
Iconic Object (Entertainment)
Social Identifier (Prestige)
Information Provider (Education)

It is important to see how ubiquitous these roles are and how they skew our thinking and cloud our vision.

Art as Money

Among the things we pay the most for, art does the least for us in terms of sustaining our lives. The price of an artwork, as I point out in *The Value of Art*, is based on collective intentionality, a consensus among artists, dealers, and collectors. Since most art is portable, and depending on the time and place, can be sold or exchanged at an agreed upon value, it has been used through the ages for investment and the transfer of assets. In some countries, its import or export is taxed, in others (the United States, for

example), it can be given to public institutions in lieu of taxes and is subject to no tariffs other than sales tax.

During most of the twentieth century, the commercial value of art was of small concern except to collectors, museums that bought (and sold) art, and the dealers who helped them do so. Art was discussed on high-, middle-, and low-brow levels in popular magazines, newspapers, and journals, including ones devoted solely to art, with virtually no mention of what the works of art being discussed might be worth. The Impressionists were admired and the modernists mocked with no need of dollar signs.

The opposite is true today. It is difficult indeed to find discussions of artworks in the popular media that fail to mention their commercial value. When and how did this come about? In most parts of the world, the concept of fine art is intertwined with the ideas of monetary value and its corollary, investment potential. One of the things even children learn about art is that it costs money, sometimes at amounts that beggar the imagination. This "value" may be what they want to "see" when taken to a museum and shown a painting by Vincent van Gogh, Pablo Picasso, or Andy Warhol.

While there are some who think all art should be free and that artists should be supported by the state, as an art dealer I know that it is healthy for collectors to be driven to some degree by the possibility that what they are buying will rise in value. This is one of the principles of patronage.

I said "to some degree" because we are now in a culture so monetized in every respect that in judgments of everything from Old Master paintings to the products of Yale University MFA students, the only criteria seem to have become, how much today and how much tomorrow?

The auction houses work overtime to make sure the public does not lose sight of the money factor, although their targets are really the handful of individuals who might consign to their next auction. In 2012 Sotheby's snagged a version of Edvard Munch's *The Scream*, and scream their press office did when it sold for just under $120 million.

Three years later it was Christie's turn to own a screaming headline in the *New York Times* celebrating not a work of art but a sum of money: "Christie's Has Art World's First $1 Billion Week." With paintings by Lucian Freud and Andy Warhol selling for more than $70 million combined, one

would imagine the sale was noisy and suspenseful, but it was in fact a dull, matter-of-fact affair despite the simultaneously unctuous and patronizing exhortations of the auctioneer.

At the end of one sales marathon, *New York Times* art reviewer Roberta Smith weighed in with an article headlined "Art Is Hard to See through the Clutter of Dollar Signs," in which, with no apparent irony, she wrote: "These events are painful to watch *yet impossible to ignore* [my italics] and deeply alienating if you actually love art for its own sake." Not to be outdone, another *New York Times* reviewer filed a lengthy cri de coeur, "Lost in the Gallery-Industrial Complex," a two-thousand-word blast at the power of money in the art world. It has shades of Captain Renault in the film *Casablanca* claiming, "I'm shocked, shocked to find that gambling is going on in here!"

The average evening auction of the kind of art that receives front-page attention is attended by about 750 people, of which perhaps thirty-five actually bid. Possibly another thirty-five people may be bidding by phone. With around sixty lots in the auction, the number of sellers is likely to be about forty, since some will be selling more than one item. Auction staff directly involved in the sale perhaps number twenty, so in reality the auction is ninety minutes of brokered transactions involving, at most, a total of 150 people (sellers, buyers, and staff). This commercial event, covered exhaustively by the press, takes place twice a year in both London and New York, before a ticketed audience, in exactly the same ritualistic fashion. Although the art sold is usually (not always) different, the participants rarely change. The magic ingredient is the avalanche of auction house marketing, the constant emphasis in breathless emails and press releases on "the market" persuading the media that this whole semiannual circus actually matters to you, the reader, or you, the art lover. Money is so much easier to write about than art because everyone knows the meaning of a dollar.

The media discusses art when one or more of the following factors, all having to do with money, can be "reported" to suggest newsworthiness: commercial value, investment history and potential, theft, forgery, or celebrity ownership. When news breaks that there has been a theft from

a museum or a suspected forgery, the first calls I get the next morning are from reporters asking my opinion of the value of what has been stolen or faked. I am never asked about the works themselves. On September 12, 2001, still in shock from having watched the destruction of the Twin Towers in New York and losing a close friend, I was appalled to get a call from a reporter asking me for the value of the works of art in the buildings. How would I know? Why would anyone care?

Most sales of works of art at every level occur as private transactions in galleries around the world. Far higher prices for better paintings are paid privately than at auction and escape the news cycle simply because they are not public transactions—no more than the last time you bought a new pair of socks.

Tethered as our culture still seems to be to the Protestant work ethic, and determined as it is to make capitalism work for everyone, America celebrates the cost of everything and anything above and beyond other values. Financial considerations may be most appropriate when it comes to agriculture, manufacturing, import and export, even international aid, but money also has become the primary means of evaluating literature (top selling), film (top grossing), theater (longest running), and art (highest price for a living/dead/American/Pop/Impressionist artist).

Like it or not, in a museum we gravitate toward the works of those artists who we know have had their reputations burnished by high prices, and it is not easy, standing in front of those works, to ignore this. Just remember, the market is not history, the market is not a judge of quality. The market reflects fashion, trends, and current availability. While I agree absolutely that great art deserves to command high prices, I dispute that just because two people compete to pay millions of dollars for a work of art it must be great.

One of the most celebrated Victorian painters was Lawrence Alma-Tadema, whose superbly painted, coyly erotic, yet to our eyes saccharine pictures, wowed not only the high and mighty of his time, but also the general populace. His paintings sold for upwards of £5,000 (in today's dollars a fortune; a carpenter then earned £100 per year). It is not so different perhaps than a work of art that sells today for $25 million, which is five

hundred times a yearly salary of $50,000. Alma-Tadema's plunge (together with many of his fellow Victorian painters) from great fame and fortune to virtual obscurity was swift and sure. It can happen again.

In 1983 thirty-one-year-old American artist David Salle painted *Tennyson*; six years later it was sold at Christie's for $550,000. At the time, he and a few fellow artists like Julian Schnabel and Eric Fischl occupied pedestals in the art world formerly reserved for older, more established figures. When the art market took a tumble in 1991, the cultural winds changed and the accolades diminished. This does not mean that Salle is permanently barred from the pantheon of great artists, but it does mean that more people paid attention to his work when it was breaking auction records. Great art deserves to be expensive, I firmly believe, *but expensive art doesn't deserve to be called great.* Jeff Koons's work drew more than three hundred thousand people into the artist's 2014 retrospective exhibition at the Whitney Museum of American Art in New York, and many of them came to see themselves reflected in the shiny stainless steel surface of his giant replica of a balloon dog (such as clowns make for children), another version of which Christie's proclaimed the most expensive work sold by a living artist when the auction hammer came down at more than $58 million in 2013. The event received worldwide news coverage, almost none of which discussed the quality of the object as a work of art. Reporters generally take the position that if a work of art "wins" at auction, then it must be the best (unlike prizefighters who can win in the ring and still receive stinging reviews).

Noise about money drowns out the art itself. I spend my working days buying and selling art and too much of my free time talking about buying and selling art. This is why I make an effort to eliminate commercial considerations ("I wonder what I could sell that for?") when I have the opportunity to spend time in museums. The purpose of the art on the walls is not for me to value it. Nor, in fact, is it there to encourage my speculation about the love life of the artist or the person who gave it to the museum, nor even to make me wonder what the artist said about why or how she made it. It is there for me to really see (not just look at)—to let in, absorb, ponder, enjoy (or not), accept, dismiss, criticize, appreciate, and in some cases, inspire me to find more like it.

Art as Entertainment

Neither is art simply entertainment, although aspects of the contemporary art business today appear to be an unholy alliance between celebrity culture and the luxury goods industry. Don't be fooled by artists, dealers, collectors, or curators who are boldfaced names in the gossip columns—that does not make the art associated with them great or good or even interesting, just expensive.

The idea that art must have a function besides experiencing it is deeply embedded in the way most museums are managed. Whether for profit or not, museums compete with (other) entertainment centers for the public's time and money. Most charge admission fees as well as fees for special exhibitions, and almost all rely on income from their shops and restaurants. Their goal thus becomes attracting as many visitors as possible, and this is accomplished by marketing. All forms of mass entertainment promise to deliver a special type of experience to their audiences, whether it is enjoying a hit Broadway musical or cheering on downhill skiers at the Olympics. They promise to deliver excitement. The aim of art as entertainment is no different.

With the advertising slogan "It's Time We Met," New York's Metropolitan Museum of Art sought to create a sense of anticipation, using photographs taken by visitors of themselves in the galleries—thus cleverly harnessing the epidemic of "selfies," self-objectification usually by smartphone, which is no longer confined to those under thirty. Naturally, many images were of people in front of (not seeing) works of art, and many images were of nice-looking couples, to suggest that the Met is a neat place to take your partner (or find one). I cannot argue with that, but perhaps great works of art should be in the foreground, not the background, of museum advertising.

We collect experiences rather than engage in them, as demonstrated by our widespread use of cameras in museums and galleries. We glance at a work of art, tell ourselves that it is so compelling that we want to remember it, and immediately capture its image digitally. Ironically, what we

experience is capturing the image, not actually seeing the work, and often the experience of taking the picture is all we remember.

The more electronic assists museums give us, the less likely we are to truly experience or remember what we are seeing. A very inventive gadget can be found in a Japanese museum that houses top-notch paintings by Claude Monet, Picasso, and others. By hitting keys on a panel set in front of one wall, the viewer can adjust the lighting for particular paintings, creating variations claimed to be the equivalent of:

> Winter morning glow: Normandy
> Summer dusk: Paris
> Spring afternoon: South of France

After playing with this, I couldn't help but wonder how many people remember the paintings as well as they remember the toy.

Rapid advances in technology literally diminish our need to focus. We can, and many do, wave our smartphones at an interesting object in a museum and click to capture it as our eyes are sweeping the rest of the room. Further, because we now have its image in our possession, we move on to the next work without really having seen the one we found so interesting. To make the experience even more collectible, we might take a photograph of ourselves or a friend (or ourselves and our friend) standing in front of the interesting work of art, thus relegating it to (partially obscured) souvenir status. Since visitors have been allowed to take photographs of works in the Galleria dell'Accademia in Florence, including Michelangelo's sculpture *David*, one tour guide described the daily scene as "a nightmare . . . People now swarm the paintings, step on anyone to get to them, push, shove, snap a photo, and move quickly on without looking at the painting."[2]

Some museums competing for maximum attendance now fear for the safety of what they are pledged to protect for the ages. The Hermitage Museum in St. Petersburg hosted 3.1 million visitors in 2013 and has no cap on attendance other than the physical limitations of the space, "or the number of coat hangers in the coatroom during the winter."[3] The head of visitor services told the *New York Times*:

Such a colossal number of simultaneous viewers isn't good for the art, and it can be uncomfortable and overwhelming for those who come to see the art. Thankfully nothing bad has happened, and God has saved us from mishaps.[4]

Museums that don't have extensive collections rely mainly on borrowing works for exhibitions that they organize. They understand that in order to maximize attendance, branding is essential. Top brands include names like Rembrandt, Leonardo da Vinci, Monet, Picasso, and Warhol.

As with scoring tickets for a sold-out Broadway hit, attending a branded exhibition at a museum offers the opportunity to score social points, especially for out-of-towners, by being able to say they have seen the show. In 1992 New York's Museum of Modern Art held a magnificent retrospective exhibition of work by Henri Matisse. A few weeks after it opened, I attended a dinner party at the home of a prominent collector in Dallas. There were about twenty invited guests, and when the hostess opened the conversation by saying she had just returned from seeing the Matisse exhibition, a social chasm opened up between the people who had seen it and those who had not. Apart from vague generalities, the artworks themselves were not discussed. It was enough to have been there.

As museum marketing becomes more and more successful and lines form around the block, many museums become less egalitarian than their founders might have wished. Crowds descended on the Solomon R. Guggenheim Museum in New York in 2013 to view a triumphantly beautiful exhibition by James Turrell, a contemporary artist using light as his medium. The artist had taken great care to create an environment conducive to quiet contemplation and the gradual revelation of the effects of subtly changing light and color. My first visit was on a weekday morning. The museum was packed, making it impossible for anyone to contemplate the art, let alone meditate. The noise level from excited chatter in many languages was increased by the repeated command, "No photos!" barked simultaneously by several guards attempting to keep order.

However, like airlines that now charge a premium for what used to be a free service (a meal, checked baggage), museums offer a better class of

experience if one pays an annual membership fee. I am a member of the Guggenheim, so a few days later my wife, Victoria, and I enjoyed an exclusive evening visit to the Turrell exhibition in the company of about thirty like-minded, semi-affluent New Yorkers, and we had a magical experience: quiet, peaceful, and regenerative, and we even managed to take a couple of photographs.

As a result of aggressive marketing and touting numbers of visitors as the measure of their success, museums are hoisted by their own petard. Today, visits to successful exhibitions, whether with "timed ticketing" or not, are often exercises in straining to glimpse the art through dense crowds, particularly those works that have been preselected by the management as worthy of audio commentary.

Despite the proliferation of audio guides, I still often see groups of adults trooping from painting to painting, led by a museum staffer or possibly a volunteer docent. In the Kunstmuseum Basel in Switzerland not long ago, I was in a spacious Impressionist gallery with quite a few visitors, including a group of about ten people being addressed loudly by a French-speaking guide. When my companion and I started to chat quietly about a painting by Georges Braque, the guide yelled from across the room at us to keep quiet!

Visual distraction is equally a problem. The principal villain for me is the wall label. It demands attention, reminding us that a work of art is "by" somebody and "about" something. Even if we ignore it, it remains on the periphery of our vision as we view a work. (Yes, I am fairly fanatical on this topic!) On a recent visit to the Nelson-Atkins Museum of Art in Kansas City, Missouri, I was delighted to see a wonderful painting by Mark Rothko.

All great works of art deserve to be seen unsullied, but the power and resonance of the form and color of a painting by Rothko, an artist whose vision is especially pure and subtle, only fully function when the work is "naked" on the wall. Sadly, I found it almost impossible to concentrate on this work in Kansas City. I might manage (from long practice) to tune out the large wall label less than ten inches from the right side of the painting (the work's less than engaging title is *Untitled No. 11, 1963* [1963]), but I

Illustration of Mark
Rothko's *Untitled No. 11,
1963* (1963) installed at the
Nelson-Atkins Museum
of Art, Kansas City,
Missouri

could not overcome the distraction of the white steel cage about two feet
high that projected from the wall and surrounded the work.

Curiously, in another gallery I was able to sit (there were no benches in
the gallery with the Rothko) and stare at my leisure (about ten minutes)
at a magnificent late painting of water lilies by Monet, which, although
6 ½ feet high by 14 feet wide, sported no railing, and while I was enjoy-
ing it, a young couple photographed themselves with their backs no more
than an inch from the delicate surface of the work. Collectors who lend
their works to a museum often demand stringent security measures, but
both the Rothko and the Monet are in the permanent collection of the
Nelson-Atkins, so it intrigues me that one should be so much more visi-
bly accessible than the other.

I fully appreciate the need for security and to keep art enthusiasts of
all ages from closing in on works of art, but surely that is why museums
employ guards? In fact, on that same visit to the Nelson-Atkins, I was
approached twice by visitors with questions, which puzzled me until I
realized that most of the guards were male, about my age, and, like me,
wearing blazers and ties. I was happy to oblige, although one couple asked
me if they could take pictures and, although I knew the answer was "Yes,"
I was tempted to say, "No, use your eyes."

Visitors to the Museum of Modern Art in the 1960s had their questions answered by then-guards Sol LeWitt and Robert Mangold, both of whom lived to see their own artwork in the permanent collection, as did Brice Marden, who was a guard at the Jewish Museum in New York at the same time. Museum guards have far greater interaction with the general public than virtually any other members of museum staff, curators included, and thus their role needs to be enhanced, not diminished by replacing them with guardrails and, in some cases, truly distracting alarms that beep loudly when someone gets too near a work.

Museums morphed into entertainment centers relatively recently. Until late in the twentieth century, many American museums offered what novelist and essayist Zadie Smith described (apropos a well-run library) as "an indoor public space in which you do not have to buy anything in order to stay." She continues, "In the modern state there are very few sites where this is possible. The only others that come readily to my mind require belief in an omnipotent creator as a condition for membership."[5] Writing in the *Art Newspaper*, Blake Gopnik observed, "The museum as library, where you can choose what and how you will see, is being replaced by the museum as amusement park, with visitors strapped into the rides."[6]

Former Dallas Museum of Art director Maxwell L. Anderson, commissioned by the Getty Leadership Institute to study "metrics of success in art museums," was unflattering in his conclusions, which included the observation that the "self-described 'venture philanthropists'" who now fund America's art museums (cultural progeny of the museums' rugged but more generous nineteenth-century founders) "are just as determined to measure the value of their investment in nonprofits as they are in venture capital investments."[7]

Even though Anderson believes that what he calls "quality of experience" is the most important goal of a museum, it is also the hardest to measure (particularly for venture philanthropists). Anderson considers metrics that simply chart membership and attendance to be deceptive "because they resemble denominators of more familiar markets (like feature films), [that] are easy to document and report, and may be presented in a positive light." Instead, he advocates the adoption of indices that

measure a museum's core values, mission, and organizational and financial health.[8]

The metamorphosis of many museums from institutions for the acquisition and exhibition of works to entertainment centers is the result of planning and policy that is in plain sight. Visiting the Tate Modern in London in 2014 to see the magnificent exhibition *Henri Matisse: The Cut-Outs*, I was intrigued by a vitrine in the lobby showing models of a new building designed by the Swiss architects Jacques Herzog and Pierre de Meuron, which they hail as "a new iconic addition to the London skyline." It baffles me that something that does not yet exist can be an icon or indeed that there can be such a thing as a "new" icon, but I am a nitpicker. Captions for the handsome models indicated that the purpose of the museum-to-be is to "redefine the museum for the twenty-first century integrating learning, display, and social functions."

I wonder if the use of the word "display" was a deliberate public relations decision, to minimize the old-fashioned function of the museum as an exhibition space. To me, "display" suggests methods of presentation for the eye to graze upon rather than contemplate. "Learning" we cannot fault, it's always a good thing, but very vague. "Social functions" is the most sinister phrase, covering so many possibilities, from a modest cafeteria to catered weddings and corporate banquets. What seems to be abandoned by this redefinition of the museum's function is the active support of art and artists in the local, national, or international communities.

The synchronicity between museums and tourism is an established principle. Darwin, Minnesota (population 350), boasts a museum (and gift shop) for a ball of twine weighing 17,400 pounds that took Francis A. Johnson thirty-nine years to roll. Paris (population 2.2 million) boasts the Musée du Louvre with 35,000 works of art (but perhaps no twine), one of which, by Leonardo da Vinci, is known as the *Mona Lisa* (1503–19) and is the undisputed permanent gold medalist of "destination" paintings.

In the twenty-first century, parts of the world experiencing economic growth that are developing new or rebuilding old cities are keenly aware that museums are keys to tourism and development. Witness Saadiyat Island in Abu Dhabi, United Arab Emirates, boasting not only a projected

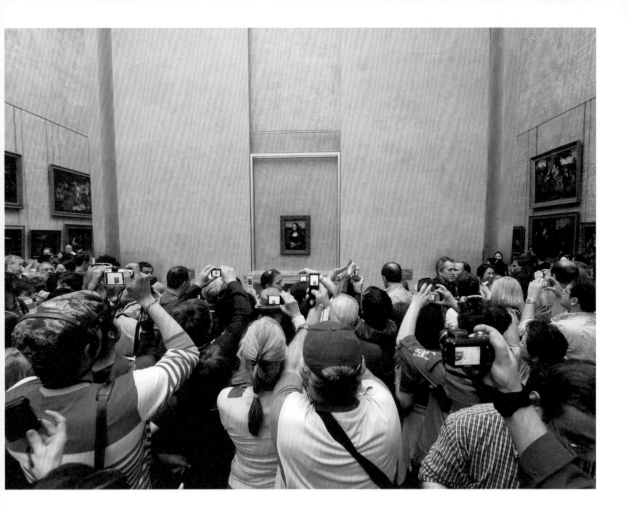

National Museum honoring the region's culture and founding family, but also franchised branches of both the above-mentioned Louvre in Paris and the Guggenheim Museum in New York.

Art has performed this function for centuries. From the mid-seventeenth until the late-nineteenth centuries, wealthy Europeans finished their education with a Grand Tour of capital cities, traveling in luxury, eating well, and staying at each other's palatial homes, where they would admire private collections of art as well as Renaissance treasures in churches.

When train travel became common, the hoi polloi could mimic these pilgrimages, just at the time when many national museums were being established. Motives were mixed then, as they are now, and the social aspects of the outing, whether local or international, always played an important part.

When I started to visit Japan in the 1980s, I was intrigued to learn that there was a museum devoted to the work of Marie Laurencin, a French

painter of charming, highly stylized young women in colorful costumes, a talented artist but not of the historical stature that might merit a museum. I was informed that the museum held the collection of one devoted collector who had also developed a nearby spa. In those days it was not proper for an unmarried young couple to announce they were spending a weekend together at a mountain resort hotel in Nagano, but it was quite acceptable for them to tell parents they were visiting the nearby Musée Marie Laurencin. The Japanese may be the most art-destination oriented of any nationality, Dr. Shin-Ichi Fukuoka, a molecular biologist and number one Johannes Vermeer fan arranged a teaching position for himself in New York so he could enjoy *Vermeer, Rembrandt, and Hals: Masterpieces of Dutch Painting from the Mauritshuis* at the Frick Collection. Tellingly, the *New York Times* ran a story about Dr. Fukuoka slightly longer than their review of the exhibition, which featured a reproduction of Vermeer's *Girl with a Pearl Earring* and a lead more *New York Post* than Old Gray Lady: "... she's back in town, that gal with a turban, the Christmas-bulb gem. . . ."[9]

While I rail against museums becoming entertainment centers, I have little doubt the trend will continue. Many dedicated professionals, including museum directors and curators, are firmly opposed to this, but are at the mercy of trustees dedicated to growth and box-office success. No surprise because, in the twenty-first century, corporate culture has successfully taken over not only museums and auction houses, but is also lowering the bar in all the arts.

There are, however, in every major city, places where the public is welcome to see interesting and sometimes great works of art from all over the world and from all periods, free of charge and, unless you glance at a usually discreet price list at the front desk, with no taint of monetization. Ironically, these are our commercial galleries. Of course, to keep art dealers like me eating three hot meals a day, commercial transactions take place in these establishments all the time, but generally out of sight and sound in the private offices. You are allowed, if not encouraged, to wander at will in the galleries and, unless you are carrying an Hermès Matte Crocodile Birkin bag or a gold-topped cane, you are unlikely to be bothered by the staff.

Art as Prestige

Few collectors admit that their sole motivation for acquiring art is to show it off, and, after having spent much of my life with collectors as friends as well as clients, I know that most collectors' motivations are a mixture of actually being attracted to the work, its investment promise, and the attention it commands. Some are quite secretive about their collections; perhaps they are naturally shy or simply don't relish a lot of attention. This is true of many European collectors.

American collectors often enjoy lending works for public exhibition and inviting people to visit their homes. When the San Francisco Museum of Modern Art reopened in 1995, leading local collectors opened their homes and "showed off" their collections to visitors with a series of teas and cocktails and dinner parties. This is a timeworn tradition in American communities that boast fine private collections; Texans are particularly hospitable in this regard.

From a prestige point of view, the question "Have you seen the Yoko Ono exhibition at the [Museum of] Modern [Art]?" is ideally answered, "Yes and no. I was at the opening but it was so crowded [with important people like myself] that I have to go back and see it quietly [but I doubt I will have the time]." We all like to show off, and attendance at art exhibition openings can reveal a community's pecking order, but truthfully, openings are the worst possible way to experience art. The circumstances dictate at-a-glance reactions, loud positive comments, whispered negative opinions, and constant interruption.

Museum marketing departments are keenly attuned to the prestige element in what they can offer, so various levels of membership allow the ordinary non-collecting citizen art lover to ascend (by tax-deductible donation) the ranks and be invited to events of increasing exclusivity—lectures by curators, receptions, wine tastings, and meetings with the director.

All well and good, but quite a remove from simply seeing and enjoying works of art. In this regard, museums provide "assisted looking" activities, not for the geriatric among us but for those who believe themselves to be too aesthetically frail to manage on their own.

Unfortunately, just as there are people drawn to art for social prestige, there are many who disdain an interest in art because they perceive it as a snobbish plaything. The vaunted art historian Bernard Berenson was once asked, "Who is art for?" to which he responded, "People like us," meaning himself and the collectors and dealers who revered his opinions and lined his pockets for providing them.

Rather than admit we could enjoy art for its own sake, we are more comfortable considering the tangible benefits of art as conferring social distinction. (Now that really *is* being a snob!) What if we adjusted our thinking slightly to include the reward that is the awakening of our senses as a tangible benefit of modern art? This benefit is much more inclusive (investors and social climbers can join in too) since there are millions of us within fairly easy reach of venues for modern art, which we may visit at little or no cost, other than the expense of getting there. Perhaps we need to convince ourselves that the principal function of modern art is to provoke a very wide range of feelings, from rapture, joy, and delight to boredom and bewilderment, all the way to unease, anxiety, and disgust. And why would we want to be disgusted? The answer is, you do not know until you try it.

Our culture condones and even applauds men as well as women getting "carried away" by music and even food, yet draws the line at fine art. It simply is not cool to get agitated in the presence of art. At least not in America. Taking after the great French novelist Stendhal, some Europeans may still admit to the syndrome that bears his name because, when he visited the Basilica di Santa Croce in Florence, he claimed:

> I was already in a kind of ecstasy from the idea of being in Florence and the proximity of the great men whose tombs I had just seen. Absorbed in the contemplation of sublime beauty, I saw it close-up—I touched it, so to speak. I had reached that point of emotion where the heavenly sensations of the fine arts meet passionate feeling. As I emerged from Santa Croce, I had palpitations (what they call an attack of the nerves in Berlin); the life went out of me and I walked in fear of falling.[10]

Excusing the florid language of the nineteenth century, we must admit that this avowal is not an intellectual conceit but genuine emotional turbulence precipitated by art. Have we changed to such an extent in a hundred years that today such a reaction seems more than slightly ridiculous and frankly undesirable? If so, we are not only missing the point of great works of art but selling ourselves short in the feelings department. If an artist does not strive to move our emotions beyond the commonplace, what worth is the work? We may use art to make money, entertain ourselves, and show off, but unless it transcends those functions it is not worth our attention.

Art (as) Education

Just what I thought, Mark Rothko. You see this—it looks really simple.
But it's worth so much money now. We studied him in art history.
—ONE COLLEGE STUDENT TO ANOTHER,
 DALLAS MUSEUM OF ART

How did you learn about art? Were you lucky enough to have good art at home as a child, even in reproduction? If you are reading this book, it means something got through at some stage in your life. Many collectors tell me that "art appreciation" as part of their education bored them to death. So what changed their minds? It may have been a casual yet providential encounter with a work of art in a real-life setting.

It strikes me that there is a tragic disconnect between every preschooler's aptitude for messing around with paints (and being told whatever they do is a masterpiece) and the names and dates of "famous" artists and the "real" masterpieces they made. Many modern artists have been inspired by the visual language of children. How about showing our children these works first and let them make the connections?

The most educational words that can be spoken to a young child about art are "What do you see?" and "What do you feel?" Describing what we see, even to ourselves in our own words is the vital first step toward true

engagement. A teacher encouraging a child to describe a work is doing a much more valuable job than a teacher who tells a student what a work means or is "about." Young children telling each other the different things they see in the same picture creates excitement that can ignite a lifelong passion much more readily than fidgeting while a work of art is explained. We can learn a lot from the uninhibited reactions of children to almost any kind of art but particularly modern art. Children are closer to their feelings than most adults and less afraid to express them. Not yet knowing what society considers sophisticated in art is a blessing. Before she is told the names and that they are famous, a five-year-old can enjoy what she wants; and we must not forget that it was a child that called out the nakedness of the Emperor.

A child first learns through play. All art originates with play. A child first learns about art by making pictures and objects. We are born with a desire for uninhibited form and color, and in infancy this yearning is integrated seamlessly into the narrative of our lives, what we see, what we feel, and what we make. When as toddlers we start to play with color and form, we make a mess. Go into any hardworking artist's studio and find the same: a mess; out of this mess emerges "art"—powerful, delicate, blunt, evocative, scrutable, inscrutable.

The best way to learn how to see art, particularly if you are a child, is simply to do just that, see it. The real thing. I didn't teach my children to ride their bicycles by showing them images of bicycles and telling them how they worked. Children have the amazing capacity to be both literal and imaginative, and both are excellent qualities that grown-ups should cultivate. And almost any "live" art is better than pawing through pictures of art, whether in books or on screens.

Museums may have special galleries or programs for children, but they are better off, if supervised, in the main galleries. And it is a pity they cannot touch the sculptures, particularly the sturdy kind, because crawling over a huge Henry Moore bronze is a unique sensation. When my daughter, Beatrice, was four years old, we were invited to a party by Lisa de Kooning at what was her father Willem de Kooning's studio in East Hampton on Long Island, New York. Outside it was a monumental bronze sculpture by Moore,

Seated Woman (1969–80), which was on a turntable base, and all afternoon long it was revolving slowly, festooned with clambering youngsters.

Encountering any bronze sculpture later in life, they will know instinctively what it feels like, and this is all part of being able to enter a work of art. Until they have been taught that art is coded as information, culture, and money, children engage quickly and are unembarrassed to voice their responses. Bringing "masterpieces" to the attention of children before they have had a chance to see and make up their own minds often has an intimidating effect that inhibits some of us for the rest of our lives.

I am being unfair to those schools and museums that encourage children to enjoy art in an experiential and participatory way, but the thrust of many museum programs aimed at adults as well as children is "we know stuff you don't know," and before you can enjoy the art on our walls you should listen to what we say (or you should listen *at the same time* as you look at it).

For many children the twig is bent so early that they feel they cannot look at a work of art without first reading the label. We encourage infants to make marks and applaud them no matter how muddy the result. Yet even in early grades, the practice of *seeing* develops a visual acuity that is then often blunted in favor of *identification*, in which children are taught the circumstances of a work of art but not given an opportunity to experience the object itself. As the child learns to read and write, "art" becomes the names of artists and the potential for insightful experience is stifled in all but the very talented. Famous artists are held up as standards of achievement, and our culture quickly informs even primary school students that some art is worth mind-boggling sums of money. The die is cast.

The five-year-old child doesn't need any words to enjoy what she is doing and when she is taken to a museum, she doesn't need to have explanations for works by Georges Seurat or Paul Klee or Franz Kline. Sadly, five is about the age that adults make the child aware that her highly praised splotchy daubs lovingly framed or attached to the refrigerator door are *categorically* different from the work of famous grown-up artists that we take her to see in museums and galleries. This is where the rot sets in because the child's work is in fact categorically *the same*; the difference is

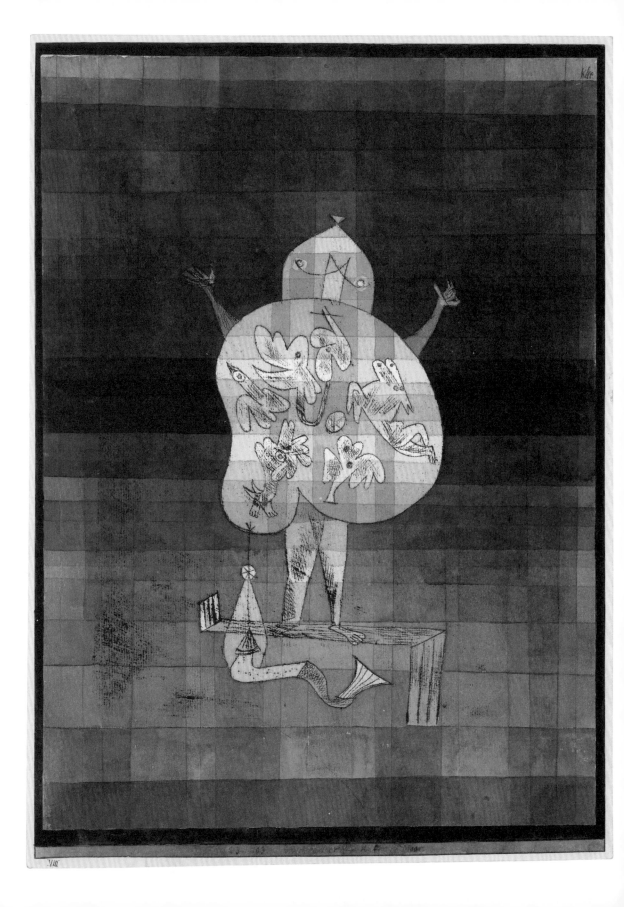

the older artist's ability to provide a profound experience with the same basic means. This requires spiritual, mental, and physical skills and dexterity that are acquired with age and practice.

Malcolm Gladwell famously proposed in his book *Outliers* a "ten-thousand-hour rule," which has been misinterpreted to suggest that anyone can become great as a painter or a musician or a chess master if they just practice for ten thousand hours. I wish! Gladwell explains: "Practice isn't a SUFFICIENT condition for success . . . The point is simply that *natural ability* [my italics] requires a huge investment of time in order to be made manifest."[11]

Matisse's mother gave him paints when he was sick in bed, and many artists I know have credited a family member, friend, or teacher who encouraged them to keep "playing" and provided support, advice, materials, and, in many cases, trips to museums to instill a love of the process, the path, the journey that is making art.

Sadly, many of us are soon made aware that our first efforts to make images have nothing to do with "real" art. "From kindergarten on," writes the aforementioned Dr. Ellen Langer, "the focus of schooling is usually on goals rather than the process by which they are achieved."[12] Whether one is making art or truly seeing art, a goal-oriented mind-set is a formidable obstacle. When children ask, "Can I?" or "What if I can't do it?" explains Langer, anxiety about success or failure predominates "rather than . . . the child's natural, exuberant desire to explore."[13]

Moreover, observes Langer, the style of education that concentrates on outcomes usually also presents facts unconditionally. But crucially, engaging modern art requires an embrace of creative uncertainty: this object or form might be this, but it also might be that, as we will see further on.

Exposing even young children directly to works of art, while refraining from prejudicing their judgment with extraneous information, can lead to a richly rewarding experience for both student and teacher. Kids do not need to know the title of the work they are looking at in order to tell us what it might make them think about and how it makes them feel. Children can be alarmingly articulate about modern art, if they are allowed to respond to it with as little prompting as possible.

OPPOSITE
Paul Klee
Ventriloquist and Crier in the Moor, 1923
Watercolor and transferred printing ink on paper, bordered with ink, mounted on cardboard
16½ × 11⅝ in. (41.9 × 29.5 cm)
The Metropolitan Museum of Art, New York. The Berggruen Klee Collection, 1984

A striking example of this was an unforgettable visit I made in 1966 to Talladega College in Alabama. The Museum of Modern Art in New York had organized an exhibition of works on paper by the British artist Bridget Riley and it was touring college museums. Talladega asked if someone could come down and give a talk. I was at that time working at the gallery that represented Riley, and because I knew her and her work well, the Museum of Modern Art asked if I would give the talk. The works are fairly small, detailed black and white studies on graph paper for large paintings that in London and New York were heralded as part of the Op Art movement, the "op" for "optical," a term applied to abstract works that seemed to dazzle the eyes. Riley's carefully calibrated, closely spaced wavy black and white lines provoke an exciting sensation of constant motion.

I delivered a talk to the college students in the morning and was approached by one of the professors, who asked if I would consider speaking to a group of schoolchildren coming to see the exhibition after lunch. I said I would be delighted, whereupon he went to great pains to warn me not to expect too much from them because they were mostly middle-school students from rural areas and would be well behind their New York City peers in terms of knowledge and sophistication. Little did he know!

The children arrived and milled around in the gallery space. They were not particularly well behaved and made a lot of noise. Once we got them to sit down on the floor and concentrate on the drawings, things changed considerably. I was attempting to kick things off by giving them some rudimentary information when suddenly, one after the other, talking over and around each other, they eagerly competed to tell me what they were seeing. They were not remotely interested in the name of the artist or Op Art or whether these were sketches or finished works or indeed in anything to do with "art." They were captivated visually and not at all shy about describing the movement they saw in the images and how it made them feel—certainly different in each case. They went straight into the works of art, eyes and soul.

By the time we reach middle school, there is an enormous gulf between the categories "student messing around with paint" (more generously,

"studio art") and works she or he is taught to consider part of the grand march of art history. This is when art in museums and galleries is turned into information rather than experience. Students are rewarded for being able to identify names and dates; and art from ancient times, the Middle Ages, and the Renaissance is often viewed not for its own sake but used to illustrate history lessons.

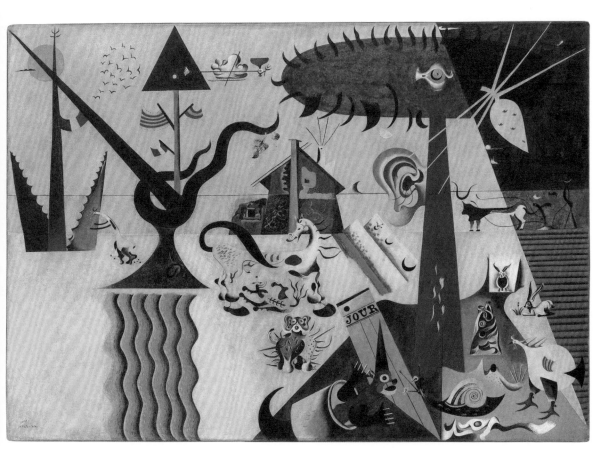

When it comes to modern art, many teachers make the assumption that it must be explained, either before or while it is being viewed, which suggests to the student that modern art has "rules," like those of grammar or geometry. A teacher who is unafraid to assign Rick Riordan's *The Kane Chronicles* to his incoming sixth grade class to read over the summer, and then, when class is underway, simply starts by asking one of them to talk

about it, will not take the same approach when it comes to looking at *The Tilled Field* (1923–24), an extraordinary painting by Spanish artist Joan Miró often on view at the Guggenheim Museum in New York.

The drama, excitement, and sheer whole-lot-going-on of this masterpiece is dead in the water if a teacher starts droning on about the history of landscape painting, Surrealism, or even, God forbid, Spanish history. It gets worse when a teacher utters, "What the artist intended is. . . ." First of all, no one knows what the artist intended, often including the artist himself. At the time he painted *The Tilled Field*, Miró wrote to a friend about paintings like this one, "I have managed to break free of nature and the [landscape paintings] have nothing to do with outer reality. . . ."[14] However, he also went on to say they appeared more like the actual landscape than if they had been painted from nature. In other words, real and not-real at the same time, which makes no sense at all as I write it, but perfect sense on the canvas.

A lot of artists are articulate after the fact, and in my experience their most honest answers are vague or, like Miró's, ambiguous. Unlike the creative act of designing, in which the skilled hand follows a plan that has been organized by the brain, the act of making original art involves the skilled hand as a translator of the imagination. If there is any plot to follow, it is subject to constant change, and progress can be swift or agonizingly slow, as inspiration and execution leapfrog one over the other.

Further on, I will discuss what I call "prior agreements," or beliefs, some neither reasonable nor valid, that may skew our attitudes toward art. One of the most damaging of these, reinforced by inept educators, is that modern art has definite meanings, which can be taught. Langer observes that "in most educational settings, the 'facts' of the world are presented as unconditional truths, when they might better be seen as probability statements that are true in some contexts but not in others."[15] In education about art, in particular, meanings must be understood conditionally, not as facts but as possibilities, suppositions, interpretations—all depending on the contexts in which they were proposed.

When a voice of authority interprets a work of art, we need the courage to tell ourselves it is merely a suggestion, and that the only truth is

in what we see. True engagement with art involves the discovery of what that work of art means to you (and perhaps you alone). What it means to others, including the artist, is certainly interesting but cannot invalidate your experience.

One of the most perceptive commentators about art, someone who completely understands both its capacity to amaze and its elusiveness when it comes to teaching, is James Elkins. He writes: "The world is full of things that we do not see, and when we begin to notice them, we also notice how little we can ever see. . . . It is almost as if seeing is too full, too powerful to indulge in without careful rules and limitations."[16]

If we show a child a photograph of a painting in a book and explain who the artist is and what the painting means, we are presenting art as a learning category. If instead we take children to a museum and ask them to choose something they enjoy seeing and talking about, we are presenting art as an experience, a category of living. In addition, as studies have shown, the opportunity to make choices increases motivation.[17]

Elkins again puts his finger on one of the major drawbacks to learning about art in the classroom: "Books of art history tend to review the same images over and over again."[18] These are often images of works that major museums make available for publication and that help to "brand" the museums and attract visitors. Thus the student identifies van Gogh with the endlessly reproduced *The Starry Night* (1889), and when his class visits the Museum of Modern Art that is the van Gogh everyone stares at, perhaps overlooking his *Olive Trees* of the same year close by—an equally powerful but less famous work.

By high school, we generally encounter what I call the "standard-bearers" for specific artists, such as *Woman, I* (1950–52) by Willem de Kooning and *Campbell's Soup Cans* (1962) by Andy Warhol—and, hey, I have used the de Kooning again in this book! There is nothing wrong with considering frequently published works, so long as you actually make time to go and engage with the works themselves.

At the same time, we should seek out other works by these artists that may be capable of moving us just as strongly (or more so, because they lack the cliché factor). Specific paintings (or sculptures) become standard-bearers

not simply because they may be among the best examples of a particular artist's work, but because they are owned by high-profile institutions with extensive exhibition, publishing, and marketing programs. The selection is not always based on curatorial expertise or critical consensus; the most frequently reproduced artworks often become standard-bearers simply because they happened to enter a museum's collection first.

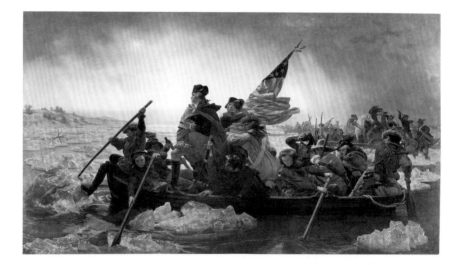

Emanuel Leutze
*Washington Crossing
the Delaware*, 1851
Oil on canvas
149 × 255 in.
(378.5 × 647.7 cm)
The Metropolitan
Museum of Art,
New York. Gift of John
Stewart Kennedy, 1897

While one of the many shortcomings of impoverished school systems is that they neglect art altogether, a failure of less-impoverished school systems is that the subject of art, like almost everything else taught there, has a pot of gold, or at least reward system, attached to the learning curve.

By the time we are adults, most art is buried under the generic label of "history," no longer alive for us. Recently I showed a very beautiful pastel of two women conversing in a hat shop to a young couple looking for a good work by Edgar Degas. The wife told me it was "too old-fashioned looking," by which she meant that the wide hats and leg-of-mutton sleeves of the ladies' fashionable dresses spoke too much of the late nineteenth century. The couple responded better to a nude because there were no (or few) clues to its time period, naked women being more or less the same in every era. Even ballet dancers were deemed suitable since traditional ballet costume is still familiar to us.

As historians we can be fascinated by what a painting tells us about the culture that produced it, less so its timeless qualities, but great art both illuminates and transcends the culture in which it was produced. We may turn to art if we are interested in how Napoleon looked and dressed (and paintings make good illustrations for history books), but we have to see beyond the fashions of the times. Historical information is a by-product; it is not what makes the work important.

Great art expresses aspects of our existence for "us," whether that "us" is the royal court of Akhenaten in ancient Egypt or the dislocated and damaged society that emerged in Paris and Berlin following the First World War. Wandering through the Egyptian galleries of the Metropolitan

Larry Rivers
Washington Crossing the Delaware, 1953
Oil, graphite, and charcoal on linen
83 ⅝ × 111 ⅝ in.
(212.4 × 283.5 cm)
The Museum of Modern Art, New York.
Given anonymously

Museum of Art, we may travel back in time effortlessly, no reading or listening required. Likewise an exhibition of work by German artists like Max Beckmann, George Grosz, and Otto Dix tells us immediately that something rotten was going on in the Weimar Republic, no history book required.

Unfortunately the works of art most frequently pressed into the service of history are rarely wonderful works of art, regardless of how well they seem to illustrate an occasion. Painted in Germany seventy-five years after the event it depicts, *Washington Crossing the Delaware* (1851) by Emanuel Leutze is a staple in American high school history books and one of the most visited paintings by school groups in the Metropolitan Museum of Art. It records an event that certainly occurred, a turning point in the American Revolution, and it is justifiably revered in the United States. Inspired or not by its patriotic appeal, many have been unmoved by the painting as a work of art. How much more vigorous would the classroom discussions be, about both history and art, if textbooks were instead to use the 1953 painting of the same title and subject by the American artist Larry Rivers, a work that, with its repetition and fragmentation emblematic of mid-twentieth-century culture, is more likely to provoke lively discussion.

We are told that Leutze was inspired to re-create this pivotal moment in American history as a political statement in sympathy with the revolutionary spirit that emerged in Europe in 1848. Had he actually witnessed the event that occurred so far away in 1776, his painting might have expressed more emotional depth. Alternatively, consider the work of Jacob Lawrence, best known for the sixty small paintings on hardboard, collectively titled *The Migration Series* (1940–41), that he completed when he was twenty-three. Lawrence actually lived through the period and witnessed many scenes like those he painted. Intensely moving, these figurative works represent virtually every aspect of the decades-long migration of African Americans from the rural South to the urban North of the United States, a migration that began around 1915.

As soon as it was completed, the series was bought by the Museum of Modern Art, New York, and the Phillips Collection, Washington, D.C., and twenty-six of the works were published in color in *Fortune* magazine. The

OPPOSITE
Jacob Lawrence
In the North the Negro had better educational facilities (Panel 58 from *The Migration Series*), 1940–41
Casein tempera on hardboard
12 × 18 in. (30.5 × 45.7 cm)
The Museum of Modern Art, New York. Gift of Mrs. David M. Levy

paintings have been the subject of many books, most aimed at young readers, the best of them emphasizing the artistic merit of the works as well as engaging the student with the historical facts they represent.

Whether by direct reference, as in the work of Jacob Lawrence and Andy Warhol, or by nuanced gesture, as with Robert Irwin's transformative installations that harness natural light, art must be of its time; and it is fascinating to pursue the study of it in that context, but history is only one aspect of the experience of art. When art endures and speaks to future generations, we call it "timeless." Utilizing art in the service of illustrating history inhibits our imagination and shortchanges the artist.

The Essential Value of Art

Do not look for obscure formulas or mysteries. I give you pure joy.
Look at my works until you see them. Those that are closest to God
have seen them. —CONSTANTIN BRANCUSI

I was thirteen in 1958 when I encountered Matisse's *Nude Study in Blue* (c. 1899–1900) on a school visit to the Tate Gallery in London. While it produced some titters of interest from my chums (our all-male boarding school afforded few opportunities to gaze on the female form, clothed or otherwise), I found myself strangely transfixed. It was unlike anything I had ever seen in a frame. We each had to pick one painting we liked and report back to Mr. Kerr with a description and why we liked it. When I thought about describing this painting, it sounded really ugly: a naked woman with greenish flesh, no face, bony body, posing awkwardly in a multicolored (a few years later I might have said "psychedelic") room. I tried to cheat and find something else to "like" that was easier to describe, but I kept coming back to her. It is hard for me to re-create my exact feelings, but they were a combination of excitement and discomfort. I knew that I was discovering something—mostly things about myself: that I could be moved by art; and the art that moved me most was called "modern."

Fast-forward fifty years: as an art dealer, I can give you a fairly decent spiel about why *Nude Study in Blue* is an important painting, but that has little to do with why it still delivers every time I see it. It excites me not because of what I now know about it but by what (still) happens when I am standing in front of it. Thirty-five years after we first met, the strange magic was still working when I saw her again in the 1992 Matisse retrospective at the Museum of Modern Art in New York.

In *The Value of Art*, I championed what I labeled as art's "essential" value, "essence" defined as "the intrinsic quality of something, especially something abstract, that determines its character."[19] This is the elusive "holy ghost" of that book's trinity, the other elements being commercial value and social value. Art provides us with plenty of opportunity for profit and

play, but we are missing the real payoff if we ignore its potential to impact us in more profound ways.

During the Middle Ages, art was considered an intrinsic part of religious worship, elevating the souls of the faithful to the greater glory of God. At the same time in China, and for centuries since, art was considered a form of spiritual practice. In the twenty-first century we may be more comfortable with facts than spirit, but the inescapable gift of art (if we choose to accept it) is the ability to stir our *feelings*.

In his fascinating book *Famous Works of Art—And How They Got That Way*, John Nici describes the debut viewing of Rembrandt's *Aristotle with a Bust of Homer* (1653) when it was acquired by the Metropolitan Museum of Art in 1961. The crowds were so huge that it had to be installed in the Great Hall near the entrance. The visiting throngs, overwhelmed by the presence of the painting, moved quietly, almost religiously before the new acquisition, some men going so far as to remove their hats.[20]

Museums are no longer designed, in emulation of houses of worship, as sanctuaries for objects that invoke hushed tones. Frank Lloyd Wright embodied that with the continuous, open spiral exhibition space of the Guggenheim Museum in New York, which encourages a dynamic physical experience as well as a visual one and which, on a busy day, looks and sounds like the Tower of Babel. This is not at all a bad thing—enthusiasm is often noisy—but it can be seriously distracting if you or I want a quiet zone for our seeing and feeling.

The most important thing for us to grasp is that the essence of a great work of art is inert until it is seen. Our engagement with the work of art liberates its essence. Think of one of your favorite paintings in a museum, by Gustav Klimt, perhaps, or Mark Rothko, or Jasper Johns, as a gift to you by the artist. In order for a gift to function it must be received. In order for that strange, ghostly white map of America by Johns to function, you have to see it. Then what? What within you is stimulated and how? If only your intellect responds, you are receiving a partial gift. What really counts is what you are feeling.

Of course, my feeling of delight in front of Andy Warhol's painting *Campbell's Soup Cans* (1962) may be matched by your feeling of disgust that

anyone would waste their time painting such a thing. We are as diverse inside as we are outside. We all have emotional receptors tuned to different channels, and because the world of art is thankfully more diverse today than it has ever been, there is something somewhere to delight everyone; all we have to do is make sure the battery is connected.

What are some of the most obvious feelings that art can generate? You might see a painting of tall poplar trees by Claude Monet and feel soothed and peaceful and then turn to a landscape by Ernst Ludwig Kirchner and feel startled and unbalanced. While we may struggle to understand the "meaning" of abstract paintings by artists like Barnett Newman and Jackson Pollock, letting them settle on our eyes without thinking too hard can produce feelings of grandeur and rhythm, not unlike some kinds of music.

In my daily life in the art world, genuine appreciation of good art is signaled by relatively blunt language that has little emotional flavor ("Yeah, it's really great, I like it"). This is not necessarily a symptom of a lack of engagement but instead inhibition, an unwillingness to express feeling for fear of being considered, God forbid, a "spiritual" being. In fact, everyone has the capacity (and I think the need) to be deeply spiritual, a state that, depending on the culture, can be described in terms of religion or even psychology.

Philosopher Jesse Prinz argues persuasively that the cardinal emotion when we fully engage with art is *wonder*, which he associates with three dimensions, one of which is spiritual, the others being sensory and cognitive. The first impact of a work of art is on our sense of sight; we stare. Then we are puzzled, we have never seen anything like it before, or we don't understand what we are seeing. Finally, perhaps, we are uplifted, we have a feeling of lightness or displacement. The artist Ed Ruscha succinctly but eloquently renders this sequence as:

(Looking)
"Huh?" (I have NO idea what that is supposed to be.)
"Wow!" (It moves me.)[21]

For Ruscha, weak art may initially startle ("Wow!"), but then fall flat, leaving the viewer with no feeling, just head-scratching ("Huh?").

Prinz scores early twentieth-century art high on the wonder scale but believes "the second half of the twentieth century has been a flight away from the emotions" and blames the art itself, citing the "cerebral" nature of Pop Art and Minimalism. This is where I part company with Dr. Prinz. New approaches to art, no matter how seemingly radical and different from what has gone before it, will always be capable of generating wonder if genius is present. We just have to be able to leave our baggage at home and not listen or read too much before we have a firsthand experience.

Certain kinds of "new" art provide endless fodder for an increasingly wide set of intellectual skills, but the bottom line, for me, is still the "wow" factor. Regardless of the artist's approach or materials, she or he *imagines*. One magic day in 1910, Wassily Kandinsky *imagined* that a painting did not require a subject; later, Salvador Dalí *imagined* a melting clock face, and Barnett Newman *imagined* the eloquence of one vertical stripe on a vast red ground, and Roy Lichtenstein *imagined* a painting that looked like a cartoon, and Dan Flavin *imagined* a sculpture made of fluorescent neon tubes, and Richard Long *imagined* that he could make art by walking.

When we are struck with wonder by works by these and other talented artists, it is because their imagination has resonated with our imagination. This is not going to happen if we approach with preconceptions about the "meaning" of Pop Art or Minimalism.

CHAPTER TWO

BAGGAGE HANDLING

\vee

We don't see things as they are,

we see them as we are.

—

ANAÏS NIN

Prior Agreements

We bring a great deal of baggage with us when we encounter any work of art; it is important to know when and how to check this baggage so that we may see art more clearly. Yet there is no such thing as a purely aesthetic response to art. No one is so enlightened and removed from the world that he or she can commune with a work of art on some perfect celestial level. Our engagement with every work of art is conditioned by our personal history and current state of mind. Life is a journey and we are both blessed and burdened with invisible suitcases filled with prior agreements. We all have them, inevitable consequences of having survived childhood.

A prior agreement, then, is a belief based on what we have done, read, or been told, which becomes a principle in our lives whether or not it is reasonable or valid. I could use the word "prejudice," but I prefer "prior agreement" because it suggests the possibility of evolution and development and of change through reexamination.

Prior Agreements and Learning

I was once told that a baby elephant can be tethered to a tree by a hemp rope, which it cannot break, and that the same elephant as an adult can be tethered to the same tree by the same rope because, "by prior agreement," the elephant believes it cannot break the rope. In fact, it can, and some do. Prior agreements about art are part of the overall scheme that we adopt as children to understand the world and that we continue to elaborate and negotiate as we become adults.

A more clinical description is "premature cognitive commitment," defined by Dr. Ellen Langer as a mind-set formed when we first encounter something, which we then cling to when we reencounter that same thing.[22] Such mind-sets, she writes, "especially those formed in childhood, are premature because we cannot know in advance the possible future uses a piece of information may serve."[23] In childhood we create prior agreements about context as well as information. I was educated by Jesuits,

and my discomfort at entering a non-Catholic place of worship persisted long after I stopped going to Mass on Sundays.

The context of our first encounters with art can govern our relationship with art later in life. What decorated the walls of your childhood home and what part did it play in your family life? I have known children of great collectors who, having grown up with modern masterpieces, are totally indifferent to art because they were told from infancy not to engage ("That's very valuable, don't touch it!"). Others of us may have grown up in homes with no "original" works of art but perhaps a few reproductions that made us hungry to see the real thing. Many of us, sooner or later, are taken to an art museum by parents or a teacher and that first experience in front of a work of art is when premature cognitive commitments are made, positive or negative. Were you encouraged to engage with works of art that caught your eye and to talk and respond in your own words, or was the goal of the exercise to absorb knowledge about works of art identified as important?

Our first encounters with art are inevitably confused with identification. As we focused our two-year-old eyes on a watercolor in our parent's bedroom, did they say:

Tell me what you see, darling.

or

This is by Aunt Helen. She used to be talented and went to art school.
It's supposed to be a barn.

The watercolor becomes Aunt Helen. It will be Aunt Helen for the rest of your life. Then comes the *Mona Lisa*. "This is the most famous painting in the world. By da Vinci. [Well, strictly speaking the artist is *Leonardo* from *Vinci*.] It's in Paris but you can't see it because the gallery is always crowded and it's quite small." For sure, you will never forget who painted the *Mona Lisa*.

As I have mentioned, the concept of "play" is in fact the heart of all creative endeavor, regardless of how serious the painting, poem, novel, symphony, or cathedral that it produces. A principal element in all play is choice. Preschool children allowed to choose their own materials make

more interesting collages than those who are given assigned materials. It makes sense that a child who is allowed to choose what to experience in a museum is going to spend more time with it, ponder it more, and enjoy and remember it better than if directed to a painting chosen by an educator.

Prior Agreements and Modern Art

When a friend says to me, "I can't understand modern art, I don't know enough about it," I am tempted to ask them, "How much do you know about ancient art?" What my friend actually means is: "What I have heard or been taught about modern art didn't help me." A parent who rails against it, a teacher who is pedantic and long-winded, a group of friends who scorn it—these are all occasions for us to establish a prior agreement that sculptures made out of old automobile parts or paintings with drips or ones of red squares or Campbell's soup cans are not worth our attention.

We bring prior agreements to every kind of art, although works of art that are reasonably representational and seem to demonstrate obvious skill in their execution find a larger and more sympathetic audience than other sorts of modern art. But just as we might be able to spend one evening listening to Johann Sebastian Bach, another to Igor Stravinsky, and yet another to Billie Holiday with equal but different types of enjoyment, so should we be able to wander from Jean-Auguste-Dominique Ingres to Pablo Picasso to Mark Rothko (and on to Agnes Martin and Donald Judd) without furrowing our brows.

Those of us who have been focused on the art as primarily educational are unfazed when we encounter art of the past of other cultures since we expect unfamiliarity, and rather than scold ourselves for not "getting it," we are quite pleased when we do manage to score an accurate observation about a gold-ground Italian painting or Chinese bronze without eyeing the label. We may find *Napoleon Crossing the Alps* (1801) by Jacques-Louis David a trifle melodramatic, or a Venus by Peter Paul Rubens too well fed, but if Rubens had used Kate Moss as a model, he would have been ridiculed. Standards of male and female beauty can change in our culture in a couple of generations, so it is only natural that the image of an alluring courtesan

and her patron in an eighteenth-century Japanese ukiyo-e painting might have little in common with Julia Roberts and Richard Gere in *Pretty Woman*, but because we know we are seeing the product of another place and time, we can suspend our contemporary tastes and enjoy the journey. We care less when we don't fully understand art of other times and cultures and certainly don't particularly expect to be moved by it. If we want to know what it means, we can listen to the audio guide.

Modern art, on the other hand, challenges our prior agreements because our very definition of art may be mentally circumscribed by the idea of a picture in a frame, a sculpture on a pedestal, a drawing under glass. Color, imagery, medium, skill—how much of our likes and dislikes are matters of taste informed by really seeing modern art? Or how much of it is based on prior agreements?

Open Mind Required

We all know what we mean when we say someone has a "closed mind." Seeing art, especially modern art, requires an open mind. We must let go of our ideas about what art is or is not; where it is appropriate or inappropriate for it to be seen; and any requirements we think are necessary for its makers, whether in terms of education, age, and gender; or even whether or not a work of art has to be made by an individual as opposed to a couple or a group.

Many of us try to lead principled lives. Others may scorn the principles we uphold. Your right to carry a gun versus my right to safety. Your abhorrence of obscenity versus my belief in freedom of expression. Besides testing and stretching the boundaries of what art is or is not, some modern art also tests and stretches the boundaries of social conventions, including those of politics and religion.

As I look back on the New York art world of the 1960s, collegial as it seemed to me at the time (and tiny compared to now), I realize that it was also lacking in diversity, and I don't just mean in terms of race and gender, though, yes, most artists were white males. I assumed that being an artist meant carrying an invisible card, which read:

I vote for left-of-center candidates and I believe in free love but not God.

I was so convinced of this that when a friend of mine offhandedly remarked that the painter Henry Pearson, whose work I admired, was an ardent Republican, I was astounded and somewhat bewildered. Such was my prior agreement equating creativity with a left-wing outlook on life.

If you see a work of art and some aspect of it offends your belief system, first of all make sure that what you think you are seeing and finding offensive is the work and not in your own mind. A glance is not enough; give it, say, one minute. If you are still upset, simply move on.

Strangely enough, religious subject matter in modern art is possibly more controversial than any other topic. Forgetting, or perhaps ignorant of, the morbidly gruesome and even scatological art that flourished in Christian Europe through the Middle Ages (think Pieter Bruegel the Elder) and the Renaissance, today's guardians of religious morality continue to denounce, censor, and seek to cut off public funding for, and in some cases destroy, contemporary art that they deem offensive.

Famously, Andres Serrano's 1987 photograph *Piss Christ* and Chris Ofili's *The Holy Virgin Mary* (1996; created with various media, including glazed elephant dung) became fodder for culture wars from Avignon, France (where protestors destroyed the Serrano), to New York City (where the mayor threatened to evict the Brooklyn Museum for exhibiting the Ofili). In the end, this kind of attention only serves to obscure what might be genuinely engaging (or not) about such works of art. Let you and me decide. For instance, among art dealers there is an adage that it is not easy to sell a painting by Marc Chagall of Christ on the cross. The reasoning is that Chagall, who was Jewish, largely appeals to Jewish collectors, and Jewish collectors are generally not interested in Christian imagery. Fair enough.

Artists are not usually out to create controversy; they go where their inspiration takes them, and then get caught in the cross fire. Ofili employs many different types of materials in his artworks, and my suggestion is that the shape and color of dried elephant dung, mixed with resin and glazed, was what he wanted not only for the color, texture, and composition

of his work, but to also challenge the associations that might be made by viewers of different cultures and backgrounds.

Marc Chagall, now strongly identified as Jewish, was once commissioned to create stained glass windows for French cathedrals damaged in the Second World War. He also worked with Henri Matisse on designs for a Dominican chapel in the French town of Vence. Does the artist's ethnicity or spiritual beliefs or practices matter? They may be manifest in the work, but our reaction must be to the work, not what we know about the artist.

German sculptor Arno Breker lived in Paris in the 1920s and was friendly with Picasso, the poet Jean Cocteau, and art dealer Alfred Flechtheim. He made bronze portraits of Alberto Giacometti, Isamu Noguchi, and other fellow artists. Yet today he is damned as "Hitler's favorite sculptor," which indeed he was, and he profited very handsomely from the patronage of the Third Reich. Coming across one of his heroic neoclassical bronzes in a museum and knowing nothing about the artist, one might think it quite stunning. Oh dear.

In the art trade, it does pay to be aware of cultural and social bias in your customer. In 1993, very early days for western auction houses operating in Asia, I was part of a team that assembled what we hoped would be a landmark auction for Christie's in Taipei, Taiwan, of western art aimed primarily at new Asian collectors in the region. It was grandly titled *Western Art: Old Masters, 19th Century, and Modern Pictures*. This was long before the economic boom in mainland China, but collectors in Taiwan, Hong Kong, and Singapore were bidding in the New York and London auctions.

We failed, however, to do any significant market research, and so the great Dutch still life of dead game, the anonymous sixteenth-century diptych of the Baptism of Christ, the nineteenth-century cardinal taking tea with his kitten, and indeed most of the paintings of playful kittens (yes, there were more), went unsold.

As these were being hung for a public viewing at the Shin Kong Life Tower, two of my Chinese colleagues had approached with furrowed brows, shaking their heads.

"No Chinese will buy paintings of dead animals," one said.

"Unless they are cooked," said the other. And they were right.

OPPOSITE
Chris Ofili
The Holy Virgin Mary,
1996
Acrylic, oil, polyester
resin, paper collage,
glitter, map pins,
and elephant dung
on linen
95 ¾ × 71 ¾ in.
(243 × 182.4 cm)
Private Collection

WHAT IS A WORK OF ART?

∨

I like to compare myself

to other artists, like Picasso.

—

MADONNA

Many objects are referred to as "works of art," meaning, metaphorically, they are of such quality that they are *like* a work of art. We refer to pop singers as "recording artists" and designers as "graphic artists." Nevertheless, the word "artist," simply stated, suggests a person creating objects or environments with no purpose other than to act on our senses in an extraordinary manner.

Traditionally, such objects have been understood as handmade—that is, implicitly unique objects in a narrow array of mediums: oil paint on canvas, ink on paper, marble, bronze, and so on. Most of us are comfortable recognizing objects made with these materials as art, whether we like the specific object or not.

In the twentieth century, many artists explored ways in which to create art with nontraditional means (and not necessarily handmade), so that in today's culture we can enjoy "art" not just as objects that can be collected but as experiences that may take place in an art gallery, a museum, or indeed any public or private space. Our participation is paramount to the realization of the work of art, regardless of its nature; we are the artwork's indispensable partner.

Fundamentally, the artist makes visible the invisible. The artist reaches into darkness and brings things to light, as well as bringing light to things that may already be in front of us but not visible *as art*. As viewers we are essential to this process; the object as it has been made is only activated when viewed—by bearing witness, we turn on the engine.

I think this notion first came to me visiting a work by Cimabue in a small and very dark church in Tuscany, Italy. In order to see the work one had to drop a coin into a box, which turned the lights on for a few minutes. Not so different perhaps from the admirer of Felix Gonzalez-Torres who, following instructions provided by the artist that are part of the artwork, removes a wrapped hard candy from a diminishing pile on the gallery floor, which is the work of art. One way or another, we must participate.

If we accept the proposition that our participation is an essential ingredient in making art manifest, we have to jettison some notions we may

harbor: that evidence of the artist's hand is essential, and that an artwork necessarily is unique. These precepts were already challenged in 1917 when Marcel Duchamp purchased a porcelain urinal from J. L. Mott Iron Works on Fifth Avenue in New York. He titled the urinal *Fountain* and signed it "R. Mutt." Subsequently photographed by Alfred Stieglitz but, ironically, never publicly exhibited, Duchamp's urinal empowered subsequent generations of artists to exhibit a wide variety of "found objects" as artworks.

In 1922, Berlin-based Hungarian artist László Moholy-Nagy had five paintings in porcelain enamel factory made per specifications he gave over the phone. In the latter part of the twentieth century it became commonplace for artists to have their work fabricated. They included not only sculptors (who for centuries have worked with skilled artisans as assistants) but also painters like Sol LeWitt, whose massive wall drawings were executed by his staff.

While we may subscribe to the romantic idea of the artist alone in the studio facing the challenge of an empty canvas, in reality many artists have veritable manufacturing plants. This is not a new phenomenon: French sculptor Auguste Rodin employed more than a hundred workers in two studios. Andy Warhol called his studio the Factory, though his handful of on-again, off-again assistants and gaggle of hangers-on pale in comparison to the highly skilled employees staffing the corporate-style manufacturing enterprises of artist-entrepreneurs like Jeff Koons and Damien Hirst. Perhaps the most ambitious such studio is that of Shanghai-based artist Zhang Huan; more commune than factory, it encompasses three huge warehouse buildings in which more than a hundred assistants work in separate studios for printmaking, painting, and sculpture, and who are served by two in-house chefs.

Must an artwork be the product of a single artist? Artists sometimes work in pairs, as did the husband-and-wife team of Christo and Jeanne-Claude, or even as an anonymous collective, like the Bruce High Quality Foundation.

We can debate (and many do, endlessly) whether the products of any of these enterprises deserve to be called "art," but that is a separate issue. The question of whether the object of your attention is or is not art is not

germane to the process of *seeing* encouraged by this book. This process applies to anything you encounter in a museum or gallery. First and foremost, you will get to know it. Only then will you decide if you like it or not, and you will be confident in your judgment regardless of whether I or anyone else has a different opinion.

Skill

"My kid could do that!" is the indignant comment often heard in front of paintings by Wassily Kandinsky, Joan Mitchell, Pablo Picasso, Jean Dubuffet, and many others. The phrase is often applied to "non-objective" (i.e., abstract) paintings with loose brushstrokes and an apparent absence of any principles of composition.

To those indignant parents I suggest they purchase brushes, canvas, and paint, and spend a Saturday morning with their child creating paintings in the manner of the derided work. Both parent and child might learn something about color and composition and at least have some fun. I am dead serious.

Representational paintings and drawings that appear childlike yet are done by professionally trained artists (as opposed to untrained "folk" or "outsider" artists) may require no less skill than a photographically realistic work. A number of major twentieth-century artists including Picasso believed that in drawing and painting, children (as well as the mentally unstable) use a language that perfectly expresses thought, feelings, and "reality" in unison, before they are told what art should or should not be or do or say. When Picasso was being shown around an exhibition of children's drawings at the British Council in Paris in 1945, he remarked, "When I was their age I could draw like Raphael, but it took me a lifetime to learn to draw like them."[24]

Art dealers have been known to beg acceptance of work that looks "easy to make" by telling their client "but he can really draw very well, the early work is extremely lifelike," suggesting that Piet Mondrian could paint like an Impressionist (although they were derided in their time for not being realistic), if he really wanted to, thus bolstering the résumé of an artist

known for rigorously rectilinear compositions of black lines and blocks of primary colors.

I believe it is superfluous to make this argument because there is usually a fine draftsman in the student work of every great artist whether or not they apply that skill to their mature work. Drawing from life helps the art student to see, as we will learn in the next chapter.

We should not assume that the artist who drips and dribbles like Jackson Pollock or slashes like Lucio Fontana or scorches with a flamethrower like Yves Klein possesses less skill than an artist who can make a lifelike portrait of your mother. All art is the product of the imagination channeled by physical activity, and the great artist creatively controls that activity regardless of its nature.

Materials

I am more interested in seeing what the material tells me than imposing my will on it. —JOHN CHAMBERLAIN

Female Figurine
from Berekhat Ram,
Golan Heights, Israel,
Lower Paleolithic
233,000 BP
Volcanic material
1⅜ × 1 × ¾ in.
(3.5 × 2.5 × 2.1 cm)
The Israel Museum,
Jerusalem

Art does not have to be made from pastels on paper, oil on canvas, marble, or bronze. Long before the fifteenth century, when Jan van Eyck boiled glass, bone, and mineral pigments in linseed oil to make "oil paint," human beings invented ways to make pictures, and since the dawn of time sculptures have been made from whatever could be manipulated or worked with tools. The creation of portable sculpture-like objects may in fact predate our species: the so-called Venus of Berekhat Ram, a human figure in stone discovered in the Golan Heights of Israel in 1981, is thought to be more than two hundred thousand years old and the product of a hominid-like *Homo erectus*, earlier even than Neanderthal man. Bronze casting is more than five thousand years old, and since then there is virtually no hard material that has not been used by one civilization or another to create objects of art.

The first creative decision that an artist makes is the choice of materials, and no great artist ever takes this for granted.

Ink and pen, paint and brush, chisel and mallet are carefully selected. The choice of materials is obviously based in culture, but artists who break with historical precedent and use unconventional materials are challenging themselves to create the equivalent of new alphabets and challenging us to engage them as potent vehicles of expression. When times are tough, artists are forced to use whatever comes to hand, which can lead to creative innovation.

In the early 1990s, some dissident artists in China were not allowed to purchase conventional art materials. Ma Liuming, RongRong, Cang Xin, and others, living in a desolate area of Beijing they dubbed East Village in emulation of the New York City neighborhood, developed photography-based installation and performance works that became the foundation of a strong new wave of contemporary art in China that soon attracted international attention.

John Chamberlain
Dolores James, 1962
Welded and painted steel
72 ½ × 101½ × 46 ¼ in.
(184.2 × 257.8 × 117.5 cm)
Solomon R. Guggenheim
Museum, New York

Whether dictated by political or economic exigencies or freely chosen, the stuff that works of art are made from engages our senses and is part of what we see. Sculptor John Chamberlain chose salvaged auto parts as his sculptural medium and was able to wrest from them dynamic and vivid sculptures that transformed, yet did not disguise, their origins. The casual viewer may pass one and think, "Crumpled cars—that must be a Chamberlain," and move on, but the engaged viewer will pause long enough to see (and feel) its force and drama.

Does bronze appear hard or soft? The finish and patina of a bronze sculpture affects our perception of it just as much as the thickness (or thinness) of layers of pigment on a canvas determines how we see a painting. The walls of painter Lucian Freud's Spartan London studio were laden with inches-thick layers of paint wiped from the loaded brushes he used when applying layer upon layer upon layer of congested paint to build the fleshy substance of his nudes and portraits. We like to think of great artists "mastering the medium," implying skillful manipulation, but with some modern art, the more nuanced concept of letting the medium speak for itself is just as appropriate.

This is true for artists who employ technology, create environments, and perform. Are we intrigued with installations by Joseph Beuys because of the novelty of the mediums he used (such as felt, fat, hare's blood, zinc, and beeswax) or because, after spending time with them, we experience our senses shifting?

For Beuys, substance and texture play as important a role in his work as color, possibly more so, and with dramatic success. Immersed in it, our eyes become our fingers, there is no need to touch; the substances proclaim their own power. Artists who choose to use less conventional mediums are challenging themselves to make them "speak" and it is up to us to accept the challenge by not dismissing them simply because we find the medium unorthodox.

Early in the twentieth century, artists began to use whatever came to hand, so-called "found objects." I have mentioned Duchamp's 1917 *Fountain*. Another piece of found sculpture, from circa 1917, is a cast iron plumbing trap, turned upside down and mounted on a miter box, assembled by

Morton Livingston Schamberg and Elsa von Freytag-Loringhoven, who titled it *God*. Since then we have had a century of sculptors using everything from sticks, stones, and sand to household appliances. David Smith welded together pieces of rusted farm equipment and Jean Dubuffet (a former wine merchant) made sculptures of cork. Sometimes cost was a factor, particularly early in an artist's career, since working with marble and bronze is expensive, but more importantly, these and other artists found inspiration in everyday materials and were challenged to alter our perception of their basic properties. In 1955 Robert Rauschenberg purchased a stuffed Angora goat for fifteen dollars and eventually combined it with a discarded car tire, mounted them on a horizontal painting, and called it *Monogram* (1955–59).

Morton Livingston Schamberg and Elsa von Freytag-Loringhoven
God, c. 1917
Wood miter box; cast iron plumbing trap
Height: 12 ⅜ in. (31.4 cm);
Base: 3 × 4 ¾ × 11 ⅝ in.
(7.6 × 12.1 × 29.5 cm)
The Philadelphia Museum of Art.
The Louise and Walter Arensberg Collection, 1950

When I visited the late Hollywood producer David Wolper and his wife's magnificent collection of Picasso sculpture, he pointed out the one he liked best. Titled *Centaur*, the work is made out of old boxes, an easel, a light stanchion, and a lens box, materials left lying around after Henri-Georges Clouzot filmed Picasso painting for his film *The Mystery of Picasso* (1956).

In the 1960s and 1970s, young American artists experimented with anything and everything (particularly if it could be bought cheaply in the myriad stores on Canal Street in Lower Manhattan in New York City where every sort of hardware might be found in bins on the sidewalk). Claes Oldenburg engaged his wife Patty to sew soft sculptures of everyday objects made out of canvas and vinyl stuffed with kapok; Robert Morris and Richard Serra experimented with felt and vulcanized rubber; and Bruce Nauman used wax, fiberglass, polyester resin, aluminum foil, and neon tubing. In Europe, Günther Uecker was making three-dimensional paintings using nails. Some of the (to me) most original and strikingly beautiful sculptures of these years were made by Eva Hesse out of a very wide variety of commonplace materials including latex, rubber, fiberglass, rope, string, plywood, Masonite, papier-mâché, cheesecloth, cotton, sawdust, and hair.

Need I go on?

Even when we are not actually touching an object, our eyes can sense its texture, and we can be shocked by the novelty of the material or we can enjoy the physical "feel" of it. Other senses can also be engaged: Swiss sculptor Jean Tinguely's electrically powered machine sculptures make a wonderful racket, and not long ago the Museum of Arts and Design in New York found enough artists engaging our olfactory senses to mount an exhibition devoted to *The Art of Scent 1889–2012* (2012).

OPPOSITE
Pablo Picasso
Centaur, 1955
Painted wood
90 × 79 × 29 in.
(228.6 × 200.66 × 73.66 cm)
Los Angeles County Museum of Art.
Gift of Gloria and David L. Wolper

Color

Describing a work of art by listing its colors is pretty useless. Not only do you and I probably have a different red in our minds when someone says, "This painting has a red stripe on a blue background," but unless we see it we have no idea how the "red" stripe is modified by the "blue background." Colors juxtaposed change just as much as colors mixed together, and all

colors are modified by light. Plus, there are two types of light: the light "in" a work of art—the sense of light created by the artist—and the light "on" a work of art—the artificial or natural light in a museum, gallery, or home.

As an art dealer I know how much a work of art can be made to live or die, depending on how well or poorly it is lit. Impressionist paintings created in the open air often come alive in natural light, while other works, created in the studio, can only bear more gentle artificial light. The light "in" a work of art is determined by the degree with which it is mixed with white (to tint) and black (to shade). Tinting and shading produce light tones. When red, yellow, and blue (the primary colors) begin to be mixed, our attempts to describe the results may become unreliable. Your "blue-green" may be my "greenish black."

Our ability to engage with the colors in a work of art, as with its other qualities, is proportionate to the amount of time we are prepared to spend experiencing the work of art. Visiting the Museum of Modern Art in New York and glancing at *Panel for Edwin R. Campbell No. 4* (1914) by Wassily Kandinsky, we might, if asked, say it was composed of the colors blue, green, and red; in fact, it does include those colors, but there are also about twenty others in it as well. Why did we choose only green, yellow, and red? Because they occupied the greatest area? Perhaps. Because we like those colors? Perhaps. Because we do not like those colors? Perhaps.

If we stay with the painting for a minute (or two), our eyes will adjust and we will begin to see subtleties of color and quite possibly colors for which we have no names. We are not taking snapshots; *we are seeing*. What we will not see are Kandinsky's complex theories of color as informed by his association with Theosophy, an esoteric spiritual practice. Some modern artists espouse "scientific" theories of color (which, frankly, we do not need to know about in order to enjoy their work), but that does not mean that these artists work *without* color. You may read that Ad Reinhardt made "black" paintings and that Robert Ryman made "white" paintings. Encountering a work by either artist, your first glance might confirm this, but after a minute or two you will see rich detail, texture, and, yes, color.

A few years ago I saw a woman at an art fair in an incoherent rage in front of what I assume she thought was a "blank" painting by Ryman.

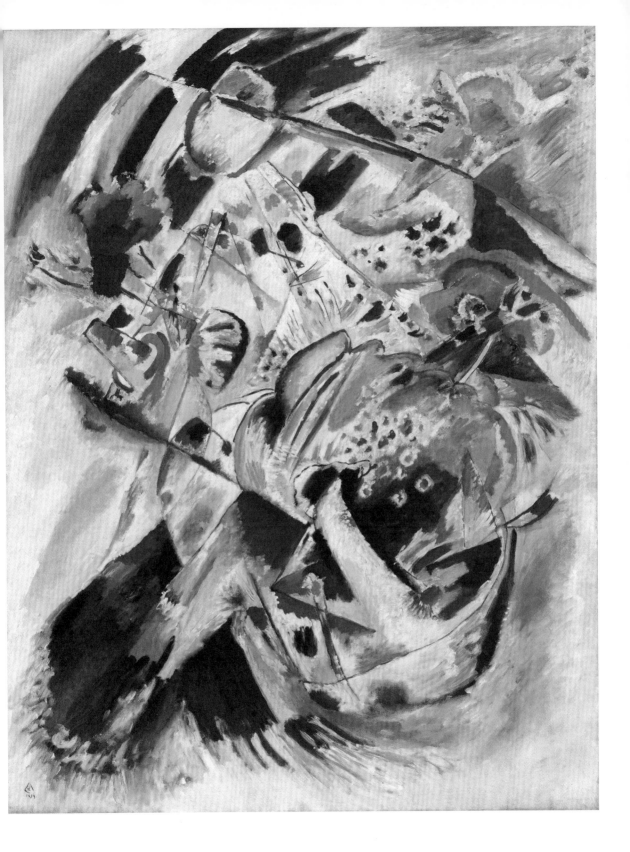

"This is not art!" she was screaming until she was gently escorted away. It is a pity she spent her time seeing only what was in her head and not seeing what was on the wall. Thankfully, I did not have the opportunity to ask for her definition of art, but the incident did remind me of just how much our responses to color (or an apparent lack of it) are predetermined.

What was your favorite color as a child? Our associations with color start in infancy, and they may be hardwired. Think about it—why is green your favorite color? The grass between your feet when you first staggered upright? Or yellow? A box of Cheerios? Or red? The robe your mother wore when she kissed you good night?

Two of us observing the same painting will see the same colors, but we will see them differently, owing to our prior agreements. I may be soothed by a certain shade of gray next to a vivid yellow, while you may be agitated by the same juxtaposition. At a recent exhibition of Henri Matisse's late cut-outs—dynamic, color-filled works made of paper shapes cut out by the artist from gouache-painted sheets and mounted on canvas—two friends and I paused before *Black Leaf on Red Background* (1952). We had been talking about color and when I saw Mark grimace and turn away, I asked, "What's the matter"? "Third Reich," he replied, "red and black—ugh!" Sarah interrupted us, "Well, I like it! I was a child in Trinidad when we got our independence and those are our flag colors. We all had one. It makes me feel happy and proud." If you find yourself dismissing a work of art because you don't like the color, it's worth pausing to ask yourself why, and then allowing yourself to pay attention to how the artist has used it.

Beginning with Georges Seurat, many modern artists like Bridget Riley and Ellsworth Kelly have delved deeply into the nature of color itself, particularly how our perception of color is affected by the juxtaposition of hues, shades, tints, and tones. Often works by these artists will not come to life (or even project a strong sense of movement) unless you spend a few minutes looking at them. People were startled when they first saw the elliptical dot paintings of Larry Poons in the 1960s. A former student at the Juilliard School, his colorful dots dance like musical notes across the canvas with afterimages appearing and disappearing in their wake.

Scale and color are intimately connected because the extent of a color changes our perception of that color. Paul Klee and Mark Rothko might be using the same ultramarine blue, and it may twinkle and charm in Klee's modestly scaled works but fill us with apprehension in one of Rothko's giant vertical fields. In fact, Rothko believed that the larger his paintings became, the more intimate they were, which makes sense when I think of standing four feet in front of someone much bigger than myself (too close!) as opposed to someone much smaller (come nearer, please).

The color of light (and colored light) itself is the medium for artists like Dan Flavin, Chryssa, James Turrell, and Robert Irwin. Sometimes we are not aware at all of being "in" their works until we are actually being bathed in light.

Our prior agreements about color are particularly complex when we engage with figurative art because, again going back to infancy, sooner or later we came to believe that the sky was blue and grass was green. The older sister looks at her younger brother drawing a blue cow and says, "Stupid! Cows aren't supposed to be blue!" (Apparently no one told that to Marc Chagall.)

What colors are things "supposed" to be? What about "flesh-colored" Band-Aids? Whose flesh and what color? Detractors excoriated the Impressionists for painting landscapes in colors, which, they claimed, did not exist in nature, although Claude Monet and Camille Pissarro were sticklers for painting exactly what they saw. They painted the same subjects over and over, often rendered with completely different palettes, in various kinds of weather and different seasons and times of day. Good artists know how to use color, and we are hugely rewarded, when we respond to their works, if we let the colors sink in.

On long summer evenings I stay in the garden as long as possible at dusk, reading until the light goes. I gaze across the lawn to see one of our Japanese maples, perhaps my favorite tree. I don't think I could accurately describe its color in bright daylight (reddish brown?) but words fail me as I watch it slowly change color many times in the final hour. Maroon? Scarlet? Deep purple?

Imagery and Scale

Prior agreements provoke immediate and possibly irremediable revulsion when perceiving certain images. When I worked at Christie's auction house, there was a principle in the Impressionist and Modern Art Department that we would accept no work of art that featured a swastika, regardless of the context. This sometimes meant excluding work by anti-Nazi German Expressionists like George Grosz, who were clearly mocking the symbol. It was felt that the swastika, which for three thousand years in many cultures represented peace, the sun, and good fortune, had been so tainted by the Third Reich that it was irredeemably offensive. Though it is still widely seen in Asian cultures, the proscription of it in the West is enduring. For Jewish people it can never regain its pre-Nazi symbolism.

While our society tolerates and even protects extreme forms of behavior (at both ends of the political spectrum), which the media exploits, those of us inhabiting the very broad middle realm hew to fairly uniform social sensibilities. Modern art, however, can divide neighbor from neighbor.

Since the last century, artists deemed "ahead of their time" have shocked the public with works ranging from truly original and genius to merely meretricious. Duchamp was thirty when he presented *Fountain* as a work of art; seventy-nine when he completed *Étant donnés: 1° la chute d'eau, 2° le gaz d'éclairage . . . (Given: 1. The Waterfall, 2. The Illuminating Gas . . .)* (1946–66) in 1966, an elaborate three-dimensional landscape tableau, including a waterfall in the distance, permanently installed in the Philadelphia Museum of Art. Visitors first encounter a crude wooden door built into the gallery wall, which has no handle. One at a time, viewers may peep through two small holes in the door. They see a three-dimensional landscape with an apparently active waterfall in the distance, in which a naked woman (her face obscured) is lying, legs spread wide toward the viewer, holding a flickering gas lamp.

While tripling attendance for the Philadelphia Museum of Art in 1969, the installation, unveiled, so to speak, in the tolerant Swinging Sixties, created little of the public furor that greeted the 1847–48 tour across America

of Hiram Powers's larger-than-life sculpture of a nude woman in chains, *The Greek Slave* (1846). In today's world of high-resolution pornography, there are few areas of taste left untested by iconoclastic artists, but each of us brings our own social and sexual sensibilities to art. And while some of us may be turned off because we cannot stomach certain images, others may need to be wary of liking art solely because it breaks rules.

One common prior agreement is that shapes and colors, unless formed into people, places, and things, have no meaning. This is the case despite the fact that the advertising industry spends vast sums establishing just what size and shape of cardboard box in exactly what color is going to make us feel warm and fuzzy enough to buy the contents without reading the ingredients in very small type on the label. We are fooling ourselves if we think we cannot be deeply affected by non-figurative art. Artists (and designers and architects) know that shapes and colors are extremely expressive, and while our prior agreements may lead us to different conclusions about the same painting, this does not invalidate the potency of an abstract image.

When we considered art and language in the previous chapter, I pointed out that not everything we see has a name. *We do not need to be able to express something in words to value it as an experience.* Abstract works of art can be approached less fearfully if we substitute "How do I feel?" for "What does it mean?" Ubiquitous in airports and sculpture gardens, large sculptures by Alexander Calder, moving or static, invoke feelings of weightlessness and grace, not because they "look like" towers or mountains, airplanes or birds, but because they act on our senses in a way similar to those types of things. More forceful for some viewers are the giant, dangerous-looking, swinging I-beams of Mark di Suvero. The concentric rings of Peter Sedgley's paintings and kinetic works positively glow, while the vibrantly colored "circle" paintings of Ugo Rondinone seem to spin. Paintings like these do not "mean" anything, they "do" something. Some works act immediately on our senses, while others need time to be fully perceived, rather like an old-fashioned photograph being developed.

Warhol is a good example of an artist who delivers everything at once—"Bam! Here's a huge *Triple Elvis*. Cool," we say, and move on—what is the

point of spending more than a few seconds? For me, the litmus test for a work like that is not so much whether I get more out of it the more I stay with it, but when I see it again, and again, do I get what I got the first time? Staying power: if it wilts the longer I see it, if it bores me, then I probably have no interest in seeing it again.

On the other hand, I might just say, before we leave the museum, "Wait a second, I just want to see that Warhol again," just to get a "hit," which I know will be as good as the first time. How does Warhol make that happen? Is it the image? Yes. The colors? Absolutely. The scale? Definitely. In

Henri Matisse
The Red Studio
Issy-les-Moulineaux, 1911
Oil on canvas
71¼ × 86¼ in.
(181 × 219.1 cm)
The Museum of Modern
Art, New York. Mrs.
Simon Guggenheim Fund

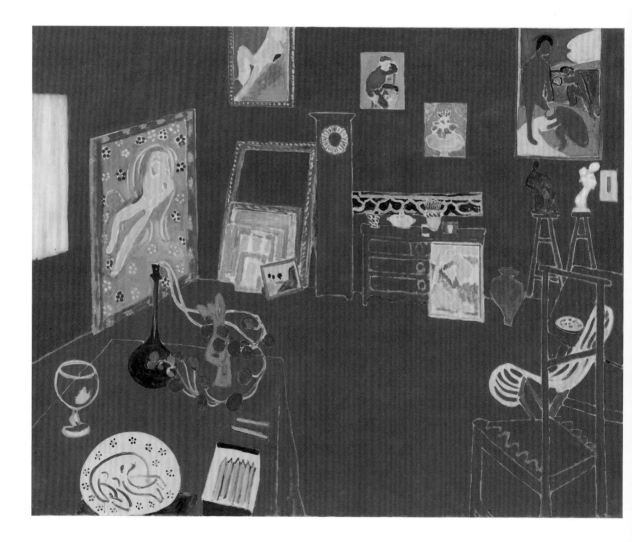

fact, it is every factor working to the same end—maximum impact and staying power.

Then we come to *The Red Studio* (1911) by Matisse. It may take five minutes before you finish exploring all its elements, allowing each one to work its way toward your senses, and another five minutes (perhaps moving back a couple of feet) to absorb the painting as a whole. After a while, nothing is as it seemed at first glance, not even the color red. I was visiting the conservation department at the Museum of Modern Art one day when this painting was having some very minor work done on it. I was granted a very close look: with the help of magnification I examined the edges of the unframed canvas and could see not one but several layers of paint, one color under another, which enriched the (mostly) red surface. Of course, we cannot, need not, and should not see that "underpainting" when the work is hanging on the museum wall, but we engage with the result of it. Some works of art explode onto our senses while others, like *The Red Studio* are no less powerful for seeping slowly into our consciousness. We may think we are only using our eyes, but in fact we sense every work of art with our whole body. Without necessarily being conscious of it, our sensory reaction to artworks has a lot to do with their scale. Even though the whole work is within our field of vision, we may step back and away when we encounter a painting larger than our body and we may move in toward a smaller work. Unconsciously we react to works of art according to their relationship to the scale of our body.

I was having a drink with the artist Richard Smith, who at the time was making large abstract-shaped canvases, and he said he was working on a "wide" painting. "How wide?" I asked. "As far as I can reach, of course." I was still puzzled, and he stood up and moved his right arm from far left to as far right without moving his feet. "That's the width, that's my maximum brushstroke." Viscerally, we react differently to works we might be able to pick up compared to works that are "beyond our reach."

If we are willing to suspend the prior agreements we have made about language and allow ourselves to look and *see*, rather than glance at and away from works of art that do not seem to mean anything to us because they do not represent people, places, and things, or any kind of narrative,

we might find a positive response in the part of our brain that is not language based. There may be alignments between us and works of art that operate beyond our intellect, in other words, prior agreements of which we are completely unaware that are part of our basic nature.

It may be useful to remind ourselves that the artist who made the object from which we rear back in dismay is not privy to our prior agreements. She or he does not know about the *Golden* Retriever that bit us or the strange *green* of the homemade pea soup that sent us to the hospital. The work of art that seems to challenge our sturdy opinions may in fact be a window to a new world, new thoughts, new feelings. The artist is asking us to take a journey and all we risk is a minute or two of our time.

So What Makes It Art?

The issue of whether something in a museum or gallery is or is not art is a red herring unless someone is trying to get you to cough up a small fortune to buy it. If I pay a modest fee to wander around a major museum with lots of interesting things to look at, there is no need for me to get outraged and demand my money back if I come across a slightly moth-eaten stuffed shark in a tank of murky water. It is not doing me any harm and probably will be gone the next time I visit (it was). It is also dangerous to extrapolate from one "not-art" object to the next. In other words, if they think that string of lightbulbs is art, how can I take anything else in this gallery seriously? Actually, you don't have to, but you may not have really looked very hard.

"That's a Henry Moore!" you cry out triumphantly as we drive past the Seattle Public Library. Sorry. Wrong. What you are looking at is a large horizontal bronze sculpture created by a man named Henry Moore. Am I being pedantic? Perhaps, but one of our persistent preconceptions is that the work of art *is* the artist insofar as it exists to represent an individual. We may be proud of what we know (or think we know) about an artist and be familiar enough with his or her work to stake a claim when we spot one. But successful works of art transcend the biographies of their makers and are not personifications. A collector may tell me, "I own a great

Giacometti," and while I may discount the qualification as run-of-the-mill vanity (no one has ever told me, "I own a mediocre Giacometti."), I am left with no other information about the work itself. If they tell me with even more pride, "I own a great Giacometti 'Head of Diego,'" the "great" work is being further personalized by author *and* subject, but Giacometti made so many very different heads of his brother Diego that I am still left with nothing. What I want is to see the portrait Giacometti made of his brother Diego. Let's not mistake the artist (or the subject) for the art.

We all have an appetite for gossip, and in our culture the excesses and tragedies of artists, past and present, make good copy. The modern artist in particular is presented as an outsider living a colorful if not dangerous life. Fascination with those who die tragically young (Vincent van Gogh, Amedeo Modigliani, Eva Hesse), those who enjoy the highlife (Warhol at Studio 54), and those with alcohol issues, multiple marriages, and mistresses (Willem de Kooning), buries their work beneath their life history. At best it gives us a word or two to mutter to ourselves or our companion as we arrive in front of their paintings, but it has nothing at all to do with what we are looking at.

Many artists live relatively ordinary lives. They stay married if that is their thing, they even raise children. But instead of an office, they go to their studios to work. For a number of years, I would often run into and chat with Pop artist Tom Wesselmann on the subway platform as he set off for his studio at the same time I set off for my gallery. When painting, René Magritte wore a three-piece suit with celluloid sleeve protectors like the bank clerks of his time. I am afraid to even suggest this because it might inspire someone to witless research, but I am willing to bet there is no correlation between the degree to which an artist's personal life deviates from the cultural norm and their ultimate place in history. By all means, read artist biographies for pleasure but leave them at home when you set out to see their work.

CAN WE LOOK AND SEE AT THE SAME TIME?

⌄

The question is not what you look at,

but what you see.

—

HENRY DAVID THOREAU

The Musée du Louvre in Paris once determined that its visitors spent an average of ten seconds in front of a work of art, and this included reading the label. A speed walker in the Louvre could probably see far more than five hundred paintings in two hours. This leaves only 34,500 objects on view still to be seen, or rather, glimpsed. And to those of you with the Louvre on your bucket list, I suggest you do it as soon as possible, since the museum expects the number of its annual visitors to exceed twenty-five million within the next ten years.

What is actually happening, neurologically, when we spend four seconds reading the label and six seconds staring at the artwork? Let us imagine for a moment standing before one of the great masterpieces in the Museum of Modern Art in New York, Pablo Picasso's *Girl before a Mirror* (1932), painted, the wall label tells us, in Le Boisgeloup (a hamlet in Upper Normandy, France), whose subject is Picasso's young mistress Marie-Thérèse Walter. Our brain is an extremely fast computer, especially when it comes to language. All our associations with the words "Pablo Picasso" and "1932" and his then girlfriend "Marie-Thérèse Walter" spring instantly to mind. Our brain probably won't need to absorb the other information usually found on a wall label (medium, dimensions, museum accession number), or the historical and interpretive information sometimes also found on wall signage. But our gaze moves in a flash from painting to label as the brain retrieves what we think we know about Picasso (*Spanish … dead … genius … philanderer … big money*); by the time our eyes have returned to the painting, that information has become a critical component of our perception. We have already started to project those labels (accurate or not) onto the work before we have had a chance to see it.

I maintain that if we learn how to see, we can experience actual sensation, regardless of who the artist is or what the work's subject, date, or place of creation may have been. But for this to happen, our minds must be open and clear.

Let's start with our minds and explore the difference between merely looking and really seeing.

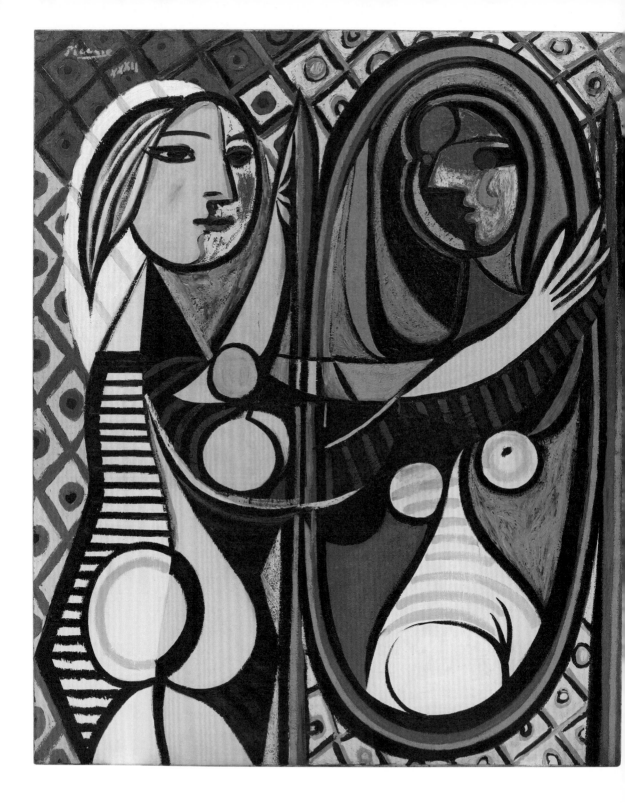

Art and Technology

Our daily lives train us to speed-look. We are losing the ability to contemplate thoughtfully, that is, to *see*. This ability is essential if we expect to engage with art. One of my favorite expressions is *Il dolce far niente*, Italian for "It is sweet to do nothing." Many of us, myself included, find this almost impossible. When we take the bus or subway, we always have a newspaper, a book, or a tablet to read. When was the last time you sat and gazed into space?

Technology delivers a constant stream of images and abbreviated texts, which we rapidly sort, digest (gulp), and dismiss. Crossing Broadway at Forty-Fifth Street in Times Square in a rush-hour crowd, I check a message from my wife on my smartphone as I step off the curb, noting that the crossing signal is blinking seven seconds left to reach the opposite curb, even as I check out the twenty million pixels of the two-story-high screen the length of a city block previewing a bigger, better smartphone than the one I'm holding. And I can do this all at the same time (I think I can, anyway). So why do I need more than ten or even six or even two seconds to see a painting?

In 1989 Christie's offered for sale a magnificent painting by Jacopo Pontormo, the *Portrait of a Halberdier* (1528–30), which you can now see at the J. Paul Getty Museum in Los Angeles. A life-size painting of a fresh-faced young man with a halberd, it possesses a startling presence.

Today, auction houses eagerly embrace every aspect of modern technology to make their wares exciting and desirable, but a quarter of a century ago a full page in color in the auction catalogue along with an advertisement in an art magazine was regarded as high-profile advertising. For the Pontormo, however, Christie's decided to take a daring (albeit belated) leap into the twentieth century and invest in a short video documentary. The camera panned back and forth across the painting and around it, as a well-modulated baritone male voice talked about the history of the work and George Frideric Handel's "Water Music" provided a suitably grandiloquent musical score. During the week before the auction, the painting was presented, alone, in Christie's aptly named Great Room in London.

OPPOSITE
Pablo Picasso
Girl before a Mirror
Boisgeloup,
March 1932
Oil on canvas
64 × 51¼ in.
(162.3 × 130.2 cm)
The Museum of
Modern Art, New York.
Gift of Mrs. Simon
Guggenheim

Well, almost alone. Facing the work across the room was a television, on a pedestal, continuously showing the promotional video. Crowds of visitors came. Many turned their backs to the painting and watched the video. Even those visitors who did grant the painting more than a glance spent far more time looking at the video—a triumph of advertising.

To be fair to Christie's, they were doing their best to lure a buyer, which they accomplished with flying colors, although I am fairly certain that the eminent George R. Goldner, who purchased the painting on behalf of the Getty, where he was then curator of drawings and paintings, was not swayed by the film version of the painting. Once settled in a museum, however, does a great work of art need to be set in motion to grab our attention?

More than a quarter of a century after Christie's first efforts at video promotion, we may be close to the point when educational apps make museum-going obsolete. One such app, featuring artists like photographer Cindy Sherman and the late Keith Haring, promises: "It will be like a mobile retrospective and it will hopefully be a fun way to explore art through an interactive, storytelling experience."[25]

Presumably, interactive stories are more fun than going to a museum and experiencing actual works of art. The motive behind filming art objects is not only to make them accessible to people who may not otherwise be able to experience them (noble), but to make them more interesting. The technology may have evolved from grainy black-and-white film to sophisticated digital applications, but the underlying assumption is that the work of art by itself is not enough. It needs to be dramatized, with the camera zooming in and panning around it, accompanied of course with a script and a musical score, negating visual art's greatest strength: the capacity to hold before us a motionless image or form for our contemplation, for as long, and as many times, as we may wish.

Not that motion pictures cannot be art—far from it! Great is the painter who can engender in me the same depth of feeling as when I see Maria Falconetti as Joan of Arc suffer her hair to be shorn in a harrowingly long scene, done in a single take, in Carl Theodor Dreyer's 1928 masterpiece *The Passion of Joan of Arc*. I believe in technology in the service of making art, but not in technology as a way of serving up (and dressing up) art.

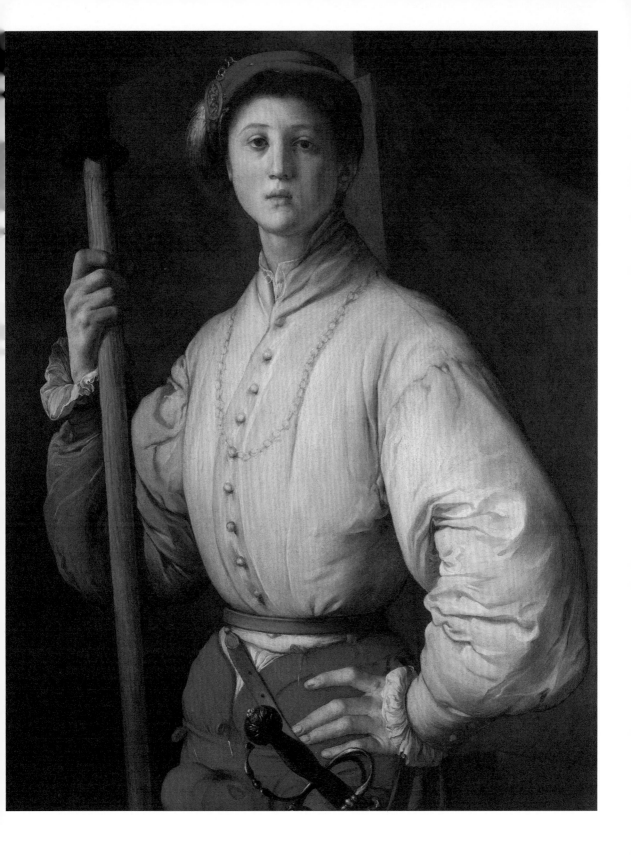

While we think of our eyes functioning as cameras, recording faithfully (perhaps with the help of glasses and contact lenses) what we see, our eyes are in fact not perfectly constructed for the business of seeing. Our ability to see clearly and accurately is a function more of the brain than of the eye. The eye gathers incomplete data and simultaneously the brain makes assumptions and inferences based on previous experience. Can you read and understand the following?

> This txet will demonsrtate that yuor brian dose not trnaslate exaclty
> what yuor eye sees. Intsaed, infulecned by waht it has laerend,
> it reocgnizes wrods golbally, wihtuot paynig muhc attnetoin ot teh
> ordre of teh lettres.

The same thing happens when you first look at a work of art. The brain organizes it into something familiar before your eyes have finished scanning. We then interpret this data based on what we think we are seeing, or what we want to see, rather than what may actually be in front of us.

Let's go back to the Museum of Modern Art and find Picasso's *Girl before a Mirror*. Taking my advice, don't read the label. And because you don't have a lot of time to spare, pause briefly to take the painting in—just a bit longer than the lady next to you, who is letting her camera do the seeing.

The first thing you see is a blonde figure on the left whose face seems similar to the "real" faces your brain processes every day. You first register it not as it is painted—a face combining frontal and profile views—but as a face seen straight on. At the same time, you register red, yellow, and green; it takes you a moment before you add in the blue and purple. Next you become aware of all the spheres and curvy bits. Then you notice the diamond-pattern wallpaper. Do you see the head in the mirror, top right? Of course you do, but it is the last element your perception accepts, perhaps because it is recessive, somewhat oblique (just like some images in a mirror), and the colors are darker than those in the rest of the painting.

You perceive all of this in a split second (you are in a hurry, remember), and if you now stroll on, you will have barely seen what Picasso painted. What you took in is your brain's heavily edited version of the painting as it sought the shortest route to the easiest answer.

Now imagine you are the master of your time and can spend another minute or three. Even thirty seconds more (and perhaps taking a step or two back) will allow you to really see all of the painting, both the parts and the whole. Another thirty seconds unites color and form and allows you to become aware of the wonderfully intricate relationship between the figure on the left and her reflection.

Simultaneously, you become aware of the thick texture of the paint, the feathering and layering of it. The work starts to appear as a tangible object, not just an image. Within a couple of minutes, your brain stops editing the information being recorded by your eyes and you can start to really see and feel the work.

The capacity to reward our sustained gaze is a litmus test for the strength of every work of art. The question is not whether the work has endured the march of history but does it retain the ability to come alive for the five minutes a silent, calm viewer is willing to spend with it, without tech backup of any kind.

Art and Language

To see is to forget the name of what one sees.
—PAUL VALÉRY

Aristotle proposed that to know something it was necessary for it to be named. This proposition is deeply embedded in our culture. Some people, even some incontrovertibly brilliant people, cannot understand something if it does not have a name. When the great philosopher and mathematician Bertrand Russell was a student at Cambridge University in the early 1890s, a fellow student experimenting with the pioneering idea of testing intelligence used him as a guinea pig. Russell performed brilliantly until he was asked to sort a big pile of shapes into matched pairs. He went at it speedily, but after finishing half the pile, he got up and announced that he could go no further. When asked why, he said it was because *he did not have names* for the remaining shapes. Brilliant as he was with words and numbers, Russell was less than literate visually.

Many artists today work in ways that defeat naming. Earlier I mentioned Robert Irwin, who has worked extensively with natural light (and nature itself), creating a profoundly moving and provocative body of work that no ism could possibly encompass. Not all of the masterpieces at the Getty Center are to be found inside the museum (like the Pontormo already mentioned); one of the most transfixing is the Central Garden (including a babbling brook) designed by Irwin. What is that kind of art called? What can we learn about its essential nature by naming it that we cannot know better by experiencing it?

Knowing the name of something is not necessarily as helpful to memory as preference. At Cornell University, psychologist Gary Lupyan gave copies of an IKEA catalogue to a group of students. Half of them were asked to examine illustrations of certain items and say aloud the object's name ("chair" or "lamp"). The other half of the subjects saw the same illustrations and were asked simply to state whether or not they liked each of them. The volunteers who named objects were less able to recall details than those who had stated a preference. According to Dr. Lupyan, labeling builds mental prototypes at the expense of recognizing individual features of an object. Thus, reading the wall label for a painting is less likely to help you remember it than deciding whether or not you like it.[26, 27]

Non-objective painting, which we like to call "abstract," puzzles viewers who are accustomed to identifying things by their names. The viewer who says, "I don't understand modern art" often, like Bertrand Russell, really means, "I don't have the language to describe it to myself." But perhaps you may say that we, in fact, get a more heightened experience of objects, places, or even persons, by naming them. You may suppose that our *visual* experience of a painting is enhanced by our ability to determine whether it should be compartmentalized as "figurative" or "abstract." Yet these constantly reiterated identifiers were meaningless to modern artists such as Henri Matisse and Willem de Kooning, whose bodies of work easily embrace both of those intellectual constructs.

We don't teach our children to read by making them learn the word "apple" and describing what an apple is. We show them an apple (or a

picture of one) and *then* the word. Infants learn what an apple feels like, looks like, and tastes like long before they know what it is called. The word "apple" is a convenient word to describe an object that we see, taste, smell, feel, and, if crunchy, hear. Do we need to know the word "apple" to enjoy a still life by Paul Cézanne? No. Even reading the words *Still Life with Apples* on a wall label may limit our enjoyment to simply musing on how well they resemble "real" apples before moving on.

We tend to believe that once a thing is described, it is known. But all languages are circumscribed by place and time in ways that images are not. The term "still life" in other languages—*nature morte* in French, literally "dead nature"—conveys meanings very far from what we understand in the context of English usage.

Fundamentally, unless used creatively and imaginatively, language fails art, which is why titles are often applied as an afterthought by the artist, the historian, or the collector. We can be sure that while Diego Velázquez may have referred to his masterpiece of 1647–51 as *The Toilet of Venus* or even *Venus and Cupid*, he certainly did not call it *The Rokeby Venus* as it is now usually called, because a hundred and sixty years after it was painted it was acquired by an English collector and hung at Rokeby Park, an estate in the North Riding of Yorkshire, England. Since 1906 it has been in London's National Gallery, where it is titled *The Toilet of Venus* ("*The Rokeby Venus*").

Titles are often worse than useless, stating the obvious, like Cézanne's *Fruit and a Jug on a Table* (1890–94). But would we get more joy from that painting if it were titled *Narrow-neck Single-handled Gray Jug on a Wooden Table with Blue-patterned Drapery and Ten Pieces of Fruit, Most of Which Are Apples but There Is Probably at Least One Pear and Perhaps a Lime*? Will knowing the exact name of each element in this painting increase our engagement with it? I say no, and beyond that, trying to "name that fruit" is about as engaging as the puzzles on the kids' menu in a diner.

A work of art is a real thing. Words are not real. Words are representations of reality. When we allow a work of art to have a direct effect on our feelings, when we simply experience it *as it is*, we are in the real world, which is exciting. As soon as we start to *know about* the work of art, we

are representing reality, which is safer to many of us, but it is a weaker experience.

Art and the Brain

As rational beings, we often seek the reason why an artist creates in a particular way, and the medical profession, in particular, enjoys discovering (or inventing) pathologies in artists to "explain" their styles. Dr. Michael Marmor, a professor of ophthalmology at Stanford University, has authored studies of both Claude Monet and Edgar Degas linking their late styles to problems of sight.

Reviewing the history of attempts to understand Vincent van Gogh's state of mind, Dr. Dietrich Blumer, writing in the *American Journal of Psychiatry*, observes, "The illness of van Gogh has perplexed 20th-century physicians, as is evident from the nearly 30 different diagnoses that have been offered, from lead poisoning or Ménière's disease to a wide variety of psychiatric disorders."[28]

In 1956 Dr. Henri Gastaut published his belief that poor van Gogh suffered from temporal lobe epilepsy precipitated by the use of absinthe in the presence of an early limbic lesion. Recently, in the *Western Journal of Medicine*, clinical professor of pathology Dr. Paul Wolf proposed that Dr. Gachet overmedicated van Gogh with digitalis, causing a distortion of his vision that led him to favor green and yellow.[29]

Neuroaesthetics is a new branch of brain study with very little to say about specific works of art. The celebrated French neuroscientist Jean-Pierre Changeux defines art as "symbolic intersubjective communication with multiple, variable emotional contents in which empathy appears as an essential feature of intersubjective dialogue."[30] Explaining how we respond to art neurologically, but defining all art as "multiple, variable contents," seems to me akin to a psychotherapist asking, "How did you feel at the time?" before trying to find out what I experienced.

In "The Science of Art: A Neurological Theory of Aesthetic Experience," V. S. Ramachandran and William Hirstein posit "eight laws of artistic experience," by which they mean to suggest a "loose analogy" with the Buddha's

eightfold path to wisdom and enlightenment.[31] Asserting that any theory of art must have three components—logical, evolutionary, and neurological—they posit, for the third component, that "art is most appealing if it produces heightened activity in a single dimension" that has been generated by one of the principles (the "laws"), which "artists either consciously or unconsciously deploy to optimally titillate the visual areas of the brain." Among these laws is the peak shift principle, which they explain with an example:

> If a rat is rewarded for discriminating a rectangle from a square, it will respond even more vigorously to a rectangle that is longer and skinnier than the prototype.[32]

The authors do not indicate what form the rat's vigorous response might take, but presumably, even the longest and skinniest rectangle might fail to produce ecstasy. The thirty-four-page paper mentions very few artists by name, and it has a lot to say about caricatures of Richard Nixon, but cites only one specific work of art, Salvador Dalí's "erotic masterpiece," *Young Virgin Auto-Sodomized by the Horns of Her Own Chastity* (1954).

A University of Toronto study published in 2014 involving more than thirty participants in seven countries who viewed paintings "inside the confined space of MRI scanners" (they must have been very small paintings) concluded that "paintings activated areas of the brain involved in vision, pleasure, memory, recognition and emotions in addition to systems that underlie the conscious processing of new information to give it meaning."[33] Well, what did they expect?

The progress that science has made in recent decades is impressive, and I expect that by the year 2100 we shall know a great deal more about who we are and where we are, but we may never know why we are. Isolating the areas of the brain stimulated by seeing this or that kind of art is excellent fodder for academic study, but it brings us no closer to knowing why you may enjoy the monochromatic squares-with-squares of Josef Albers or why my spirit soars when I see a craggy painting by Clyfford Still.

My brother Dr. John Findlay is an acclaimed biochemist, and I dimly recall long-ago arguments between us about art versus science when he was firmly on his way to a doctorate in organic chemistry and I was barely

out of shorts. I was convinced that art was somehow a higher calling, but I must confess to being jealous that he was much better at making art than I was at understanding science (he could have had a successful career forging works by Raoul Dufy). Since those days, I have managed to learn that science and art can inform each other and that great scientists, like great artists, take risks and make leaps of faith and imagination to reach for the unknown.

In *The Value of Art*, I wrote that when we see a work of art, only 20 percent of the information that reaches the brain is transmitted "up" from the retina; the rest comes "down" from regions of the brain governing memory. Looking at the same painting, you and I may actually "see" differently. People with synesthesia, considered abnormal, can "see" music as color, their senses being to some extent overlapping or interchangeable. I suggest that we may be born that way, but to function "normally" the brain develops a balance by separating the rational and linguistic functions of the left brain from the visceral intuitions of the right brain—although recent studies at the University of Utah suggest that the common notion that left brain equals logical and right brain equals artistic is a cultural myth that is not supported by brain scan data.[34]

Nicolas Rothen and Beat Meier at the University of Bern's Institute of Psychology believe that synesthesia facilitates creativity, and they cite the experiences of painter David Hockney as well as novelist Vladimir Nabokov, in addition to a self-reported study that found a prevalence of synesthesia in 23 percent of 358 art students.[35]

What goes on in our brain when we see a work of art? A research project led by Daria Martin at the Ruskin School of Art at Oxford University, "Mirror-Touch: Empathy, Spectatorship, and Synaesthesia," has investigated a neurological condition called mirror-touch synesthesia. "People with mirror-touch synaesthesia," they explain, "respond to touch that is seen out in the world—applied to other bodies or even to objects—by feeling a corresponding touch on their own bodies." In its extreme form, it apparently causes sufferers to have an immersive emotional reaction to works of art. For one patient, contemplating a thin spectral sculpture by Alberto Giacometti resulted in such overwhelming identification as to

cause "a redistributed sense of self."[36] I wouldn't mind a minor case of this once in a while.

Regardless of how it works for those of us not experiencing forms of synesthesia, what our eyes record is instantly processed by our experience. We cannot help but "make sense" of it. This is obviously critical when we are about to cross the road and see a red light, but possibly much less helpful when we walk into a museum and see a sculpture by Dan Flavin consisting of red neon lightbulbs. We see what it is, but what is it *for*? What does it *do*? In my opinion, its purpose is to engage our senses positively; to do that it must be experienced, and in order for it to be experienced, we must stay with it for a reasonable amount of time, quietly.

Facing a work of art, our intellect may be stimulated by reading the label and listening to the audio guide but our senses will not be engaged until we concentrate only on the object. Modern and contemporary artworks propose more questions than they answer. The answers to those questions are in experiencing the work of art. Art exists to be experienced. Art is for you. Everything else is collateral.

Listening to a piece of music for the first time or the hundredth time can be a transformative experience engaging our emotions, from the shallow to the profound. The same can be true of art. Author Susan Jacoby was a callow twenty-three-year-old reporter when she first visited Florence and saw the Florence Baptistery, whose east doors, created by Lorenzo Ghiberti, are known as the Gates of Paradise. Forty-five years later, she wrote, "Before that day in Florence, I had viewed love of 'great art' as a cultivated pretension. That changed—though I could not have explained what was happening to me at the time—the instant I caught my first glimpse of the doors."[37]

Testifying further to the power of art to pierce our psyche, she recalled viewing panels from the doors when they were exhibited in New York in 2007:

I attended the exhibition at the Metropolitan Museum of Art in New York with the man I loved, who had Alzheimer's disease. As he gazed upon the creation scene, the dullness vanished from his eyes and was replaced by an attentiveness approaching adoration. He remembered

having seen the panels in Florence many years earlier and said, "It's miraculous to recognize this."[38]

Art has the power to overcome the limitations of rational thought. I was up to my neck in the commerce of the art world at a recent art fair in Basel, Switzerland, when I took a morning to visit the Fondation Beyeler to see an exhibition of work by Paul Gauguin, which included some of the artist's well-known paintings and many, from Russian museums, that were not familiar to me. The exhibition was full of people whom I knew, so I was distracted by a certain amount of meeting and greeting while I was trying to spend as much time as possible with those works that reached out to me. One that stopped me cold was a horizontal painting of a naked young girl lying in a landscape holding a flower with a fox grinning over her shoulder.

Paul Gauguin
The Loss of Virginity,
1890–91
Oil on canvas
35¼ × 51¼ in.
(88.9 × 129.5 cm)
Chrysler Museum of Art,
Norfolk, Virginia

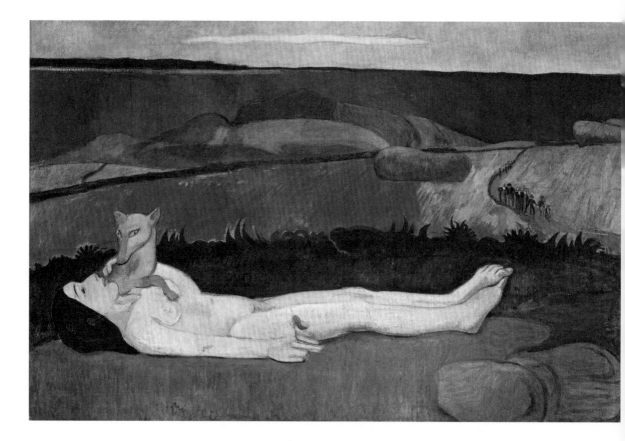

Rather embarrassingly, tears welled up in my eyes. My left brain was telling me it was a rather heavy-handed homage to Édouard Manet's famous painting *Olympia* (1863), and my right brain was operating the waterworks. What on earth was going on? Unlike those of many artists, Gauguin's titles are explicit, and they are often painted onto the works themselves. This work is called *The Loss of Virginity*. Why should that have such an effect on me? I didn't have to think very hard. My daughter had just turned fifteen.

One reason to spend more than a few seconds with a painting, a sculpture, or a drawing is that our brain is not receiving a seamless thread of data from our environment but instead anticipates what it thinks is going to be important at the moment, and it is easily distracted. When given time off from multitasking, the brain naturally seesaws between focusing and daydreaming, which, according to Daniel Levitin, author of *The Organized Mind: Thinking Straight in the Age of Information Overload*, "helps to recalibrate and restore the brain."[39] This state of recalibration is where we need to be when engaging with art: focused, but willing to daydream.

The Difference Between Looking and Seeing

No philosopher, ophthalmologist, neuroscientist, or, God forbid, art dealer will ever achieve a Unified Theory of Art, modern or ancient, because although great art is sensed with the eyes, what is perceived is as much spiritual as intellectual. This means that we need to use both sides of our brain to be fully engaged.

Because our culture venerates technology and we have built computers that "think," we fantasize that our brains are just supercomputers. Neuroscience takes this seriously, appropriating computational terminology such as "processing," "inputs," and "outputs." Thus we look at a painting ("input") then "process" what we see. Such language may describe part of what our brain does, but the machine model ignores both emotions and development.

Technology takes things a step further, letting us store an image of the work of art via digital photograph so that we can "input" and "process" what we have captured later at a more convenient time, instead of seeing it in the moment. We may also make digital images of wall labels instead of reading them. After taking enough pictures, we may, with a feeling of satisfied accomplishment, head for the museum cafeteria or a convenient Starbucks and, as we munch on a chocolate éclair, idly scroll through what we have just not actually seen. What we have "processed" is wall label text and a pixelated (and probably far smaller than actual-size) image on our device screen. We could have stayed at home and found online a far better image of the work and a more substantial text.

However, all is not lost. Some museums are fighting what might be a rearguard action by forbidding photography. In London, for instance, you may not take photographs at the National Gallery (but you can at the Tate Modern and the Tate Britain). *The Art Newspaper* has reported "camera rage" in Amsterdam that led to the Van Gogh Museum reintroducing its ban on photography.[40] I feel entitled to see a work of art without you barging in front of me with your camera, and you feel equally entitled to take a photograph of it. On my side is psychologist Linda Henkel, whose research indicates that art lovers who take photographs remember fewer works (and fewer details of those works) than those who use their eyes only: "When you click on that button, you're sending a signal to your brain saying 'I've just outsourced this, the camera is going to remember this for me.'"[41] The photos are trophies that show people where you've been, rather than noting to yourself, "This is important, I want to remember this."

Some of us feel incomplete if we leave the house without a handy device. What if something happened? What if someone has to reach me? What if I have to find a restaurant? What if I see a work of art and don't know what to think?

Going to a museum with the goal of seeing an exhibition often results in glancing at everything on the walls, diligently reading the labels, and/or listening to the earnest play-by-play. The takeaway is likely to be, at best, a general impression and a few bits of information, and, at worst, fatigue.

Live dangerously. Shut off your cell phone. When you are offered the audio guide, just say "no." I equate "looking" with naming, and "seeing" with engagement. Engagement leads to osmosis and this is our goal.

Can Art Be Heard?

The meaning must come from the looking, not from the talking.
— BARNETT NEWMAN

Corrective lenses are the only human invention that can help us see art better. All others, from the written word to the latest app, serve only to subvert our engagement with art. Yes, I know, there is a fundamental paradox here: I am writing to tell you to ignore writing.

David Sipress,
March 18, 2013
The New Yorker

"It's an audio guide, sweetheart, not a remote."

Rayon magnate Samuel Courtauld (1876–1947) went on a four-year shopping spree for art in the second decade of the twentieth century, and we can enjoy the fruits of his passion at the Courtauld Institute of Art, one of the greatest public collections of Impressionist and Post-Impressionist art. Housed in elegant rooms at Somerset House, a palatial building on the Thames river in central London, it has long been a mecca for art lovers, and I have enjoyed returning there year after year to see some of my favorite works by Manet, Cézanne, van Gogh, and others.

On a recent visit, it was evident that the formerly discreet labels had been replaced by intrusive wall signage displaying not only verbiage above and beyond what was necessary to identify a work and its maker, but also a prominent square QR (Quick Response) code, next to which was written: "Beyond the Label—Learn more about the stories about this artwork." After pausing briefly to consider the repetition of "about," I did manage to restrain myself from whipping out my smartphone in order to see and hear the "story" of a landscape by Cézanne.

Being wired inhibits contact with art. Our desire for and acceptance of a tech program created to function when we see a work of art is a tacit admission that we believe the work of art cannot communicate without assistance; it requires someone (or something) to speak for it to be fully appreciated. We have been programmed to believe that only the words of an authority can reveal to us what is "in" a work of art or what a work of art is "about."

Networking dominates social activity; to achieve our goals, we maintain a state of receptivity. This means checking our email before we get out of bed, wearing earbuds and keeping an eye on a smartphone or tablet all day long while we bicycle, drive, or take the subway to work. A few of us include art in our wired lives by buying and selling art, collecting, exhibiting, or writing about art, and socializing at art parties. But what if we just want to experience art? Is that OK? Not for profit, not for knowledge, and not even for "personal growth"? I am amazed that many people who are retired, and presumably can unwire themselves a little, treat a museum visit as a learning experience rather than an opportunity to relax and enjoy.

I spend a lot of time in museums and I have yet to see someone with any type of audio guide or other electronic device who is transfixed with emotion. Visitors are usually trying to find the next "important" painting. In the late 1990s, there was an excellent exhibition of early works by Picasso at Boston's Museum of Fine Arts. I visited on a day particularly crowded with groups and soon found myself cheek by jowl with an elderly lady turning in circles and shouting (over the sound of her audio guide) to her companions, "I have no idea what I'm supposed to look at, but it sounds very interesting." When we agree to be wired by the museum, either with

an audio guide or an app for our own device, we engage in an act of perceptual contraception.

I have never understood why we need audio guides to tell us which works of art to look at, in the process orphaning unheralded works. I was amazed not long ago to see visitors to the new Barnes Foundation in Philadelphia (with its miraculous evocation of the original museum's galleries) moving zombielike in near proximity to certain paintings while fixated on images of those works on handheld devices as they listened to a recording tell them stories about the artwork they were not, actually, seeing.

The next step is almost here: labels and captions of any kind will be redundant. Entering the museum, we don (unless already wearing) our smart glasses and launch the appropriate app, which will direct us to the works of art that our consumer profile has indicated we should like. Standing near a particular painting will activate a stream of audio and visual commentary focusing on "stories about the artwork." Works we particularly like, but for obvious reasons do not have more than a minute to see, can be recorded, with commentary, by gentle pressure on our tiny tablet's asterisk key. The sole virtue of this scenario is that museum walls will be devoted only to works of art.

Of course we spend most of our lives simultaneously seeing and hearing; in live performance, movies, television, and all forms of video, we are seeing, more or less, images that talk. The difference between those experiences and looking at a work of art while listening to a commentary is that in the film and the performing arts there is congruence between what we are seeing and what we are hearing, and the author or authors (or at least organizers) of both sight and sound are a team, if not one and the same.

Works of art do not speak. Before 1900, the enjoyment of art was a silent experience (well, we could talk amongst ourselves). Then the slide lantern was invented, and ever since, as Prof. Robert S. Nelson has perceptively observed, art history became an oral practice to the extent that for most people the history of art is the illustrated lecture.[42] Students of all ages stare at a simulacrum of the work of art and are energized more perhaps by the animated and eloquent brilliance of the lecturer than by what they are seeing (or bored by both). For more than a hundred years

we have become used to hearing (about) art like this, in the lecture hall and inevitably on television, delivered by the delinquent genius Robert Hughes in *The Shock of the New* and with the earnest passion of "art nun" Sister Wendy Beckett on the BBC.

It is possible, of course, to deliver a lecture about a work of art in front of the actual painting, and I still see groups of students, usually quite young, gathered on the floor of a museum, some attending to the words of a teacher. Technology now allows us to see the real work of art and simultaneously hear about it from a suitably erudite (and/or entertaining) voice in our ear. Wonderful. Except, are we concentrating on the voice or the picture? Silly question, you may say, we can do both at the same time! Really? Multitasking aside, can we take in all the visual communication of the work of art while we are distracted by noise that is telling us what to think about what we are looking at?

You have seen people at concerts and perhaps even at home closing their eyes while they listen to music. You may do or have done this occasionally yourself. It can make a big difference. Whether the music is live or produced by a poor recording, with my eyes closed, the sound is clearer, I hear more, and I hear more profoundly. Imagine your awareness is distributed equally among your five senses—20 percent each. When you are watching a movie while eating popcorn and holding hands with your partner, you may be engaging all five more or less equally (20 percent × 5), and it is an enjoyable experience. On your own, without partner or popcorn, you might actually see and hear the movie better (50 percent seeing plus 50 percent hearing). There may be nuances (the size of the Hobbit's feet) you might not have noticed. Watching a silent movie is sometimes a great treat, and one of the reasons the funny ones make us laugh so heartily is because we are concentrating 100 percent (if alone and popcornless) on what we are seeing.

While there are works of art that make noise, such as Harry Bertoia's sound sculptures, most art lives and is best seen beyond the babble of words, no matter how erudite and informative. Remember, information is not experience. Not only does the act of listening distract your full attention from what you are experiencing, but the words you are hearing are

not your own, and when it comes to art, and modern art in particular, you must form your own opinion.

Can Art Be Read?

Let us say we are on vacation in another country; we take a long walk along the cliffs from our hotel and after a while we happen to see a charming village near the beach. What is the first thing we do? Instead of taking in the scene slowly and feeling the slight breeze as we descend toward the shore, we reach for the map to find out where we are. Or, rather, the name of what we are looking at. Why do we need a name? Because once we know the name, we feel safer, we know *more*. In fact, we may think we know everything about the place. If we are feeling a little tired, we can just read about the village in our guidebook and not have to go all the way down to explore it.

If we are not careful, it can be the same with art. We see a work that seems interesting, and immediately we read the label, to feel safe, to be anchored. "Oh, I know that name!" we say to ourselves as we note the artist, glance again at the work, and move on.

When it comes to fine art, by and large a wordless medium, why do we seek the safety of words? Is it to prevent the possible conception of feelings and emotion? If we can place blame anywhere for this pattern, it might be on how the appreciation of art is taught (even the concept that it can be taught); take, for example, this passage from the recent blog of an art appreciation teacher:

> There is so much more to art . . . than initially meets the eye, and without an understanding of the visual language and the historical context of any given art work we as viewers cannot truly extract all the information (content) out of the work.[43]

The idea that a work of art is a container for information that requires interpretation is deeply ingrained. Museums acquiring works by living artists often ask them to provide written answers to questions such as, "What is the subject of this work of art?" and "What are the ideas expressed

in it?" Substitute "music," "poetry," or even "play" for "work of art" in the preceding questions and it becomes transparently absurd. Artists do not hide information (content) in works of art. Artists strive to create objects of communication. The work of art is its own user manual; all we need to do is keep a steady gaze and what is "in" will come "out."

I am not at all against reading about art. I spend hours upon hours doing it, almost all of that time fulfilling in one way or another. I like most to read about art I have seen firsthand, so I can compare my *experience* of it with the writer's opinions. Perhaps there are even facts about the artist or the work that will fascinate me. I just suggest that the reading come after the seeing.

Poet Mark Doty eloquently suggests the difficulty of translating visual art into words in his charming book *Still Life with Oysters and Lemon*, a meditation on a Dutch still life painting in the Metropolitan Museum of Art in New York. What makes a poem, says Doty, is what can't be said, what is unparaphrasable. Just so with a work of art: "I may inventory, weigh, suggest, but I cannot circumscribe," he writes. "Some element of mystery will always be left out. What is missing is, precisely, its poetry." Doty is concerned here with a three-hundred-year-old masterwork, part of whose poetry is the inner life of an artist long dead, held in suspension by the artwork. "It is still visible to us; you can look at the paintings and you can feel it. This is evidence that a long act of seeing might translate into something permanent, both of ourselves and curiously impersonal, sturdy, useful."[44]

"See for yourself" is sometimes issued as a challenge. Well, that is my challenge to you with regard to art. See for yourself, and then read all you want. This applies to the two major obstacles that words present in the course of our art travels: the wall label and the book.

Words on the Wall

Would you rather walk into a room, meet a fascinating stranger, and experience him or her for yourself, or would you prefer to first read a description of that person and other people's opinions about them? With the

former option, you can enjoy your own thoughts and reactions. With the latter, you are comparing and projecting secondhand experiences instead of having your own.

When at the superb exhibition of Picasso sculptures at the Museum of Modern Art in 2015, I ran into my friend Carol Vogel, a veteran arts reporter.

"I hate this show! There are no labels," she said.

"I love it," I replied. "No distractions. In fact, I think I'll call my next book *No Labels*," I jokingly said.

"Then I won't read it!"

"Why do you need information?" I said, warming to the exchange. "Just look at the sculpture, that's all you need."

"I want to know the context, like the date."

"Why? It wasn't important to Picasso when he made it."

"I'm not him!" snapped Carol as she turned away.

It must have been a loud exchange because as I wandered into the next gallery a bystander took my arm and whispered reassuringly, "I agree with you completely."

Whew!

Why should I care whether museums and galleries provide written information on labels mounted next to works of art? Surely that is part of their educational mission. After all, when we go to the theater or a concert, we get a program; when we listen to recordings of music, there is usually some basic information about the musicians and composers. The dust jacket of a novel is likely to contain biographical information about the author and, as with this book, "blurbs" offering other readers' opinions. However, we don't usually read the theater program while we are watching the play (unless bored stiff), and one wouldn't attempt to read Leo Tolstoy's *Anna Karenina* and A. N. Wilson's biography of Tolstoy simultaneously.

So why would we read or listen to exegesis of a work of art at the very moment we are experiencing it, possibly the only time we may ever be able to see it in our lives? Part of the answer is that we confuse identification with experience. Knowing its title, the name of the artist who made it, and when convinces us we know the painting. No, we know "about" it.

Words in Books

Have you ever been in a conversation with two other people who are discussing a mutual friend you barely know? They may be enthralled, but frankly you are bored. That is how I feel when reading about art I haven't experienced. Yes, the work will be illustrated, but of course by now you probably know my opinion about reproductions.

On the other hand, when you know the person being discussed, you can pitch in with your comments and opinions. I love reading about art if written by someone with intelligence, insight, and perhaps a dash of humor, but only when I have seen the art with my own eyes. I devour well-written biographies of artists, and you will find a few recommendations at the end of this book.

Now I must be careful how I say this: although they may contain interesting facts and opinions about the creative process and even may explore what the artists themselves said about their work, they cannot "add to" your experience of the work itself. Only the opposite holds true: your experience of the work can add to your enjoyment of the book. In fact, without your having experienced the work, I will go so far as to say you are wasting your time reading about the artist who made it.

One of my literary heroes is the playwright Samuel Beckett, but I only recently discovered that as a young man he aspired to learn as much as possible about German medieval art and seventeenth-century Dutch painting. He was a diligent student, but on a visit to Germany he experienced a revelation that altered his beliefs. He explained to a friend in a letter that he was suddenly able to enter into a dialogue with paintings on their own terms, unmediated by words: "I used never to be happy with a picture until it was literature but now that need is gone."[45]

My core belief is that when it comes to the moments we experience truly great works of art, no information is necessary. Symbolism, critical theory, artist biography, and historical perspective hinder the dynamic encounter between the product of the artist's labor (whether the artist is known or unknown) and the unique spirit of each of us. I use the word "spirit"

deliberately because it is our spirit that can be most moved by great works of art, not our mind, and our spirit is more likely to be moved (raised, lowered, altered) by visceral sensation than by recitation of fact and opinion.

The common error with writing about art and artists biographically is that what happened in the artist's life that is noteworthy, particularly aberrant and dramatic behavior (alcoholism, suicide), is presented as evidence for how or why they made the art they made. There is a cottage industry in books about Vincent van Gogh's death (suicide, accident, or murder?), compared to books about his art. Most of them mention the painting *Wheatfield with Crows* (1890) as his "last" painting (one writer claiming the crows as harbingers of death), and while it was certainly painted in the last few weeks of his life, there is no evidence these were his final strokes of the brush. It has been elevated to the status of epitaph and linked to a letter in which he wrote, "my life, too, is attacked at the very root . . . I made a point of trying to express sadness, extreme loneliness."[46]

I envy the woman, man, or child, visiting the Van Gogh Museum in Amsterdam, who stands in front of this painting uneducated by the vast literature, high and low, about the artist. They might in fact agree with something else van Gogh wrote in the same letter: ". . . these canvases will tell you what I cannot say in words, what I consider healthy and fortifying about the countryside."[47]

Vincent van Gogh
Wheatfield with Crows,
1890
Oil on canvas
19¾ × 40½ in.
(50.3 × 102.9 cm)
Van Gogh Museum,
Amsterdam

Can Art Be in a Hurry?

*We're face to face with images all the time in a way that we never have
been before . . . young people need to understand that not all images are
there to be consumed like fast food and then forgotten.*
 —MARTIN SCORSESE

*A quieter life takes more notice of the world, and uses technology more for
curiosity than conquest. It finds comfort and restoration in unmediated
perceptions . . . It values persistence and not just novelty.*
 —MALCOLM MCCULLOUGH

I am expected to know a great deal about the works of art I offer for sale,
and to speak eloquently about them and answer every question regard-
ing their history, significance, physical condition, and commercial value.
But can I pretend to know what a particular work of art means? Absolutely
not. All I can do is hang it on the wall or put it on a pedestal and offer my
client a comfortable chair and as much time as she would like to take to
be with it. The wise collector is not in a hurry.

One of the bonuses of my occupation is that I am sometimes able to
see great works of art with little distraction. In private homes, galleries,
and museums I have had unhurried access to amazing works by mod-
ern masters, and I have works in my own home that I love to sit and look
at when the house is quiet. Under those circumstances my engagement
is intense yet I am completely relaxed. After a while, I am not thinking
about the work of art; instead, I "feel the paint." This has happened with
works as diverse as Paris street scenes by Camille Pissarro, Cubist composi-
tions by Juan Gris, flowers by Georgia O'Keeffe, Barnett Newman's solitary
stripes, the targets of Jasper Johns, even Donald Judd's stacks of aluminum
boxes.

As someone privileged to be among the first people to see new work, I
have spent many hours in the studios of artists both unknown and well
established. Casting my eyes on works of art uninhibited by anyone else's

opinions is often an emotional and revelatory experience. I try to focus on what they *do* to me rather than what I think they are *about*. Later they will be exhibited, priced, written about, sold, and discussed, but close to their birth there is no static to distract me from engagement and communication. It is not easy to maintain the same mind-set when approaching works in galleries and museums that have been packaged in one way or another, but it is well worth trying.

Since the Industrial Revolution gave us miles per hour in double digits, we have been glorifying speed in all aspects of our culture. We persuade ourselves that the faster we do things and the more we can accomplish, the better our lives will be. In children we equate speed of thought with intelligence, and a child who meanders we label "slow." Quick is better because it "saves time." And what do we do with this time saved? For some of us there never seems to be enough time, no matter how fast our car or our broadband connection. We read books that teach us to do things quickly (sorry, this is not one of them), like cooking and exercising and dieting. Amazon is awash in "five-minute bedtime stories"; it appears that many of us are not saving time to spend with our kids, but reducing the time we spend with them to do what?

Art enriches our lives immeasurably. Engaging with it firsthand may involve a certain amount of travel, to galleries and museums, but beyond that, the major commitment is simply time. Not even thought—the emptier your mind the better. What a deal! So, with all our labor-saving devices, techniques for quick reading, and rapid transit, we should be able to carve out a couple of carefree hours once a week or once a month for art. We cannot be in a hurry.

Unfortunately, not all museums see things that way. Pandering to the fast-track style of living, they encourage an "art attention deficit." The time, motion, and money experts that seem to be orchestrating museum visiting worldwide are opting for a technologically well-oiled and speedy journey through the galleries, hoping that time saved will be spent where money changes hands—in the restaurants and gift shops, where we can purchase objects imprinted with the images of the works our audio guides have told us are famous.

Our brave new digital world should increase our leisure time, but the assumption seems to be that we are so busy doing important things that the attention we can spare for cultural activity is severely limited. This notion, combined with the condescending one that culture has to be "entertaining" in order to be marketed to a broad audience, results in content providers (museum officials, publishers, and others) packaging modern art as entertainment snack food.

In these early years of the twenty-first century, a vast number of people live in a state of permanent receptivity. When not staring at our computer screens, we move about wearing earbuds, with personal electronic devices in hand or on our wrist, wired to a constant stream of sound and pixelated images that entertain, inform, explain, and direct every aspect of our lives. The sheer amount of "content" with which we agree to be bombarded prevents us from judging its quality and relative importance. The banal is elevated while the crucial is buried. The venerable Walker Art Center in Minneapolis, which pioneered exhibitions of modern and contemporary artists as varied as Joseph Cornell, Mario Merz, and Kara Walker, is also known internationally for originating an annual Internet Cat Video Festival (outdoors and off-line), which is now a traveling event that raises money for humane societies.[48] Would you rather spend ten minutes with any one of the Walker's fine boxes by Joseph Cornell or ten minutes watching cats? Do I want to know the answer?

Some artists paint quickly. Picasso often completed more than one work in a day. Cézanne, a famously slow painter, made his dealer, Ambroise Vollard, submit to 115 sittings for a portrait—and then left it unfinished. "I am not displeased with the shirt," Cézanne said, asking Vollard to leave behind the suit in which he had posed so that the artist might complete the painting. Unfortunately, moths ruined the suit.[49] Regardless of how long it may have taken the artist to produce it, we should take more than a few seconds to experience a work of art, even one we might immediately dislike. I have sat through quite a few really bad movies, so a couple of extra minutes in a museum will not kill me.

The eminent art historian Meyer Schapiro championed patient observation:

We do not see all of a work when we see it as a whole. One must be able to shift one's attitude in passing from part to part, from one aspect to another, and to enrich the whole progressively in successive perceptions.[50]

For this journey toward engaging with modern art, we will have the most exciting journey if we go alone, ignore the wall labels, and let others be steered by audio guides. We will go at our own speed, sometimes faster, sometimes much, much more slowly. Great works of art bear lengthy scrutiny; the more you engage, the more you get. Lesser works fail to engage us for very long and we quickly move on. Thus we are prepared to visit any gallery or museum in the world and be open to a truly transformative experience of our own, unfiltered. Better than that, the quality of the experiences will bring us confidence in our own judgments.

THE ART OF BEING PRESENT

⌄

The perception of beauty is definitely

an emotional experience.

—

MARK ROTHKO

Many works of art that live in me and that I enjoy seeing again and again did not enter my consciousness immediately and completely at first sight. I absorbed them over time. Sometimes I spent a lot of time on one visit (perhaps because I was far from home), and at other times I spent a few minutes on many visits. Some of the artworks that are most a part of me are those I see every day in my home, and although I should know them as well as the back of my hand, I still find myself looking up from the desk at which I am sitting and staring at a wonderful collage by Howardena Pindell that I have had for almost forty years.

Osmosis is unconscious assimilation. Assimilation takes place when we fully engage with a work of art, but how can it be unconscious? We are usually aware of the context—museum, gallery, or home—as well as being conscious of what we know (or think we know) about the work of art. In this chapter, I suggest ways that we can free our perception from the bondage of information. It is a simple process that requires some practice, the essential ingredient being familiarity. Every time I sit down to have dinner with my family, I see an abstract painting by Ray Parker that hangs opposite my seat. I don't perceive it as "an abstract painting by Ray Parker," but as extremely pleasing colors—blue, brown, red, black, and green—and forms inextricably associated with a sense of joy and comfort. Sometimes I recall my daughter saying that it makes her think of a brightly dressed lady with a red flower in her hair (it sort of does). Mostly, I simply feel it. Living with art is a wonderful way to assimilate it, for it to provide daily sensations, for it to become joined to your life organically. (Not everyone can afford to live with art, but you would be surprised at how little you may need to spend for good original works of art.)

Regardless of means, anyone able to view original works of art may use my prescriptions to achieve a state of open-minded clarity that will allow osmosis to take place organically. Mostly this effort involves removing obstacles, and it is not hard work. In fact, when engaging with modern art the less strenuously you work, the more you will see (and feel).

Prescriptions

Rx 1: Maintain Radio Silence

I find it next to impossible to see works of art while I am engaged in a conversation, even about what I am seeing. If you undertake a museum expedition in company, I suggest a "quiet time" for each person to wander at will. I am interested in my wife Victoria's comments about artworks, but since we do not always like the same ones, we try not to voice our opinions until we have each had a chance to engage. And it is not fair for me to grimace if she stands in rapture before something I think is perfectly horrible, although it is often the other way around.

Engaging with art, absorbing it, and sharing your thoughts and feelings with others in words that are inspired by the experience is tremendously fulfilling. When someone who has seen many paintings by Georges Braque, for instance, shares with me what they feel (not just what they *know*) in the moment we are both experiencing a great painting by him, I am willing to be infected by their enthusiasm, and this has often been the way in which I have been introduced to work I initially found uninteresting.

While the thrust of this book is to help us as individuals encounter, engage with, and enjoy modern art, it is always fascinating to learn how works of art reveal themselves differently to other people. As an art dealer, I have spent many hours sitting in front of paintings with colleagues and clients, exchanging personal enthusiasms (and sometimes reservations). After seeing a work of art with a friend, you both benefit from each other's responses, neither being necessarily "right" or "wrong."

Rx 2: Avoid Gallery Lectures

No matter how erudite or entertaining some audio guide recordings may be, they cannot tell you how or what to feel and neither can a guide repeating a potted lecture. At the Metropolitan Museum of Art in New York in 2013, the Chinese artist Xu Bing installed a breathtaking work called *Book from the Sky* (c. 1987–91), consisting of what looked like Chinese characters

but were, in fact, English words. These were in rows of books open on the floor, on panels across all the walls, and on great scrolls hanging from the ceiling. To me, it was an enveloping wonderland of exotic calligraphy. I stood enjoying it alone when suddenly a guide sped a group of bewildered visitors through the room and airily described the work as "an anti-government political statement." Very short shrift indeed and quite misleading.

The best art tour guides let viewers see first and then ask questions. If I tell you what a work of art is *about* as you are seeing it, I am creating a verbal narrative, which, while possibly compelling, is incidental to your experience of the work, and in fact my explanation will interfere with your ability to connect to it. If on the other hand, we both engage with a work of art together, silently, and then you want me to share my reactions and feelings, we may both increase our enjoyment.

Around 1900, technical reproduction allowed images of works of art to be projected in front of an audience, but prior to that, lectures about art took place in front of the actual works. The latter practice continues today in museums, with lectures given by docents and sometimes by knowledgeable curators and art historians. Educational groups and private entrepreneurs organize group visits to commercial galleries. Acquavella Galleries, where I work, receives a constant stream of such groups, and I often overhear tour guides lecture about our exhibitions. Upon entering, most groups mill around the galleries talking among themselves, waiting for their lecturer to begin before allowing themselves to glance at the works of art. When the talk is over, they resume chatting as they troop out to the next gallery.

The feature common to most talks I have watched being delivered in museums and galleries is that the lecturers face the students, with their backs to the work they are discussing. Of course, this is also the case in a lecture hall where slides or digital images of artworks are projected. The teacher thus is promoted to the role of essential intermediary, as Robert S. Nelson aptly suggests:

> When the lecturer presents the object to the audience, he may . . .
> shift from looking at the object to speaking for it or its artist. From

this rhetorical position, [he] can account for motivation and intention, because he has become either the work of art or the artist or both. This ventriloquist act enables the picture to speak, to act, to desire.[51]

Successful art lecturers are often lauded for their ability to bring works of art "to life," as if works of art were uninflated balloons on the wall, waiting for infusions of hot air. Although I must have done it many times myself, the act of talking about a work of art with one's back to it suggests that the words take precedence over the images, or at least that the words are necessary to comprehend the images.

The Swiss art historian Heinrich Wölfflin (1864–1945) was famous for an approach that today's art lecturers might be encouraged to emulate. Here it is described by one of his students:

> Wölfflin, the master of extemporaneous speaking, places himself in the dark and together with his students at their side. His eyes like theirs are directed at the picture. He thus unites all concerned and becomes the ideal beholder, his words distilling the experiences common to everyone. Wölfflin considers the work in silence, draws near to it, following Schopenhauer's advice, as one draws near to a prince, waiting for the art to speak to him. His sentences come slowly . . . Wölfflin's speech never gives the impression of being prepared, something completed that is projected onto the art work. Rather it seems to be produced on the spot by the picture itself. The art work thus retains its preeminent status.[52]

How amazingly different is this from the strident parade of facts force-fed to the weary group craning to see the work behind the docent's head? Wölfflin and other great teachers model for their listeners the act of seeing and encourage them to respond spontaneously and emotionally. Instead of attempting to absorb information, the listener is led to emulate the teacher's approach. If this results in positive engagement with the artwork (assimilation), the listener may wish to seek out more information.

Ain't Nothing Like the Real Thing

A reproduction will tell you anything you want.
—PETER SCHJELDAHL

In 1953 I was eight years old and unsatisfied with the blank wall above my bed, so I saved my pocket money and sent away for a reproduction of *The Laughing Cavalier* (1624) by Frans Hals, which is in London's Wallace Collection. I was thrilled when it arrived because, although it was printed on glossy paper, it had been die-pressed so that the surface simulated the weave of real canvas! Though I knew how far it was from the real thing, I was proud of my first acquisition.

I am frequently amazed and sometimes disappointed when finding myself in front of a work of art I had only known in reproduction. Scale in relation to us is fundamental to our experience of every work of art. Before visiting the Musée de l'Orangerie in Paris, I had seen large paintings of water lilies by Claude Monet, but when standing within the museum's oval gallery built specifically for the presentation of Monet's famous suite of mural-scale paintings of water lilies, the Nymphéas canvases, I was overwhelmed.

On the other hand, when I finally saw the magnificent Duccio di Buoninsegna *Madonna and Child* (c. 1290–1300) acquired in 2004 by the Metropolitan Museum in New York, I was hypnotized by its gentle power, and while I had heard others express surprise at its modest size (11 × 8¼ in. [27.9 × 21 cm]), the scale so acutely concentrated my perception that my response was heightened.

When Edgar Degas exhibited *Little Dancer Aged Fourteen* (1878–81), made of wax and dressed in real clothes, at the Impressionist Exhibition in Paris in 1881, it was derided by the critics as "too real," as well as ugly. It was owned by philanthropist Paul Mellon until he gave it to the National Gallery of Art in Washington, DC, in 1999. I was fortunate to see it when it was still in his home in Upperville, Virginia. I had seen a number of the bronze casts, which are the same size (and also wear real skirts and hair ribbons), so I was fully prepared (or so I thought) to see the wax version.

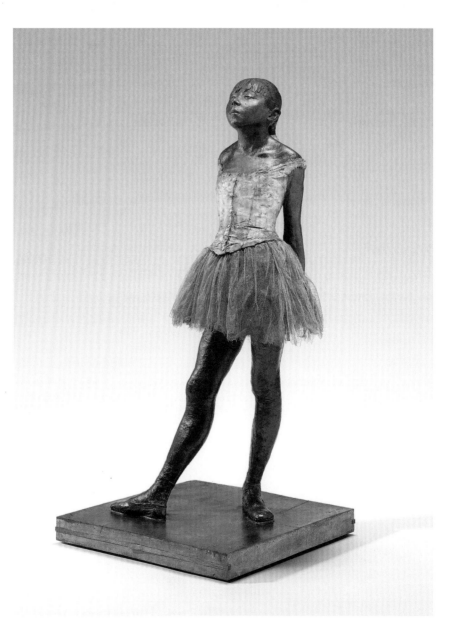

Edgar Degas
Little Dancer Aged Fourteen,
1878–81
Pigmented beeswax, clay,
metal armature, rope,
paintbrushes, human
hair, silk and linen ribbon,
cotton faille bodice,
cotton and silk tutu, linen
slippers, on wooden base
Overall without base:
38 ⅞ × 13 ⅝ × 13 ⅞ in.
(98.9 × 34.7 × 35.2 cm)
National Gallery of Art,
Washington. Collection of
Mr. and Mrs. Paul Mellon

I was alone when I entered a large sunny room, the walls of which were devoted almost entirely to works by Degas. Or was I alone? The little dancer stood in the middle of the room, so real I imagined her leg trembling. Now I understood those French critics. Even though I knew I was in the presence of an effigy, I could barely bring myself to turn my back to her when I went to look at the view from the windows. I could feel her behind me.

Mentally, I compared it to the extremely lifelike figures made by Duane Hanson in the late twentieth century, which, when first encountered,

Duane Hanson
Baton Twirler, 1971
Polyester resin and
fiberglass, polychromed
in oil and mixed media
88½ × 36 × 40 in.
(224.8 × 91.4 × 101.6 cm)
Private Collection

sometimes fool people into thinking they are real. With no disrespect to Mr. Hanson's skill, for me the figure by Degas breathes life even though I know from the get-go that it isn't "real," whereas, though I am momentarily startled by Hanson's baton twirler, once I register that she isn't moving, my interest is no greater than it would be if I were viewing a display at Madame Tussaud's. Both young ladies are silent and still, but when I am in the presence of Degas's dancer, I cannot dispel the suspicion, which causes my hair to stand on end, that her shallow chest is gently rising and falling.

Not long ago I was asked to lend a painting from my collection to an exhibition at the Royal Academy of Arts in London, and in addition to the standard paperwork, my permission was requested for them to use an image of the work on Facebook, Twitter, Vimeo, YouTube, Pinterest, and

Instagram. Does viewing an artwork on social media make us want to go to the museum to see the real thing, or is it a new "lite" way of engaging with everything visual?

To encourage people to see his collection firsthand, the great art collector and world-class curmudgeon Albert C. Barnes refused to allow reproductions in color of the great works of art in his museum in a Philadelphia suburb. His policy would seem ludicrous today, when museums, educational institutions, and publishers go to great lengths to ensure that the colors of their reproductions in print and online are faithful to the original art works. OK, what about scale? Sorry, limited by the size of the book page or your screen. What about texture? Sorry, technology is not able to mimic that yet.

Imagine I invited you to dinner at my home, and when you arrived there was a copy of *Saveur* magazine at your place at the table instead of a delicious Coquilles St.-Jacques (or bacon cheeseburger). That is the difference between any reproduced work of art (no matter how technically accurate) and The Real Thing.

Many people like reading about food and looking at photographs of food. I must confess I am not one of them. I do like reading about art, and my home is filled with books about art, many with excellent reproductions. Some of these remind me of paintings I have seen "in the flesh," and others have inspired me to visit works I had not yet seen. But in my books (or online), these reproductions are not even ghosts of the original objects.

If you were standing in front of the painting by Sean Scully reproduced here, instead of looking at this small image, you would, like it or not, be overwhelmed by the scale (imagine eight feet high by twelve feet wide) and unavoidably provoked by its actual presence as, to put it crudely, a massive object with a lot of thick paint on it.

Works of art are objects, not just images. Sculpture obviously so, but paintings are also three-dimensional, sometimes thickly painted on rough burlap, sometimes with thinned pigment barely staining fine linen. At either extreme, dimensionality and texture, deliberately created by the artist, may be as important in generating your experience of the work as the colors and the composition.

Works on paper, too—watercolors, drawings, prints, etchings, and lithographs—breathe in a way that reproductions do not. For starters, our eyes can sense the weight of the paper. Colors appear completely different when pigment is absorbed into fine artists' paper than when printing inks are seen on glossy or matte printing paper or when color is reproduced in pixels on a screen. Original art is alive. Reproduced art is dead.

What about Andy Warhol? After all, he just silkscreened images onto canvas. Surely we can enjoy his work just as much in reproduction. Sorry. The visual "taste" of the canvas has impact, not to mention the fact that he painted on top of or under the silkscreened images. Even the colors of the actual Warhols are very different from those of reproduced images. Part of the magic.

Many contemporary artists use photography as their medium; surely photographs of photographs are faithful? One would think so except that the color, scale, and texture are different on the book's printed page than in the photographer's original print. Even reproductions of black-and-white photographs rarely mimic exact shades of gray and degrees of contrast.

Sean Scully
Pale Fire, 1988
Oil on canvas
96 × 146½ in.
(243.8 × 372.1 cm)
Modern Art Museum
of Fort Worth, Texas.
Museum purchase. Sid W.
Richardson Foundation
Endowment Fund

I have a portrait by Thomas Ruff that looks like a passport image on the page but in my living room the original print is seven feet by five feet—a completely different experience in every possible way.

Certain works of art are so familiar that we no longer see them. This was humorously emphasized by the Argentine-French performance artist Lea Lublin in 1965 in a series of ironically iconoclastic works called *Voir clair/Ver claro*, "To See Clearly." She placed modified posters of well-known works such as Leonardo's *Mona Lisa* behind glass equipped with windshield wipers, then invited the public to spray water at the images and activate the wipers in order to "see clearly."

Many of us, upon finally encountering a painting we have seen reproduced again and again, do not engage with the work itself but with how it differs from what we had imagined based on the reproduction:

It's very small!

It's huge!

I didn't realize it was so red.

There's no line down the middle.

In fact, the difference between the real thing and printed (or pixelated) images of it can be so great that we immediately think that the work in the museum is somehow wrong. We made a prior agreement with technically produced images of the work of art, and those versions remained in force when we faced the real thing.

I have dwelt on obvious differences of size and materiality, but with electronic imagery, the most important difference from seeing an actual object has to do with light. Works of art may seem to express light from within, but with the exception of works of art that incorporate or utilize illumination or screen technology, we see most of them by reflected light.

When we see the image of a painting or drawing or sculpture on a typical contemporary electronic device, the image is produced by liquid crystals, sandwiched between polarized glass substrates, with a light source behind them. As a result we see brighter colors, sharper outlines, and less depth than we would see if we were looking at the actual object.

On a recent visit to the Bridgestone Museum of Art in Tokyo, I was shown a wall-mounted Panasonic 4K Ultra HD tablet, on which visitors

could retrieve images of works hanging nearby and zoom onto micro-scopic details of the picture with such fidelity that one could see the tiny cracks that the surfaces of many oil paintings naturally develop when they age. Standing in front of the actual painting (a rather beautiful land-scape by Pierre Bonnard), not only did I not see the cracks (I did not want to, nor, perhaps, would the artist have wanted me to) but I saw much sub-tler color and richly textured brushwork.

I am by no means a Luddite when it comes to the promise that techno-logical innovation holds for the arts, but fidelity of reproduction is not one of them. In this century we will surely see the emergence of talented art-ists who harness advanced technology to create new mediums and push the boundaries of both art and technology with delivery systems we have yet to imagine. I do not, however, believe that technology will ever develop a simulacrum of what today exists as a painting, a drawing, or a sculpture that *lives* as convincingly as the object made by the artist.

Photographs, slides, and computer screen–sized images of artworks are clearly not the actual works of art, and we make allowances for that even as we lazily accept their presence as lawful substitutes. Today, as technol-ogy approaches the point where movies can be made in digital laboratories, and one imagines that virtual humans will replace live actors and actresses and that we will not be able to tell the difference, it is no stretch to imagine that there may well come into existence "museums" of either the virtual or walk-in variety, which purport to present exact replicas of works of art that actually exist elsewhere.

Far more advanced than the ghostly holography of today, these virtual artworks may seem as "real" as the Marilyn Monroe who from beyond the grave will star in movies, resurrection being already an established special effect in Hollywood.[53] When we see Pablo Picasso's virtual *Les Demoiselles d'Avignon* on our living room wall, dimensions exact and colors accurate, will it "live?" I don't believe it will, but the danger is that it will come near enough that fewer and fewer of us will be motivated to see the real thing (although if this means fewer crowded exhibitions, I am conflicted).

People working with digital imaging of humans for the motion picture industry have discovered that we are extremely sensitive to nuances of

expression and movement and can sense a "strangeness" in virtual human beings, even if we cannot say why. Our virtual Picasso painting may not be as three-dimensional as the original (although 3-D printers are getting better), but the more exact the replica becomes, the more we may be aware that it is not real.

For most of us, our first encounter with art is with some form of a reproduction. The better it is, the more likely we are to seek out the real thing, but inaccurate reproductions (which can be found in the most deluxe publications) can deter us from a desire to see a specific work or, worse still, any work by a particular artist. Progressive works of art such as all-encompassing installations, paintings, and sculpture using experimental materials are only remotely echoed in reproduction (whether by still photographs or video). You are shortchanging yourself by dismissing such works without making the effort to "be there."

Where's the Fire?

We need to build stop signs into our lives.

—DAVID STEINDL-RAST

Like many small boys in post-World War II England, I spent an inordinate amount of time standing on iron bridges over railway tracks, enveloped in steam, engaged in an activity called "trainspotting." As a steam-driven locomotive billowing smoke raced toward and beneath us, we scribbled down its identification number in our grimy notebooks. For many of us, it was sufficient to have "spotted" a particular train which we then looked up at home in encyclopedic manuals so that we could study what we had barely glimpsed. Similarly, some museum visitors plan carefully to "spot" as many famous works of art as possible before collapsing in the cafeteria.

What is our most precious asset as human beings? Time. None of us know how much we have. Is that why we try to pack so much in and live in fear of "doing nothing"? As Americans, we are particularly susceptible to the culture of personal productivity. We cannot "waste" our spare time; we work hard at our leisure activities. We revile dreamers and loafers. We

listen to music while we jog, as we drink our bottled water, and plan our next activity. If we see a friend doing nothing, we ask, "What's wrong?"

I mentioned above that the Musée du Louvre had clocked the amount of time spent by visitors looking at a painting at ten seconds. Contemporary artist John Baldessari thinks they spend even less time, and he has taken this into account in his work:

> What's the average time a person looks at a painting—seven seconds?
> I want to get them hooked. I have to raise the bar in such a way that
> they're not going to get it, but they want to get it.[54]

It is a shame Baldessari has to trim his sails to catch the prevailing wind, but he does so with images that are bold, stark, and odd. What about artists whose works have become familiar, like those of the Impressionists. So easy to drift by paintings of wheat fields by Monet or street scenes by Camille Pissarro, particularly ones with no wall signage indicating an audio guide stop. And harder still to pause long enough to engage with those monochromatic fractured planes of Cubist paintings by Braque and Picasso—hard to make sense of the forms and no bright colors, so let's just fast-forward the audio guide.

Like a cop on patrol, the museumgoer glances quickly at a painting, sums it up as law-abiding (not worth arresting), and moves quickly on. "I know what that is," says the brain, activating its identification mode. "I've seen it before or something like it. I wasn't interested then and I'm not now." Dismissed.

But perhaps if you hesitated just four or even five seconds longer, you might just see beyond what your brain is saying; you might see a line, a color, or a shape that compels further interest, and that may in turn result in changing your mind about what you had dismissed as something you (thought you) knew.

Ten seconds, or even seven, is quite a long time. If you take my advice and fly solo, with no audio guide and reading no labels, you probably will drift by at three to four seconds per object, unless one catches your eye. When you do see a work that arrests you, regardless of what you think you know about it, and regardless of what anyone else is saying or doing,

stop. Do not think—just stop. If you are not alone, tell your pals or family you will catch up with them. Don't talk about the work, even to yourself. Don't just look at it, see it. Engage with it.

Seeing in slow motion takes practice. When we glance, which is what most of us do as we stroll in a museum, we look *at*. Looking *at* provokes the brain to identify and associate (*Starry Night* = van Gogh = lopped-off ear), which is essentially useless (although possibly ego-fulfilling). In slow motion, we can *look into* the work of art, that is, see it, beyond or besides identifying it and associating it with what we may have heard or read. In slow motion, we allow the work of art to engage us, to reach out to us, to bring itself halfway (or more) toward our feelings.

How about Googling?

Thanks to the US Department of Defense, which funded the research that led to the Internet, we can know everything about everything (and every-one) much more quickly than we can make a cup of instant coffee and considerably faster than it takes a barista to produce a double caramel mac-chiato. And we have Wikipedia, which guarantees that in an instant we can look up anything about modern art and all will be revealed. Or will it? If you look up a specific artist, you are likely to find a mélange of inaccu-rate images, fragmented information, and potted opinion that will not in any way enhance the experience of standing in front of that artist's work.

In fact, Googling an artist or artwork is as likely to reduce your interest as it is to inspire further inquiry. And if instead of engaging with the work itself, we are looking to our mobile device to tell us about the work, we are even less likely to retain the idea of what it looks like. And I deliberately say "idea" because when we recall in memory a work of art we have seen, recently or in the past, we are remembering the "idea" of it, we are not con-juring it up as it is (or even was, to our eyes). If we spend five or even ten minutes observing (and *seeing*) a work of art, our aim is not to take a mem-ory photograph. Yes, we should examine all the parts and the whole of it carefully and slowly, *but our goal is to engage with it, not to be able to recall it*

accurately. Women and men who spend much of their lives engaging with works of art because it is their profession, or are passionate collectors, usually develop a memory bank of works. Twenty or more years later, they can not only recall having seen a work, but can also bring to mind the circumstances of that moment, whether in a museum, a gallery, an auction sale room, or a private home. This is not because they have extraordinary memories but because their encounters with art were meaningful.

In our culture, sound bites and thumbnails pass for knowledge of artists and artworks. But knowledge is based on experience, not just information. One cannot be informed about art without having experienced it, and the only way to experience a work of art is to share its space. The experiences with art in my life that I treasure most are those that have left me speechless, without words.

Lose the Floor Plan

Most of us go to galleries and museums with a limited amount of time and the goal of seeing specific works. The more we try to cram into that time frame, the less we actually see. How long does it take to see a work of art? I would say at least a minute. Stare at your hand for a full minute. Quite a long time.

In fact, organized people who plan ahead with the museum guide and know exactly where they are headed probably see less than disorganized people. With this shopping list approach, they may end up with a full basket, but never get a good taste of anything. A disorganized person heads for the special exhibition, gets lost in the Greek galleries, barrels through the decorative arts, and ends up in contemporary art (which she doesn't like), fascinated by an Eva Hesse sculpture, an artist she has never heard of.

If we are semi-organized, we can allocate one hour to seeing what we have planned to see and at least half an hour to wandering aimlessly, which is one of the great joys of life. Donna Tartt's novel *The Goldfinch*, about a stolen painting, opens with Theo, the young protagonist, being led through the Metropolitan Museum:

I trailed behind my mother as she zigzagged from portrait to portrait
. . . ignoring many of the paintings and veering to others without hesi-
tation. . . . She'd never seen a great painting until she was eighteen and
moved to New York and she was eager to make up for lost time. . . . "It's
crazy," she'd said, "but I'd be perfectly happy if I could sit looking at the
same half dozen paintings for the rest of my life. . . ."[55]

It is too bad (spoiler alert) that Theo's mother, a perfect art lover, does not
make it to chapter four. When I started to visit the Metropolitan Museum
in the 1960s, I often had galleries to myself. In those days, some of the great
Impressionist paintings were hung in alcoves with seating. I would buy
my lunch sandwich in a delicatessen on Madison Avenue and eat it on a
bench in a nook enjoying Claude Monet's *Ice Floes* (1893), and I would see
no one for half an hour except perhaps a guard, who would turn a blind
eye to my munching. In those days, admission was free, not a strongly
"recommended" admission fee. What a luxury!

I was young but not in a hurry, and neither was anyone else in muse-
ums and galleries. It is a different story now, particularly with special
exhibitions, but until museums install those moving walkways found in
airports (not long now), we can stand still once in a while and, in hospita-
ble museums and galleries, even sit down.

Although the efficacy of seeing slowly is borne out by personal experi-
ence, I am indebted to the essay "Reading in Slow Motion" by the literary
critic Reuben Brower, based on a course he taught at Harvard University
in the 1950s. Brower believed if reading "is to do us any good, it must be
fun."[56] Ditto art. Racing around a museum on a scavenger hunt, aiming
to glimpse works of art other people have designated as masterpieces, is
not my idea of fun.

The best way I have found to slow myself down is to try to be far less
ambitious about what I want to accomplish when I go to a gallery or a
museum. My suggestion is to "unplan" your visit. Take it easy. Wander. If
you are attending a crowded special exhibition, move in the opposite direc-
tion of everyone else, particularly if it is a show of one artist, organized
chronologically. Perhaps their latest works are better than their earliest,

but there will inevitably be a bigger crowd at the beginning and there is no law that says you can't leapfrog to the end and work your way back.

My limit per stint of walking about seeing art is about one hour, then a break for a coffee or a light lunch, and then perhaps another hour and a half. If in that time you have found ten works of art that really grabbed your attention, ones you wanted to engage with for more than a minute each, then you will have had a rewarding experience, and remember what you saw. Plenty of time to look up the who, the what, and the when at home.

Fresh Air Art

Seeing art outside is a very different experience than seeing it under a roof. Some of the most sensually stimulating works of modern art may be found in the open air. Sculpture in the open is no longer confined to bronze guys on horses waving swords. Many museums have sculpture gardens, like that at the Hirshhorn Museum and Sculpture Garden in Washington, DC, with great works by Auguste Rodin, Henry Moore, and Alexander Calder; or the Nasher Sculpture Center in Dallas, with

outdoor works by Picasso, Joan Miró, and Barnett Newman. At the Kröller-Müller Museum in the Netherlands there is a seventy-five-acre park with major sculptures by contemporary artists like Jean Dubuffet and Claes Oldenburg. Other museums exist mainly as outdoor sculpture sites, such as Storm King Art Center, an hour north of New York City, which has more than a hundred works by artists like Mark di Suvero and Richard Serra scattered over and in some cases embedded in majestic scenery.

I have been fortunate enough over the years to make more than one visit to the Hakone Open-Air Museum in Kanagawa Prefecture, Japan. In the United Kingdom, Chatsworth House in Derbyshire, which puts *Downton Abbey*'s Highclere Castle to shame, boasts fabulous gardens sprinkled with monumental sculptures. We are naturally less hurried in the open air, more inclined to watch than glance, perched on a bench or sprawled on grass as near or as far from the sculpture as we wish. Placing sculpture outside is itself an art. Set in the landscape and etched against the sky, shapes and forms and textures and colors of sculpture can engage us on a deep level with perhaps more ease than indoors.

If you want a guaranteed hit and are prepared to travel, there are one-off monumental works such as Robert Smithson's *Spiral Jetty* (1970) in the Great Salt Lake in Utah and Walter De Maria's *Lightning Field* (1977) in western New Mexico, which have become must-see landmarks of recent art. Some have been labored on for years; since 1974, James Turrell has been making a work of art out of an extinct volcanic cinder cone near the Grand Canyon. *Roden Crater*, three miles wide and six hundred feet high, is not yet open to the public, but it will include living quarters and a naked-eye celestial observatory.

Spontaneous or semi-rehearsed artist-inspired "Happenings" of the 1960s evolved into the discipline of performance art at the same time as galleries started to exhibit "installations" that were a far cry from traditional sculpture. A preeminent installation artist who moved out of doors to make the earth itself his canvas is the Bulgarian-born New York-based artist Christo, who, with his late wife and collaborator, Jeanne-Claude, has created extraordinary projects around the globe, wrapping a bridge in Paris and stretching a curtain between two mountain slopes in Colorado. A work

that will live in the happy memory of many New Yorkers is *The Gates*, conceived in 1979 and installed for only sixteen days in 2005. It transcended "What is it?" and "Why is it?" to be enjoyed by thousands who had the experience of walking around and through it, and viewing it from near and far. Strictly speaking, this work was a collaboration, not only between Christo and Jeanne-Claude but also with Frederick Law Olmsted and Calvert Vaux, the designers of Central Park, itself an entirely man-made work of art.

Christo and Jeanne-Claude, *The Gates, Central Park, New York City*, 1979–2005

CHAPTER FIVE

Ignorance Is Knowledge?

You must become an ignorant man again
And see the sun with an ignorant eye
And see it clearly in the idea of it.
— WALLACE STEVENS

The philosopher and psychologist William James discriminated between "scientific" knowledge (which he called "theoretic," since it could be proven as theory) and deeper "speculative" knowledge. He proposed that theoretical knowledge about things touches only the surfaces of reality and that to experience something required "living acquaintance."[57]

The emphasis on presenting art in the context of scientific knowledge is firmly ingrained in our culture. Strolling through the galleries of the Museum of Modern Art in New York, I found that the information presented on wall labels fell into four categories, all addressing concerns of art world professionals as opposed to stimulating the interest and imagination of visitors. All four categories are evident on the label beside Frank Stella's painting *The Marriage of Reason and Squalor, II* (1959):

[Description]
This painting consists of two identical sets of concentric, inverted U-shapes. Each half contains twelve stripes of black enamel paint that seem to radiate from the single vertical unpainted line at their center. [If we are in front of the painting, we can see this for ourselves, but perhaps for a *critic* this constitutes formal analysis and needs to be articulated.]

[Method and materials]
Working freehand, he applied the commercial black enamel paint with a housepainter's brush. . . [This information is mainly of interest to a *conservator*, and why is it necessary to say, "Working freehand"?]

[Quote by the artist]
With this "regulated pattern," Stella explained, he forced "illusionistic space out of the painting at a constant rate." [Whether Stella actually

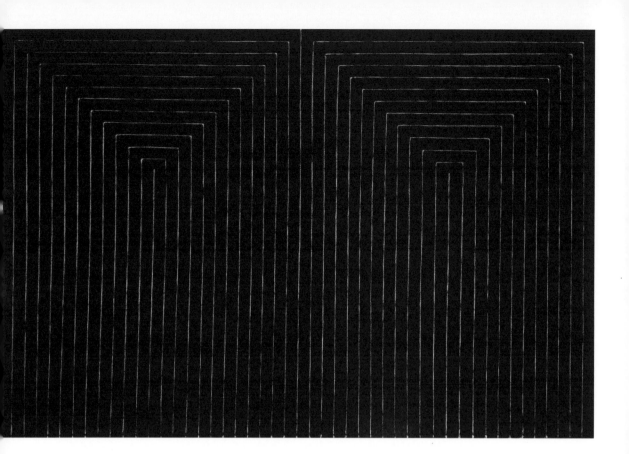

was thinking about this when wielding his housepainter's brush, or not, the quote is mostly interesting for a *biographer*.]

[History of the work]
Stella made this painting for MoMA's exhibition *Sixteen Americans* in 1959, at which time the Museum purchased it. [Aside from the museum congratulating itself for boldly purchasing it when the paint was barely dry, this information is useful only for the *art historian*.]

As an *art dealer*, I am interested in all of the above. My clients expect me to provide them with factual information, but that is usually *after* they have fully engaged with a work of art and are considering its purchase. Museum curators also engage with all four of the above categories when choosing works of art to exhibit or acquire. Reading the wall label for *The Marriage of Reason and Squalor, II* before, during, or after seeing the work is unlikely to spur a level of engagement with it corresponding to James's concept of speculative knowledge ("living acquaintance"). That is only

Frank Stella
The Marriage of Reason and Squalor, II, 1959
Enamel on canvas
90¾ × 132¾ in.
(230.5 × 337.2 cm)
The Museum of Modern Art, New York. Larry Aldrich Foundation Fund

going to happen by setting aside criticism, conservation, biography, history, and commerce, and letting the work, and the work alone, speak to you.

At the time I made this visit to the Museum of Modern Art, friends were telling me I had to see a film called *Woman in Gold* about a portrait of Adele Bloch-Bauer by Gustav Klimt. Looted by the Nazis and only very unwillingly returned to an aged, determined survivor of the prominent Jewish family that owned it, the painting is one of two such portraits. (The version in the movie belongs to the Neue Galerie in New York, a museum of early-twentieth-century German and Austrian art and design.) The one at the Museum of Modern Art was accompanied by lengthy wall signage that not only described the painting and briefly the subject, but also offered a bit of its history. The painting, it said, once belonged to "the Nazi government" and was being "proudly presented as a generous loan from its current owner."

While both awful and fascinating, that information has little to do with either version of the portrait, which for me are far more wonderful, soul-searing, and strange than almost any movie. In these portraits Klimt conjures a complex, fragile world of power and luxury with an eye for detail and emotional impact that Marcel Proust or Henry James might have envied. Of course, if the movie brings people to the paintings, all well and good; it would not be the first time we were encouraged to appreciate a great work of art by its historical circumstances. But that history is not inherent in the work of art; we impose it.

It's true that education is a fundamental part of the Museum of Modern Art's mission, so perhaps I should not be so critical of wall labels, but why not make the label a blank screen? Each visitor in turn can transmit their response to it via their mobile device. You can't get more interactive than that. When it comes to modern art, "scientific knowledge," interpretation, and opinion delivered from on high compromise our ability to develop "speculative knowledge" based on "living acquaintance" with what we are seeing. In effect, we are seeing the work through lenses provided by the management.

People are drawn to modern art because it feeds both the spirit and the imagination. No matter what form it takes, it presents alternatives to what

we see in most of our daily lives. It draws us away from what passes for our current state of reality and proposes other possibilities. And yet a work of art is a real thing; as awesomely real as *Double Negative* (1970), Michael Heizer's two trenches, displacing 244,000 tons of rock in the Nevada desert, and as intimidatingly real as Yoko Ono's ephemeral 1963 *Touch Poem for Group of People*, encouraging physical contact in a small room. One may make it easier for us to access our imagination ("This makes me think of that.") and another our spirit ("What on earth am I feeling?").

It is dicey to stress the spiritual aspect of modern art because for some it is but a short step to "God," and what has God got to do with modern art? William Wordsworth suggests a response to that question:

> And I have felt
> A presence that disturbs me with the joy
> Of elevated thoughts; a sense sublime . . .
> A motion and a spirit, that impels
> All thinking things, all objects of all thought
> And rolls through all things.[58]

I know, more flowery language, but it is important that we learn to use the non-rational (as opposed to irrational) when it comes to art. Great art produces an affect ("mental state") as opposed to effect—tired feet. We have to be present to experience that affect. Being present means noticing what you are doing, not what you just did or are about to do. If you get to the museum worried about missing your restaurant reservation, you are going to have a hard time concentrating on the art. Being present means focusing on the task at hand. It is much more important that you learn how to be totally focused than read any text about modern art.

In our lives some of us strive for emotional awareness. Hard to achieve—admitting I have emotions took several decades, but if we are in touch with our feelings (Gosh, this sounds like therapy, doesn't it?), we can stand in front of a painting and let it do the work. Our emotions are forms of cognition, and as we engage, we are getting to know the painting. We do not need to know *about* the painting. We do not need to *identify* the painting. The work of art has the potential to be perceived by us with an affect that

is sensuous, i.e., it produces a sensation, an altered state of mind, possibly a visceral feeling.

I call this process of deep engagement "osmosis," and it can only occur when intimacy has developed between you and the work of art. That intimacy is only achieved if you are in a state of mindfulness, which means being mentally prepared and having consciously decided to make yourself available for the experience.

I have mentioned the distinction between collecting an experience (photographing oneself with a work of art) and having an experience (actually engaging with the work of art). The other distinction that really matters in this context is the difference between knowledge and knowing.

Immodestly I admit there are works of art about which I have so much information in my head that I can churn out an essay or short talk in a couple of hours. With a few books open in front of me, and access to the Internet, I can do this for works of art I have never actually seen. But does that mean I really know the work of art I am writing about? One book I read twenty years ago, called *How Late It Was, How Late* by James Kelman, made a vivid and lasting impression, but when I want to recommend it, I can never remember either the exact title or the author's name. I know it as a work of literary art, but in fact I know very little about it. I cannot tell you when it was written or what other people think of it or what else Kelman has written.

We can get to know works of art in the same way we get to know people in our lives—by experiencing them. This requires contact over time. I have some helpful hints when it comes to getting to know works of modern art:

Be Chosen

A friend of mine took his eight-year-old daughter to an exhibition of Fauve paintings that had traveled to his local museum. He hoped she might like the bright landscapes and that it would be a good way to introduce her to fine art.

"I don't know how you want to do this, Dad," she announced as they entered the first gallery, "but I'm going to stand in the middle of the room and just let the colors come to me."

I am deliberately recycling this story from my previous book, *The Value of Art*, because it so effectively illustrates my first hint. I suggest that you try this young lady's technique the next time you go into a gallery or museum. Museumgoers tend to be wall huggers, shuffling sideways from one work to the next. Instead, stand in the middle of the room and scan slowly around you, then head for the painting, drawing, or sculpture that beckons you.

With respect to those talented curators who install works of art in ensembles, arranged in such a way as to teach us most effectively, I still think of works of art as individual expressions, and however intelligently grouped they may be, I am less interested in the exhibition's narrative than in being able to fully engage with one or another particular work of art.

Standing in the middle of the room is a particularly good idea if the exhibition is all the work of one artist, whether it is the first show of a young one or a grand retrospective of an acknowledged master. Let the work choose you.

This happened to me in a surprising manner when I went to visit a curator at the Philadelphia Museum of Art in 2005. I was early and my friend was occupied, so his assistant asked me if I would like to take a look at an exhibition of work by Dutch landscape artist Jacob van Ruisdael that was being installed in galleries that were closed to the public. Out of politeness I accepted, but to be honest, I would have rather seen virtually anything else in the museum. I have lamentably little interest in Dutch landscape painting and admit a certain lack of passion when it comes to Old Masters in general.

But there I found myself, alone in the galleries, the show half lit, and some paintings still leaning against the walls. I had strolled around about halfway with no spark of interest when I came to *View of Haarlem with Bleaching Grounds* (c. 1670–75).

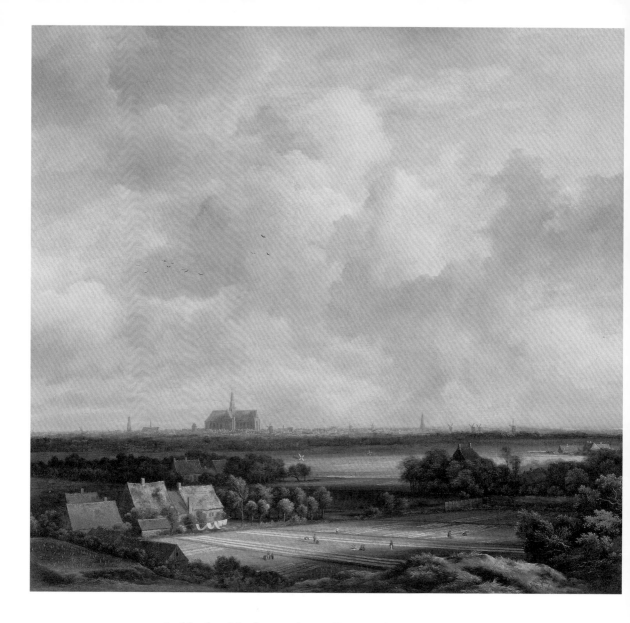

Jacob van Ruisdael
*View of Haarlem with
Bleaching Grounds*,
c. 1670–75
Oil on canvas
21⅞ × 24½ in.
(55.5 × 62 cm)
Mauritshuis, The Hague,
the Netherlands

Suddenly I felt almost physically propelled into the painting. I was mesmerized and had the sensation of being within the landscape at that time in history. This lasted for several minutes until I slowly "returned." There had definitely been a two-way communication between myself and the painting, but how and why? In Chapter Seven, I discuss similar compelling encounters, but this was one of the oddest because I felt distinctly chosen by the work rather than vice versa. Later I stared at a reproduction of the work to conjure what it was that acted on me so strongly, but the feeling did not return until very recently, when I was surprised, reading

The Rings of Saturn by W. G. Sebald, to see the work beautifully described by the protagonist, who spends a full hour in front of it.

Preparation

Preparation, as I mean it, is primarily about our mental approach to seeing art, not about planning a visit to a museum or galleries. Some of the most wonderful encounters occur when a visit is spontaneous. Our aim should be to cultivate the viewer's mind so that it can be chosen by the art.

As preparation, and in descending order of importance, I suggest following these rules:

No Audio Guide
No Taking Photos
No Peeking at Your Smartphone
No Label Reading
No Talking Until After You Have Seen the Work of Art

You may be on your own or with one or more friends or family members. If you have company, are they likely to distract you? Have you discussed what you want to see and how you want to see it? Lively discussion, particularly about modern art, can be great fun, but if it is likely to happen while you are looking at works, you won't really see them. Walking around a gallery with a chatterbox is no better than listening to the audio guide—a surefire guarantee you will not engage with the works of art. I like to either go alone or with someone (ideally my wife) who will wander at more or less the same pace and who is comfortable not commenting. If you are going to look at art as a pair, or even a group, think of it like going to the movies or a concert: keep quiet then discuss it afterward over a pizza.

It is important to remember that where we see a work of art should not define that work. Being attracted to a painting by an unknown artist at a friend's house but saying to yourself, "That can't be any good, she's not a real collector," is as misguided as seeing a painting you frankly don't like in a museum and thinking, "It must be great or else it wouldn't be in a museum."

Mindfulness

*I feel that art has something do with the achievement of stillness in the midst
of chaos. A stillness that characterizes prayer, too, and the eye of the storm.
I think that art has something to do with an arrest of attention in the midst
of distraction.* —SAUL BELLOW

I was very pleased with myself for starting to obsess about mindfulness a
few years ago, even before I stumbled across the book *Mindfulness* by Dr.
Ellen Langer, whom we met in Chapter One. In a recent interview, Langer
said, "Mindfulness, for me, is the very simple process of actively noticing
new things. When you actively notice new things, that puts you in the
present, makes you sensitive to context. As you're noticing new things,
it's engaging."[59]

It seems to me that noticing new things and being sensitive to context—
what one might call being "present" in one's life—apply very aptly to the
process of seeing art, modern art in particular, and I am convinced that
this is an extremely important tool for engaging with modern art. A *Time*
magazine cover story in February 2014 extolled the merits of "being mind-
ful" while emphasizing the Dale Carnegie aspect of using mindfulness
to get ahead in life rather than applying it to things cultural or spiritual.

Whatever else one may use it for, mindfulness is an antidote to our
epidemic of technologically induced attention deficit disorder. We can
only concentrate on one thing at a time. We have peripheral awareness, of
course (most highly developed in children), but we lose it as we age. Mine
went long ago, which is why I now have a car that warns me if another
car is too close when I am changing lanes. While my smart car may pro-
tect me from my lack of peripheral vision, my smartphone, used at every
moment and everywhere incessantly concentrates my vision on a four-
by-three-inch rectangle. I am not even looking at what is in front of me,
let alone what may be on either side.

Mindful looking at art is not about becoming all seeing, but about reduc-
ing the limitations we impose on the experience of seeing by permitting
intrusion of the distractions that are part of our daily lives, not only our

mobile devices, but all our worries and cares. We may consider the time we take to visit a museum or a gallery as recreational and use the word "relaxing" to describe such an activity, just as we describe a round of golf, an hour with a book, or a concert performance. Since we live in a therapeutic culture, our attitude is that if we choose to engage in an activity to relax, it is the job of the activity to relax us rather than our job to be relaxed in order to enjoy the activity.

But how can we be relaxed or the activity be relaxing if we feel it necessary to constantly check our smartphones for messages? Is it too much to turn off the device for an hour while we wander through the galleries? As mobile device slaves, we are condemned to a life without relaxation.

The calmer I am the more mindful I am, and the more mindful I am the more receptive, and receptivity is key to osmosis. So how can you approach art, modern or ancient, calmly? Here goes: Find a bench inside or outside the museum or gallery, and before you venture into any room to look at art, sit down, close your eyes, and concentrate on breathing deeply in and out for just a couple of minutes. You don't have to make a spectacle of yourself by sitting like the Buddha; the point is to relax before the experience of seeing art.

This is the opposite of expecting the art to make you relax. Only you can relax you. I did, however, enjoy lying flat on my back on a giant plush doughnut watching a multichannel video projection of exploding flowers at the Museum of Modern Art in 2008, part of an installation by the Swiss artist Pipilotti Rist called *Pour Your Body Out (7354 Cubic Meters)*. Then I fell asleep (too relaxed).

Several Japanese museums offer examples of unusual attention to preparing visitors for the experience of art by lowering their heart rates and inspiring a contemplative attitude. The Chichu Art Museum on the island of Naoshima in Japan is mostly underground in order not to disturb the beauty of the landscape. The museum features site-specific works by Walter De Maria, Yayoi Kusama, Richard Long, and James Turrell, as well as five magnificent late *Water Lilies* paintings by Claude Monet. You arrive by bus, which leaves you at a ticket office that appears to be the entrance, but in fact you are directed to a gently sloping uphill path, which meanders

for about half a mile next to a long pond of (yes) water lilies and croaking frogs, so by the time you find the entrance to the museum proper, cut into the side of a hill, you are much more "in the mood" for engaging Monet's art than if you were jostling off a crowded street.

Foot baths at entrance of Okada Museum of Art, Kowakudani, Hakone, Japan

Another museum that gets a gold star for experience preparation is the very new Okada Museum of Art, close to the many hot springs resort hotels of Hakone. Before entering, visitors are provided with a row of shady benches and individual foot bathing facilities. To Western visitors this may seem quaintly unnecessary, but to stop, sit, and engage in that activity for a few minutes inserts a mental and physical punctuation mark in your trajectory. It changes your rhythm, which makes you much more alert to your context.

Once you are inside, there are easily accessible lockers and this friendly notice, which I wish was in every museum:

Notice at Okada
Museum of Art,
Kowakudani,
Hakone, Japan

Then a metal detector you must pass through helps to make sure you have not concealed your personal electronic devices. The Okada Museum has a superb collection of early Chinese bronzes and Korean and Japanese ceramics, beautifully installed. Inside, people of all ages are really enjoying the works of art, slowly. Take note big-city institutions, it *can* be done!

Even if you can't wash your feet and lock up your smartphone on your next museum visit, try to spend a couple of minutes with your eyes shut in the quietest space you can find near the entrance, as I suggested, and then head off into the galleries, but let your eyes direct you, not your mind.

You may well be drawn to something you have looked at previously, and this is a good way to try out my method. A trick I sometimes use to slow down is to substitute "watching" for "looking" and suggest to myself that I "watch" a painting. We use "watch" for events that develop over time (movies, television, theater, wildlife, stakeouts), and I believe that if we "watch" works of art, they also develop over time. The process begins with us letting go of our first impressions, which come from whatever it is that guards our feelings under lock and key. almost all of which come courtesy of the brain, not our eyes and definitely not wherever many of us keep our feelings (under lock and key).

Not long ago I walked into a very large room, about fifty square feet, in which were hung, side by side and stretching around the entire gallery, 106

square paintings by Marcia Hafif, each twenty-two by twenty-two inches, each representing a step in the gray scale from white to black. My kind of art! Luckily I was the only visitor. I stood in the middle of the room and turned very slowly around, "watching" this installation come alive. It took a good five minutes for my eyes to "calm down" and really see the subtle changes in color from one painting to the next. Eventually I walked slowly past each painting, from white to black and then retraced my steps, from black to white, becoming increasingly aware that surfaces, which from a distance appeared smooth and flat, were in fact generously scumbled with discernible brush marks.

A few years ago there was an exhibition of drawings by Georges Seurat at the Museum of Modern Art. While I once spent a very long time at the Art Institute of Chicago in front of *A Sunday on La Grande Jatte—1884* (1884–86) and thoroughly enjoyed the ride, I had paid little attention to his dark and shadowy works on paper. I admired their charm and economy of means, but I had never really connected with them. I muddled through the members' preview of the Seurat drawings show, when I was startled to find myself staring at a small Conté crayon drawing of an elderly man and woman close together, seen from behind. The figures were just gray and black smudges, the man darker than the woman.

I could not get the drawing out of my mind. I went back a couple of weeks later when the exhibition was fairly empty, and I really did make an effort to relax before I started to wander around, but I found myself aiming straight for the drawing. My chest tightened and I felt longing and sadness and also a tiny bit of happiness (there is no doubt a word in German for this exact state). I did not burst into tears but there was a decided lurch in that direction. Just to be sure it was not something I had for lunch, I went back a couple of times during the exhibition and experienced the same reaction. I made a few stabs at connections. My grandmother was short and stout and wore a hat very much like the figure in the drawing, but if it was her, she was definitely stepping out on my grandfather because he was tall and skinny and bareheaded in all weather, not the same-height bowler-hatted man holding this woman's arm.

OPPOSITE

Georges Seurat

The Couple (At Dusk),

1882–83

Conté crayon on paper

12 × 8½ in.

(30.5 × 21.4 cm)

Private Collection

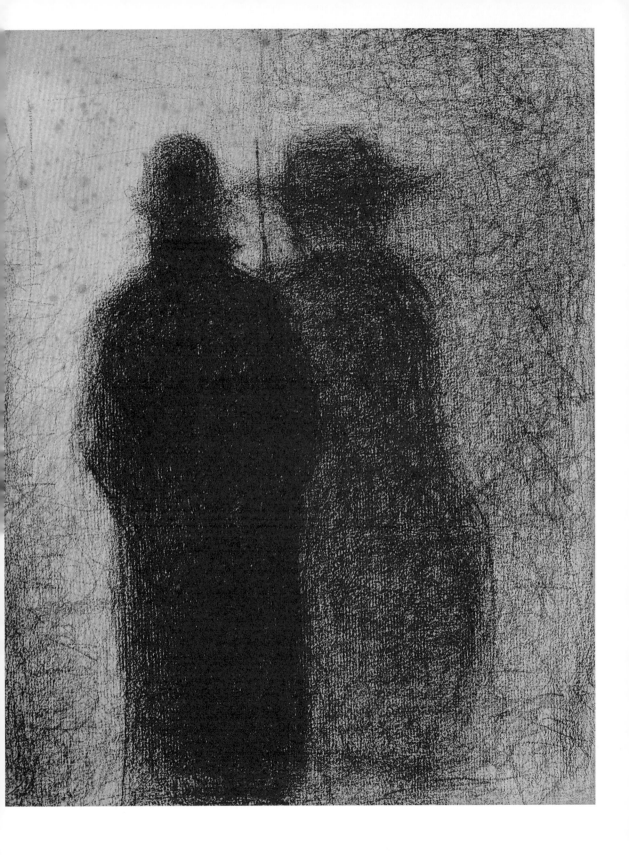

Interestingly, I don't recapture these feelings when I look at the catalogue reproduction of the drawing. It has no life. Standing in front of the actual work, I felt this couple breathe. They are moving (yes, slowly) and, to me at least, there is no doubt they love each other. This somewhat unbidden communication between me and *The Couple (At Dusk)* (1882–83), inspired me to spend a lot of time with the other drawings in the exhibition, which I enjoyed, although none struck me quite as strongly.

If you are physically relaxed and mentally present, you can leave your preconceptions at the door. When visiting in a museum a work of art that is an "old friend," it matters little that it is iconic and not at all if it matches its frequently reproduced doppelgänger on your screen or in a book. The encounter is just as exciting as coming across a work you have never seen before, whether it is by an artist not known to you or a masterpiece borrowed from a museum you never have had the chance to visit.

When it comes to revisiting a masterwork by an artist such as Salvador Dalí, Frida Kahlo, Jackson Pollock, or Georgia O'Keeffe, which has been reduced to a cliché by our culture, I think of my experience with Richard Wagner, whose music I never particularly liked. Of course I must have heard *The Ride of the Valkyries* thousands of times in snatches of television commercials, movie soundtracks, and possibly even in concert, always finding it bombastic kitsch. Sometimes on a weekend, I get the Sunday paper and drive to an empty beach to watch the waves. Early last summer, *The Ride of the Valkyries* came over the radio, in a performance at the Metropolitan Opera from 2000, with James Levine conducting. I was caught totally off guard, and it was sheer magic. For some reason I was mindful, totally present. I heard every stirring, passionate note and my opinion was reversed; I let go of my prior agreement. What was responsible? Wagner? Levine? The waves? A good night's sleep?

Not only the extremely familiar but also that which may seem, at first, strange and difficult can be richly rewarding if given the benefit of our extended attention rather than dismissing it out of hand. Henri Lazarof (1932–2013) was an esteemed composer of modern music and, with his wife, Janice, a keen collector of modern art. I loved the works in their collection by Picasso and Alberto Giacometti, but when he kindly gave me a

CD of his chamber music, I found the sounds dissonant and atonal. Luckily for me, he liked to talk to me about art, not music. Henri and Janice made an extraordinary gift of their collection to the Los Angeles County Museum of Art, and there was a private concert of his compositions in their honor, which I was happy to attend. I say "happy" because I was with dear friends, but frankly, when I saw that my chair was small and hard and in the second row, I girded my loins for a long evening and tried to settle on a suitably attentive expression while expecting my thoughts to wander. Instead, focused at first by the fact that the musicians and singers were young and charming and further by the fact that I was in for a penny, so to speak, after about twenty minutes I found I was not simply enduring the concert but starting to enjoy it, and eventually I was moved nearly to tears by a song cycle. Quite a turnaround—and all it took was staying with it.

Glancing at a "blank" canvas by Robert Ryman, or a noisy jumble of barely discernible images by Sigmar Polke, we may be tempted to quickly tag them as "boring" or "messy" and move on to the satisfyingly well-balanced Mondrian, which we know we like. Or possibly we cruise by all the abstract work and head for the delightful portraits by Henri Matisse. I am a big fan of both Piet Mondrian and Matisse, but you will find it really worthwhile to stop and take the two-minute challenge. This means parking yourself in front of something you deem boring or ugly or, best of all, "not art" for two minutes (timed; good use of your smartphone) with the specific purpose of confirming your snap judgment. Once in a while you may change your mind, and then you will have made a discovery.

In sum, it is worth making an effort to arrive in front of works of art in an open and relaxed state of mind. Imagine how wonderful it would be to sit and breathe deeply and regularly for a few minutes, perhaps close your eyes in meditation, then open them on a great painting by Barnett Newman or a sculpture by Alexander Calder. Of course you might be distracted by the man bending in front of you to read the label or by the sudden shrill ring of his cell phone. Nevertheless, with a little practice, you can "refresh" by closing your eyes between objects a bit longer than a blink. I often spot what I want to see from the middle of the room, move into it

quite closely at first, then find a seat as near to it as possible, and enjoy its presence until I am no longer bothered by other visitors.

Most of the time we are lost in our own thoughts. Genuine engagement with a powerful work of art can literally lift us out of the constant inner dialogue with ourselves. That is why I find it so strange to see someone glance at a work of art, turn to stand in front of it, and in the same movement pull out their smartphone to capture an image of themselves with their back to the object. This activity is now formalized in the culture. I recently found this greeting in my inbox:

Happy Museum Selfie Day!
Mar Dixon and website Culture Themes have declared today a celebration of the museum selfie and are encouraging selfie lovers to take to Twitter and post their favorite photos from exhibitions past and present. Jay Z already struck a pose today at the Warhol Museum.

Such willfully self-distracting behavior betrays a fear of engaging with art as art. For Jay Z (sorry, fans), modern art is merely an accessory to the endlessly fascinating (to himself) story of his life.

In some cultures past (Chinese) and present (Aboriginal Australian), both the making and perceiving of art is considered spiritual practice. The great Tang period painter and poet Wang Wei claimed that only the "empty mind" can truly mirror the world, and he believed in a cosmology of connectedness between all things that is not at all unfamiliar to twenty-first-century environmentalists. While Wang Wei may have been drawn to the Ch'an (Zen) beauty of solitude in the wilderness, his poetry's basic theme of consciousness emptied of self is excellent preparation for our approach to modern art.[60] Remaining *present* in a museum is the opposite of being self-conscious. Art historian James Elkins talks about seeing paintings ". . . as ways of thinking about something other than what I am."[61]

A truly powerful work of art has the ability to charge our feelings in such a way that we reorder the priorities of the moment. The distractions of a runny nose, tired feet, what to do for dinner, and that upsetting remark by our boss are sidelined by a communication with a painting or drawing,

a sculpture or installation that moves us profoundly, even if only for a moment.

Benedictine monk David Steindl-Rast believes that the key to happiness is gratitude, and that every moment we live is a gift within which is an opportunity for enjoyment if we can but stop rushing. He suggests we recall what we were told to do as children before crossing a street: Stop. Look. Go. For our purposes, once we STOP at a work of art, we open ourselves to the gift of the moment; and then when we LOOK, take the opportunity to SEE before we GO. It is not too difficult to form the habit of taking a deep breath when we start to engage with a work of art and that alone can be enough to bring our attention into the moment.[62]

Intimacy

Intimacy is an even scarier concept than mindfulness. We usually use it when discussing human relationships. Spouses complain of too little and rush-hour subway passengers complain of too much. What does it mean to be intimate with an object, with a work of art? In his book *Still Life with Oysters and Lemons*, Mark Doty says:

> I have been drawn into the orbit of a painting, have allowed myself to be pulled into its sphere by casual attraction deepening to something more compelling. I have felt the energy and life of the painting's will; I have been held there, instructed. And the overall effect, the result of looking and looking into its brimming surface as long as I could look, is love, by which I mean a sense of tenderness toward experience, of being held within an intimacy with the things of the world.[63]

Is "love" too strange (and strong) a word to use about our relationship to art? I don't think so. Look how we use it all the time:

> I love his jacket.
> I love this hamburger.
> I love the beach at sunset.
> And how about: I just love Rothko!

You do? What does that mean? You don't mean you are in love with Mark Rothko, who died in 1970. Oh, you mean you love his paintings? Or perhaps his works on paper? So you just love all his work, indiscriminately? Obviously not. When your friend says "I love Rothko," he probably means he's seen a few of his works in reproduction that he really liked, or perhaps he has even seen an exhibition of works by Rothko. In any case, he "loves" Rothko's work in a general manner.

To love the works of an artist generally does not involve the kind of intimacy meant by Doty. Intimacy has specific spatial and temporal requirements. We must be proximate to a work of art, and we must spend significant time with a specific work of art. We can be drawn to and "like" many works by Rothko, just as a woman can be drawn to and "like" men with widow's peaks and narrow trousers, but we can only achieve intimacy with one work of art at a time (just as we cannot be intimate with two people in the same place and at the same time—on second thought, let's not go there).

A principal barrier to intimacy between the observer and the observed is our notion that a masterpiece is the product of a mind completely different from our own, that the artist occupies a higher plane and the work is graciously presented to us, mere mortals, from on high. This barrier is reinforced by the colorful biographical narratives that accompany the most famous modern artists—womanizing Picasso, madcap Dalí, enigmatic, oracular Warhol. Whether or not the artist enjoys or exploits the admiration of a large public audience, your job is to approach the individual painting, drawing, or sculpture as the product of a woman or man with a flesh-and-blood life that probably included many of the same small joys and annoyances as yours.

Further, try to imagine the work was made for you. Animate the work with a desire to communicate with you personally. Once a work of art is publicly exhibited, it is addressed to everyone, and no individual's eyes are more worthy than those of the next. You and the work exist on the same plane and at the same level. Works of art from ages past might require some degree of translation, but modern works are a product of the world in which we live and need to withstand peer scrutiny just as they are when

they leave the studio, no need for explanations. The writer Virginia Woolf championed the authority of her readers and cautioned them against humility: "In your modesty you seem to consider that writers are of different blood and bone from yourselves; that they know more ... than you do. Never was there a more fatal mistake."[64]

This is equally true of artists. Matisse may be justifiably heralded as a great master of color, but when you stand in front of his work, let the general applause subside and think of it as having been made just for you. It comes down to clearing your mind, seeing one work at a time, and having patience.

Shutting out all the noise of what we think we know, ought to know, or what other people might know about modern art is the toughest part of engaging with it for pure enjoyment, but if we manage to clear even a small empty space in our brain, all we need to do is:

Observe the object for one minute.
See into it.
Feel what it does.

It may do nothing, a little, or a lot, but unless we give it this kind of a shot, we will never come to grips with anything essential.

Achieving Contact: A Dialogue

Don't get me wrong, we can fully engage with and enjoy a work of art without experiencing profound emotions, but at the very least we can step out of our daily preoccupations and allow the work of art to reveal itself. It matters not whether this contact invokes memories or creates them, literal or fanciful. We are not out to achieve a specific response or level of feeling; we are out to spend a brief amount of time connecting with a painting, drawing, sculpture, video, installation, or performance so that it has the opportunity to deliver its essence. We are not by any means going to be able to connect with everything, but wouldn't it be very exciting to discover works that are consistently engaging, as the following imagined scenario demonstrates:

You are in New York for a few days (or live there) and you have a couple of hours free to go alone (or with a friend who is the strong, silent type) to the Museum of Modern Art. Holding firmly onto your belongings, you sit on one of the rust-red leather benches in the lobby, close your eyes, and breathe deeply for about a minute. You are in no hurry.

Now you head up the escalators to the fourth floor and enter the permanent collection galleries. Stand and look around slowly. From the middle of the room, you look at each object for a few seconds then approach the one that seems to be beckoning you. You go up to it.

You: OK, I'm standing in front of it, and I'm pretty sure I know who did it!

Me: Sorry, no prize for that.

You: Why can't I read the label?

Me: Because if you know the artist, you don't need to, and if you don't know the artist, knowing the name will not help you see the work.

You: But what about the title?

Me: Most titles are either plainly descriptive and therefore redundant (*Man in Red Jacket*) or uninformative (*Untitled Blue Number 13*). Works of art are often titled randomly, often by dealers who need to keep track of inventory. Joan Mitchell titled a painting *Edouard*, naming it after her dog, which in turn she had named for the painter Édouard Manet. Interesting, but nothing to do with the painting.

You: Now what?

Me: What happens next is you relax and engage with the painting. I'm sorry there's not a bench in this particular gallery or else you could sit down.

You: No problem.

Me: Try not to think about anything for at least three minutes. This is a long time, as anyone with a frozen pizza in the microwave can tell you, but it's time you can afford. It takes this long for our brain (both sides!) to assimilate the image so that what you're seeing is actually on your retina, not in your mind.

One way to guarantee you know what you're seeing is to imagine describing it to someone not present. In fact, the painting that caught

your attention is Piet Mondrian's *Broadway Boogie Woogie*. You know the name of the artist, but you've read enough of this book by now to know that saying a work is a "Mondrian" or a "Picasso" is not a description of what your eyes see. Instead, you might say to yourself:

Quite big, about four feet square. Colors on a white painted surface. The colors make a grid with nine horizontal bars unevenly spaced top to bottom, all but one extending across the canvas, and ten vertical bars, most clustered toward the sides, but several of these don't extend to the bottom. The bars are mostly yellow with blue, red, and white squares at intersections of the lines and at uneven intervals along them, and there are some larger rectangular shapes, about a dozen of them between and over or under the bars. The paint surface is flat and even, though brushstrokes are visible.

Piet Mondrian
Broadway Boogie Woogie,
1942–43
Oil on canvas
50 × 50 in. (127 × 127 cm)
The Museum of Modern
Art, New York. Given
anonymously

As this goes through your mind, you're looking much harder than you would normally look, and if you then let go of the words and continue looking at the work, you'll find you're seeing it much more clearly, both as a whole and as a sum of the parts you've articulated.

What you're also doing is slowing down the process of observation, removing a sense of urgency, forgetting about "let's see what's next." Most of the art we look at is motionless, yet we are not. In order to synchronize, we must learn to engage with it in slow motion.

You: Shut up, I'm trying to concentrate.

Me: Actually, I suggest you don't try to concentrate on the painting but instead let it concentrate on you. Does that make sense? When we concentrate, we narrow our focus to specific elements. There are so many ways to absorb a great modern painting like this, our mind should be as open as possible, and empty. Let it in, through your eyes, not so much your brain.

You: Easy for you to say but I'll give it a try.

(. . .)

Me: By now you've spent about five minutes with this painting. Does it look any different from when you first laid eyes on it? Perhaps you've even seen it on other occasions; do you still feel the same about it? What does it make you feel?

You: I don't know if I feel anything, I just like looking at it.

Me: Well, perhaps we can say you don't feel bored, you feel some enjoyment.

You: Sure, it's growing on me.

Me: You might now ask yourself why. What's changed or seems to be changing about it since your first glance?

You: I can see more.

Me: You can see more what?

You: I don't know. Just more. Deeper. Into it. But I still don't know what it means.

Me: That doesn't matter. No matter how apparently simple it appears to be, a great work of art will deliver if you let it. You just have to be prepared to receive sensation rather than meaning.

OPPOSITE
Mark Rothko
Slow Swirl at the Edge of the Sea, 1944
Oil on canvas
75⅜ × 84¾ in.
(191.4 × 215.2 cm)
The Museum of Modern Art, New York. Bequest of Mrs. Mark Rothko through The Mark Rothko Foundation, Inc.
© Kate Rothko Prizel & Christopher Rothko / Artists Rights Society (ARS), New York

You: Can I move on now?

Me: Sure, pick another work in this room that appeals to you, but one by an artist you can't identify. Or how about the one behind you?

You: OK. Hey, I like it.

Me: Good, but give it a minute to settle in.

You: I don't know who did it so I just had to read the label, sorry! It says Rothko but it doesn't look at all like a Rothko.

Me: This man painted just about every day for more than forty years,

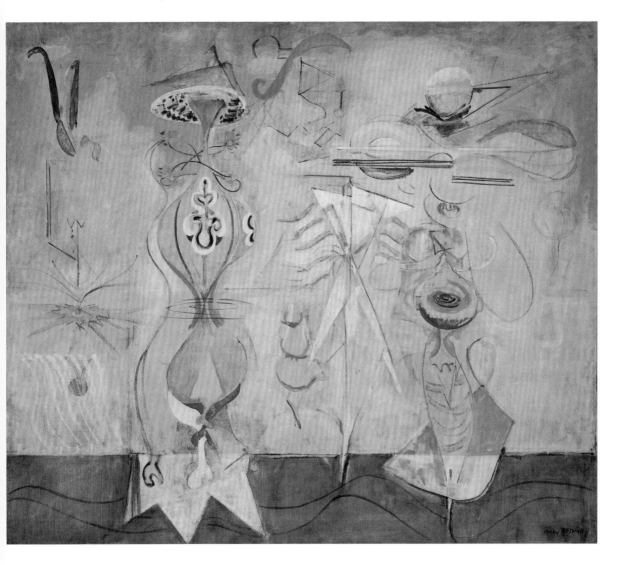

and his early and late paintings are, thank God, very different, otherwise it would've been a pretty boring life. What exactly is "a Rothko" to you?

You: You know, big colored rectangles. This isn't remotely like that!

Me: So what! You picked it out or maybe it picked you out. And it doesn't matter if the label says "Mark Rothko" or "Jane Schmo." Now stay with it for a couple of minutes and tell me what you're feeling.

You: It looks like three people wearing crazy clothes dancing on a stage, but I looked at the label again and it's called *Slow Swirl at the Edge of the Sea*, so now I'm confused.

Me: How about you forget the title and what you think it looks like? I asked you how it makes you feel.

You: It makes me feel good. Happy. It's really neat.

Me: OK, now I'm going to pick the next two for you.

You: I thought you said we should make our own choices!

Me: Yes, you should, but I'm writing this book and there are some points I need to make. Here's a favorite of mine.

You: This is Cubism! Probably Picasso.

Me: Right on the first, wrong on the second, but it doesn't matter who did it or what someone calls it. Take it in and talk to me.

You: To begin with, it's very dense and doesn't have much color; this will take some time.

Me: Good.

You: Actually, I take that back, there is color, just very subtle. I can definitely see a figure, a man, maybe on a horse, riding into sunlight.

Me: How does it make you feel?

You: It's very dramatic, kind of heroic, but I keep seeing new stuff the longer I look.

OPPOSITE
Georges Braque
Man with a Guitar,
1911–12
Oil on canvas
45 ¾ × 31 ⅞ in.
(116.2 × 80.9 cm)
The Museum of Modern
Art, New York. Acquired
through the Lillie P. Bliss
Bequest

Me: An artist once told me that genius is being able to put layers and layers of thought into a painting so it seeps out slowly and can be enjoyed for a long time.

You: I might have to come back to this one.

Me: Terrific. Don't expect everything to be immediately compelling. If a work of art grabs you and you give it a couple of minutes, and it starts to lose its hold, then you go to the next. Even if (or particularly if) it's a

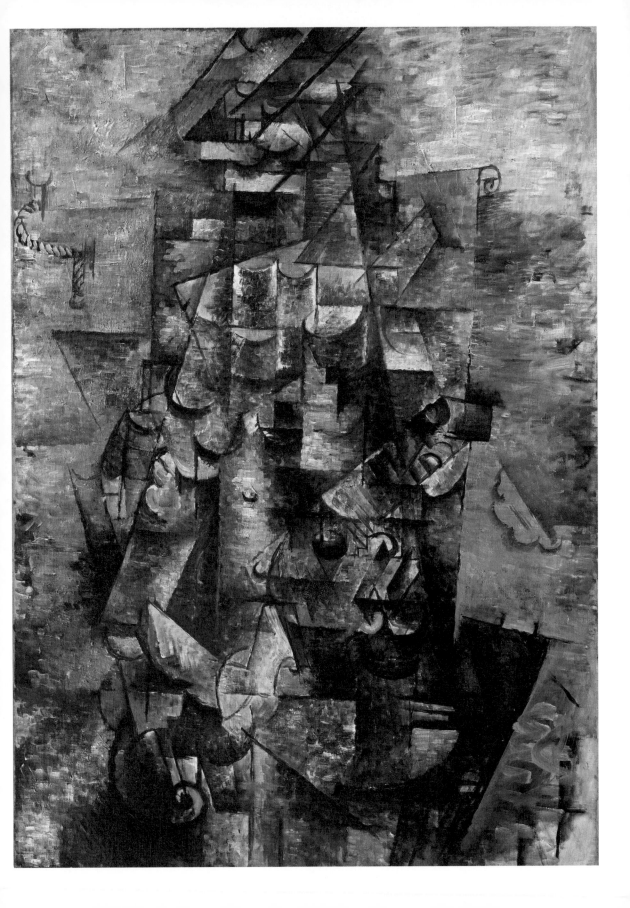

Jean-Michel Basquiat
Notary, 1983
Acrylic, oilstick, and paper
collage on canvas mounted
on wood supports
Triptych: 71 × 158 in.
(180.5 × 401.5 cm)
The Schorr Family
Collection. On long-term
loan to the Princeton
University Art Museum

"famous" painting, or something new that everyone is talking about, give
it a decent shot, then feel confident if your opinion differs from others.

You may have been given information that this painting is very import-
ant, but your experience is that it holds no importance for you. There may
be other works by that artist, or none, that you prefer. What matters is that
you base your opinion on experience. In fact, if you have a bit of extra time
to spend, I strongly suggest you find a work by an artist you don't like and
spend three minutes with it.

You: What if nothing happens?

Me: Something will always happen. I guarantee it. If you're bored after a minute, move on. What has happened is that you got bored. That work of art did not work for you. Maybe it works for other people, maybe it just doesn't work at all. That isn't your concern even if the museum has it behind a velvet rope with guards. Just to push the my-kid-can-do-that envelope, let's go and see this painting at the Princeton University Art Museum.

You: Why do we have to go there?

Me: Because this is a wonderful painting by a great artist and right now there isn't one as good by him on view at MoMA.

(. . .)

You: . . . well, I don't know what that is. I like the word stuff.
Me: Give it some time.
You: I'm not sure if I'm getting it but my thoughts are going all over the place, like I'm daydreaming.
Me: Do you like it?
You: Yeah, I really do. Not sure why—it's not what it looks like.
Me: Whatever that means!
You: Can I sit down and look at it longer?
Me: Sure.

OK, as you probably guessed, I made this dialogue up. But it is based on many I have had with students of my daylong "Trusting Your Eye" seminar at Christie's Education. The seminar includes a field trip to a local museum (The Museum of Modern Art, New York) with students divided into randomly selected pairs. Each pair is given the location of an object (not the name or any other details) and two instructions:

Look at it for fifteen minutes.
Do not read the label.

Back in the classroom, I ask each student to describe the object they saw without using the title, artist's name, or any art historical reference. And then I ask them what they felt when they laid eyes on it and what they felt fifteen minutes later.

As you may imagine, this is a lot of fun because, of course, two people seeing the same object usually describe it quite differently, and arguments even about size, color, and shape have been heated. Then I chime in and ask these questions:

Did you really spend a full fifteen minutes?
How long was it before you read the label?

Because these are students (young and adult) who have chosen to take a course in an art establishment, many of them don't need the label to identify what I sent them to see, but I am amazed by how many find it difficult to describe a painting that is by Picasso without saying, "It's a Picasso."

I also urge the pair to tell me if they spoke to each other about the work and also whether they observed other people looking at the same work and overheard any comments. This question is to emphasize the social side of going out and enjoying works of art.

I know that this relatively simple exercise has bred a deep level of engagement and grounds for wonder in some of those students. There was one woman who was so agitated when I called on her that at first she could hardly speak.

"I hated it!" she sputtered. "I know the artist and I hate his work, it's always bothered me." I knew she had been assigned *Broadway Boogie Woogie*.

"I don't like anything that looks like that, not even scarves and dresses!"

I asked her if she had spent a full fifteen minutes in front of it.

"Of course. You told us to!" Then she said nothing.

"And?" I asked, "Did anything happen?"

She suddenly got quiet and looked sheepish. "Yes. When I had to describe it to myself, I really saw what was there, not just a pattern. Then slowly I realized it was moving. It became very clear and sort of musical. I can't really describe how I felt."

"But now you like it?"

Long pause.

"Yes, I spent an extra five minutes. I was almost late getting back."

Fifteen minutes may be for art watching marathoners only, but for most of us three minutes is really worth the effort, even with a work we are tempted to dismiss quickly. Let's say you have just half an hour to spend. Would you rather glance at fifty works of art, a few of which might be worth a second look (for which you have no time), or spend three minutes each with ten works and be fully engaged with each, feelings invoked and memories strong?

The Work of Art Needs To Be Seen

The observer makes the painting.

—AGNES MARTIN

As you look at the painting and assimilate its essential nature, imagine that it is looking back at you. Many modern artists, like Agnes Martin, insist on the primacy of you, the viewer. Marcel Duchamp believed that a work of art does not exist if it is not seen:

> . . . the interaction of the onlooker makes the painting. Without that . . . there would be no actual existence of a work of art. It's always based on two poles, the onlooker and the maker, and the spark that comes from that bipolar action gives birth to something—like electricity. The artist looking at his own work is not enough . . . I give to the onlooker more importance than the artist, almost, because not only does he look, but he also gives a judgment.[65]

Eulogizing fellow artist Edvard Munch, the German Expressionist painter Oskar Kokoschka insisted that for art to exist, "as in love, two individuals are necessary."[66] This is not merely philosophical. While artists need patrons to support making work, the works of art they produce need our attention to remain in existence as art, and not simply as objects in a warehouse or on a wall. More art is being produced today than at any other time in human history, even though most of the work produced in the last fifty years is in storage and the same fate awaits most of what is being made this afternoon. We see it and it lives. We turn away and it dies, or at least sleeps. Thus we have an obligation not only to look but to look carefully, to *see* and to render judgment. Your opinion matters if it is informed by your experience, even if you are the most casual gallerygoer, far from the art world's corridors of power. While the fashions of contemporary art may be dictated from on high by curators and dealers and auction houses, what eventually finds a more or less permanent place in our museums is determined from the ground up by the general public.

If you are prepared to accept the idea that as you look at a work of art it is looking at you, then you begin to understand the process of engagement. If you think of a work of modern art as an object "over there," identified by the context of being in a museum (or worse, the context of being worth a great deal of money), it becomes impossible for you to let the artist truly share with you what he or she has made.

When that engagement does take place, the effect on us can be as invigorating and exciting as any so-called "live" experience. In a 1979 interview, painter Jack Tworkov says:

> I think that painting today is perhaps very much related to music and dance, which also have no subject but which at their best stir something primal in people, something that we've had from our very beginnings. Just as we react to the sound of a drum or the note that a trumpet makes, so I think we react sometimes to painting. It touches something that is basic, that is in us from the beginning of time.[67]

Make It Real (Reprise)

I talked about this earlier but it needs to be reinforced, and if my editor will allow me, I have to say it again: none of this works unless you are in the presence of the real thing. I don't care if it is a giant steel sculpture by Richard Serra, a wild and wordy painting by Basquiat, a small box of found objects by Joseph Cornell, a lithograph of the American flag by Jasper Johns, or a ceramic body part by Hannah Wilke, you just gotta be there, in front of it (perhaps in the case of the Serra, actually in it). Real works of art have a pulse that no type of reproduction, no matter how scientifically sophisticated, can create.

The reproduction of a painting (*Cakes*, 1963) by California artist Wayne Thiebaud barely hints at its actual color and rich texture, nor can we get any sense of its size. It is not an advertisement for a bakery; it is a hypnotic multisensory experience.

Staring at a painting (and having it stare back at you) is a real-life, real-time experience. Energy is exchanged. Looking at a digital image, only

Wayne Thiebaud
Cakes, 1963
Oil on canvas
60 × 72 in.
(152.4 × 182.9 cm)
National Gallery of
Art, Washington, DC.
Gift in Honor of the
50th Anniversary of
the National Gallery of
Art from the Collectors
Committee, the 50th
Anniversary Gift
Committee, and The
Circle, with Additional
Support from the Abrams
Family in Memory of
Harry N. Abrams

information is exchanged. No energy. This is abundantly clear when an important painting is being sold at auction, and to prime the pump the auction house has created a huge image of it, perhaps thirty feet or more high, for a banner in their windows. At the same time, there will be a reproduction of the work in a sales catalogue. When the painting itself is being sold, it may appear before the buyers on an easel, and at the same time, a large image of it is projected on a screen behind the auctioneer. Needless to say, these secondhand images may bear only the slightest resemblance to one another, and the actual painting may pale in comparison to the sharp contrast and high color of digital copies.

Beyond shapes and color, what makes an original work of art live is its texture and dimensionality. No matter how smooth or thinly applied, paint on canvas (or indeed on anything—cardboard, plastic, raw wood) is

three-dimensional. Magnify a drawing and you will see the pencil has at the same time depressed the paper and deposited a layer on top. It is not "flat." If we look to see (not just gather information), our eyes sense this texture.

A young man marches up to a painting of Marilyn Monroe, glances at the label, sees the name "Andy Warhol," takes a photograph, and moves on. Not only has he not laid eyes on the painting for more than one-tenth of a second but the image he will take home is no better than any he can find online. And what is he going to do with that image? At the end of the day he may have images of fifty or a hundred works of art. Does he share them with fellow art lovers on Facebook and Instagram? Or is taking a picture merely an exercise in establishing "I was there"? The images in his online photo albums are souvenirs of activities, one of which was a visit to a museum or gallery—or art fair, where picture taking is a blood sport. Would he walk into a restaurant, order a hamburger and fries, take a photo of his meal, and then leave? To me, it is one and the same thing.

There is concern that the ubiquitous use of technology is changing the way that human beings interact with each other, that social exchange (face-to-face encounters) is making way for electronic exchange on every level, and that eventually we will lose the ability to talk to each other (or perhaps that will be a last resort: In Case of Emergency, Use Speech). Whether or not that danger is exaggerated, the increasing use of technology in our relationship with the arts—fine art in particular and modern art especially—threatens to remove any possibility of emotional engagement.

Don't Curb Your Enthusiasm—Share!

Though I would rather not spend my time enjoying art with someone who is super chatty, a big bonus for having really engaged with art (from the great to the truly awful) is the pleasure of sharing the experience. And I don't mean social media photo sharing! I mean the brutal give-and-take of live conversation in real time with an actual person.

If you go with a group or a pal or a spouse, sit down with a coffee or a drink afterward and shoot the breeze about what you liked and why, and,

importantly, what you did not like and why. If you have been together, you don't have to worry about identification or information:

You: Wasn't the Richter fantastic?! I loved the metallic feel of the colors and the sort of sloshing waterfall-ish movement.

Me: Frankly, no. It looked like it was rolled through a giant painting machine. Left me stone cold.

You: I bet you liked the Donald Judd boxes of nothing. So pretentious!

Me: Actually, I did. I find them completely satisfying, each one exactly the same yet each one very different and beautifully made.

You: Yeah, appeals to your obsessive-compulsive side.

Me: Not fair! I loved the Eva Hesse, all that gooey stringy stuff just hanging in the air, made me think of *A Midsummer Night's Dream*.

You: Didn't I say "pretentious"?

Well, you get the drift. It is not about learning but about sharing a passion and, possibly, helping one another to expand horizons as a result of enthusiasm. This is fun for the whole family.

By the time she was twelve, my daughter, Beatrice, had visited a number of major museums in the United States and other countries, but art was not her all-consuming passion. At the fireside one Christmas, I dug out a vintage Parker Brothers board game called *Masterpiece*, which I highly recommend. The cards are all images of works in the permanent collection of the Art Institute of Chicago, and I asked Beatrice to give me her honest reaction to each painting in the deck, just if she liked it or not, and why.

She rejected a mother and child by Mary Cassatt as "inappropriate" because the child is naked, but liked a Jackson Pollock painting because "it looks like pigeon poop and the city." She did not like a Renoir work of a smartly dressed woman and child sitting on a terrace "because the girl is not connecting with the child." *The Herring Net* by Winslow Homer was rejected because "it looks like war" (the fishermen's hats resembled World War II helmets). A portrait by van Gogh was admired ("nice color"), as was a Meindert Hobbema watermill, dubbed "peaceful." A painting by Picasso of his 1950s muse Sylvette David was rejected because "it reminds me of a man with no legs we saw in Spain." A bright Hans Hofmann was

dismissed as "blobby," but a Dutch still life got high marks: "It looks delicious and I am a foodie." *The Assumption of the Virgin* by El Greco got short shrift: "I'm not religious."

Beatrice had no hesitation about being both personal and critical with the images of what she suspected were "famous" paintings. Her attitude about the appropriateness of naked children in art may change as she gets older, but I thought her comment about the Renoir was very astute. Like all of us, she brought her experiences of the world to her perception of these works of art.

While my daughter is naturally honest and direct with her comments, there were two aspects of this exercise that in retrospect I realized encouraged her spontaneity:

1. We were not in a museum.
For many children, going to a museum, particularly a museum devoted to art, implies seriousness and learning. It may have done so for you. If you were with classmates, you were probably admonished to behave, keep quiet, and stay together. A parent or teacher asked, "Do you know who did this?" You were told what to look at and told things about that work of art you were expected to remember.

2. No test.
When I shuffled the cards and asked Beatrice if she would examine them so we could have a discussion, the look on her face was "Oh no—what if I get something wrong?" Once I assured her that the names of the artists were totally irrelevant and all I wanted was her reaction to the images, she relaxed and enjoyed the exercise.

Seeing art with young children is incredibly rewarding if you let them choose and you are prepared to do more listening than talking. My son, Bob, and my granddaughter, Nikita, live in Seattle, and we frequently visit the Seattle Art Museum (SAM), where we head first for whatever special exhibition is on view and then roam galleries that have the permanent

collection we now know well. Well attended but never packed, SAM is the perfect size for wandering. We don't get lost, and it is easy for us to drag each other over to see a work we want to share. Inevitably, we end up congregating in front of West African artist El Anatsui's gorgeous *Takpekpe (Conference)* (2006).

I am very fortunate to have a job that requires me to see art every day and to travel, often with colleagues and clients, to enjoy and talk about art

in museums and galleries around the world. And when I am not work-ing, what do I do? Go to museums and galleries with friends and family! And always, we look and we talk. Often the language is blunt and simple.

Good art scores a direct hit. If your response is genuinely linked to your feelings, you probably don't need fancy talk. As much as I urge you toward mindful, deep, and silent engagement with works of art—just you and the object—I also urge you to engage in the fun of sharing with others what you have seen and felt. It fascinates me that there are so many book clubs consisting of people who enjoy reading the same book and then talking about it (without a "teacher"), and, so far as I know, so few "art clubs" of people who go to see the same painting or artist or exhibition and then just sit around and talk about it.

OPPOSITE
El Anatsui
Takpekpe (Conference),
2006
Metal tops of bottles
of liquor and cans
of evaporated milk,
aluminum, and
copper wire
94½ × 133⅞ in.
(240 × 340 cm)
Seattle Art Museum.
Anonymous gift

REAL CONNOISSEURS ARE NOT SNOBS

∨

Painting is now become the sole object of fashionable care;
the title of connoisseur in art is at present the safest passport into
every fashionable Society; a well-timed shrug, an admiring attitude
and one or two exotic tones of exclamation are sufficient
qualifications for men of low circumstance to curry favour.

—

OLIVER GOLDSMITH

I am well aware that the word "connoisseur" rankles some people. For many it conjures up smug superiority, an entitled, I-know-more-than-you aura of snobbery. I have worked with a few clients like that. When I worked at Christie's, I met a young man of instant fortune with a fairly good collection of auction-bought pictures who made an effort to learn by heart the paragraph or two bolstering each painting in the auction catalogue. When I visited his collection at his home, he would stand in front of a work unembarrassed to recite back to me sentences of strained praise I had frantically limned in the early hours to make my catalogue deadline.

What makes a connoisseur? For one, it is *not* learning what others think or say. I believe the essence of connoisseurship is being confident in your own considered reactions to works of art based on firsthand experience, regardless of the opinion of others. The connoisseur starts and ends with the object. In between there is the fascination of authorship, manufacture, condition, history, and culture, but without extended engagement with the object, the factual knowledge is useless.

Let's get personal. What makes me think I can walk into a gallery, a museum, an art fair, or an auction house with strong instincts for the good, the bad, and the indifferent? It is because I have spent half a century seeing similar objects. Remember, you are not training your eyes to become art dealers (who choose what will sell) or to become museum curators (who choose what may be popular or relevant for others); you are training your eyes selfishly, as a marksman might do, to become a better shot, but not to make a killing.

The first painting by Jean Dubuffet that I saw was in the racks of the gallery where I got my first full-time job at the age of eighteen. It was a good painting and I reacted very positively. My boss had to tell me who the artist was. Within a year or so, I had seen many more, in other galleries and in museums. This experience sharpened my judgment (and greatly increased my pleasure). Decades on, I have seen hundreds of works by Dubuffet in private collections, commercial galleries, public museums, and in major exhibitions devoted to his work. The pleasure I feel when I see a great painting by Dubuffet has been enhanced by having seen so

many others by him. The more you see, the more you feel; and the more you feel, the more you are sure about what you feel.

Caution: connoisseurship as I am discussing it here is not about the monetary value of artworks. As a dealer I may know what different types of works by many modern artists may currently be worth on the market, but that does not make me a connoisseur; it simply makes me a good appraiser.

The Qualities of Art

There are three qualities shared by works of art that inform my always developing sense of connoisseurship:

Mastery of the Medium

Today an artist's tools can be anything from old-fashioned oil paint and pig-bristle brushes to a 3-D printer, but she or he cannot express themselves effectively until they not only know how to use them but have had *a lot* of practice. And I mean a lot, perhaps even Malcolm Gladwell's famous ten thousand hours.

Those of us not trained as artists need only try making a rainbow with watercolors to find out what it means to be unable to control a medium. There is a wonderful short film from 1949 of Pablo Picasso effortlessly painting a vase of flowers on a pane of glass (the camera shooting Picasso through the glass as he works). He mugs at the camera but doesn't miss a stroke, the brush a natural extension of his body and his mind.[68] Skill is not an end in itself, and in the greatest works of art it is an invisible ingredient, absolutely necessary but not so evident as to distract from the whole.

Clarity of Execution

Because Paul Cézanne used negative space ("empty" canvas) as a vital element in many of his compositions, many suppose these are unfinished paintings. The fact is, he delivers only what is required for the painting or

watercolor to work on our feelings. Less is not always more, but the power of a great deal of modern art lies in restraint and fine editing, whether the work has hard straight lines or a jumble of thick impasto. Artists often talk of "knowing when to stop." Artists who do know when to stop, deliver clear statements with maximum impact.

Authority of Expression

The "voice" of a work of art can be very big and loud (literally, like the forty-foot-long cacophony of drums and wheels by the Swiss sculptor Jean Tinguely, *Fatamorgana, Méta-Harmonie IV* [1985], in the Museum Tinguely in Basel) or very quiet, like a subtle pencil drawing by Agnes Martin, but the voice must also have power if it is to resonate. No hems or haws or stammering. It may be that sometimes when you have stood in front of a work of art and decided it didn't "do anything" for you, it was not because of the style or composition or color, but because it had no authority.

The Connoisseur as Detective

Sir Arthur Conan Doyle's Sherlock Holmes debuted in 1887 and still inspires novels, plays, films, and television shows. The fictional detective's great talent for deductive reasoning is well illustrated in the story "The Adventure of the Cardboard Box," in which an unmarried landlady receives a box containing two severed ears. Both are pierced, but Holmes perceives that one is male and one is female. The deduction Holmes makes, which solves the case, is that one of the ears bears a remarkable similarity to that of the landlady and must have belonged to her sister.

Holmes's lesson for us is that he does not approach his work with predetermined information. Recapping this adventure for his sidekick, Dr. Watson, he declares:

> We approached the case, you remember, with an absolutely blank mind, which is always an advantage. We had formed no theories. We were simply there to observe and to draw inferences from our observations.[69]

I did not randomly pick Sherlock Holmes to underscore the importance of the "absolutely blank mind" necessary for connoisseurship. Conan Doyle's use of the "severed ears" plot device has been linked to Doyle's knowledge of the practices of the flamboyant Italian Giovanni Morelli (1816–1891), the father of modern connoisseurship. Morelli championed attention to the visual details of artworks to identify a work's artist; aspects such as the rendering of ears (and fingernails) led him to attribute previously anonymous works to Botticelli and Titian. This was in stark opposition to the documentary methods of the German art historians who reigned at the time. Not unlike some of their academic descendants a hundred years later, these nineteenth-century art historians eschewed looking at the object itself in favor of perusing documentary evidence, such as ancient catalogues and correspondence.

Morelli insisted that connoisseurship is bred "in the gallery and not in the library." He claimed, "the history of art can only be studied properly before the works of art themselves. Books are apt to warp a man's judgment." But he doubted that everyone was capable of his methods: "As in the human eye we discriminate between long and short sight, so among those who study art we find that there are some who have eyes to see, and others whom the most powerful of glasses would not benefit in the slightest degree."[70]

Well known in his time, Morelli influenced not only the creator of Sherlock Holmes, but he impressed the young Sigmund Freud, who considered Morelli's approach to art history similar to his method of psychoanalysis. But just as Holmes's job was to identify the perpetrator of a crime, Morelli's purpose was to identify the creator of a specific work of art or, almost as important for the historical record, where and when it was made.

Since the advent of photography there is much less need for experts of attribution in modern art. No matter how sloppy the records kept by the artist, their spouse, or their dealers, most art of the twentieth and the twenty-first century is correctly identified. At the fringes of the art world, there are issues of forgery, which make exciting reading for people who haunt flea markets searching for works by Jackson Pollock and Picasso.

Few people who bring forward previously unknown works and claim them to be by modern masters do so for the sake of the art historical record. They do so because of the considerable financial rewards should their work be accepted as authentic. But when their claims land in courtrooms, the principal beneficiaries are members of the legal profession. Science is often invoked, but as of yet there is no foolproof scientific method for proving that an object has been made by a specific individual, although it is possible to determine with some precision when a specific object was made.

A while ago, I was approached at an art fair by a determined lady who insisted that she had an unrecorded cubist painting by Georges Braque, which had his fingerprint on the back of the canvas, but she was unable to explain how it was known to be Braque's fingerprint. A work of art either engages you or it doesn't, whether it bears the fingerprints of a celebrated artist or it doesn't. Nothing about the object changes when science, law, or the art market accepts it or rejects it as a genuine Jackson Pollock or Andy Warhol work.

Can one be a connoisseur if one cannot tell the difference between a work by Warhol and Roy Lichtenstein of the early 1960s, the period when both artists made paintings mimicking cartoons? Frankly, I don't give a damn so long as you look at it, and look at it, and look at it again to find out what it does, if it does anything, for you. I don't hand out gold stars for being able to identify a picture or demerits for getting the name wrong, so long as you looked hard enough to actually *see* the work.

The Connoisseur as Critic

The critics I heed either tell me, "It's great, go see (or read or hear) it," or, "Don't waste your time." Why do we pay attention to a favorite critic when it comes to movies, for instance? Is it because they share our taste or because we intuit that they know what they are talking about? Usually a little bit of both.

I was a big fan of the late film critic Roger Ebert, costar with Gene Siskel of the movie review television show *At the Movies*, which always ended with

their thumbs-up/thumbs-down verdicts on recent films. Ebert ignored categories, praised "trash," refused to validate high-minded but poorly made films, and sank a good many really bad films with comments like, "Add it all up, and what you've got here is a waste of good electricity. I'm not talking about the electricity between the actors. I'm talking about the current to the projector."[71] I didn't admire Ebert for his expertise as a film theorist or historian but because he was an intelligent, perceptive viewer who saw more movies in a month than I do in a decade and who called the shots as he saw them.

In the notionally more elevated realm of visual art, what kind of connoisseur is the critic? When I entered the art business, Clement Greenberg (1909–1994) was a powerful art critic, and he would not have demurred at being called a preeminent connoisseur. A paladin of abstract painting, his job was not to assign certain works to this or that great artist of the past, but to anoint this or that living artist as "great." He championed Jackson Pollock and established a method of formal criticism, which he applied to all modern art. He believed that only artists who demonstrated what he theorized as the "flatness of the picture plane" were worthy of his attention.

He had the ear of some noteworthy gallery owners, and his visit to the studio of a young artist was a make-or-break moment. His benediction often resulted in a sold-out exhibition and his failure to comment positively might end a career. Artists like Ellsworth Kelly, Kenneth Noland, and Helen Frankenthaler enjoyed his favorable attention and were not beyond taking very specific advice from him while engaged in making paintings—sometimes altering them according to his suggestions.

In the mid-twentieth-century art world, Greenberg not only coached and championed specific artists but fulminated against all styles of modern art except what he baptized as "post-painterly abstraction," the highest form of art on a sliding scale of his own devising. Many did not listen to Greenberg, and quite a few artists unblessed by him thrived, but for a decade or two he ruled a powerful roost of artists, dealers, curators, and collectors.

Assuming a critical stance toward art moves the connoisseur far beyond determining the origins of a work of art made in the past. It puts the connoisseur in the position of making thumbs-up/thumbs-down judgments about art of the present. But in either role, the connoisseur's authority is based on the assumption that he or she knows more about art than we mere mortals do, and that their knowledge is based on information that we cannot access without further education or experience. The most dogmatic critics may espouse just one type of art and believe it to be more worthy of their attention (and therefore of ours) than other types. Don't listen. Like Holmes, look "with an absolutely blank mind" and, like Ebert, look at everything you possibly can and be honest about what you enjoy. If your partner asks what you liked best in an exhibition, don't be afraid to tell her or him that it was the bathing beauty painted by Pierre-Auguste Renoir and not the abstraction by Piet Mondrian. You are the critic in your engagement with art.

The Connoisseur as Moneybags

Half a century after Clement Greenberg ruled the art world, his style of criticism, even his very role, barely exists. There are theorizers by the dozens, in and out of academia, but few appear on the perennial lists of the art world's "most powerful." Art writers are lucky to get nominal payment for a catalogue essay that will be judged as much for its length and number of illustrations as for its content. Some are more popular than others and have loyal followings, but today there is no scribe whose words of praise or contempt have the power to make or break the reputations of artists, dead or living.

One almighty power drives popularity in the world of living artists, and that is mammon. Our fast-paced digital culture has no time for theory, whether about flat picture planes or postmodern genderism; we have only time for facts, the ones that speak to us the most eloquently are numerical, and the most worshipped numerical facts of all have to do with money, particularly large sums of it.

The reasoning is very simple: historically great art is expensive; therefore, if art is expensive it must be great. Right? Sorry, I barely made it through Philosophy 101, and I do know this to be a logical fallacy, but it is one that, astoundingly, seems to hold water in the business of promoting and selling contemporary art. If a leading gallery launches a young painter and prices his major works at $20,000 each and there are few buyers, the most common strategy is not to lower the price but to double it! Perhaps at $40,000 or $50,000 people will pay attention! This is often a much more effective way of reaching price-conscious collectors than a good review in an art magazine.

When we see a Prada handbag for sale at a low price on the street, we know it must be a knockoff. But luxury goods, whether real estate, cars, or haute couture, do display performance, finish, and, perhaps, hand-manufactured components that works of art do not need to be blessed with. Works of art are purposeless and need not look like anything at all, making it difficult for impatient buyers (investors) to judge whether they are good or bad; all they can suppose is that if the art is too cheap, it can't be very good.

Today a flamboyant breed of investor-collector is looked to by the media for connoisseurship because the sound that their money makes drowns out the fading authority of curators and academics. Jockeying for position on the "power" lists, which are now a staple of every fine art media outlet, these "players" confer laurels on whoever is making a profit for them as they trade works of art by established contemporary artists as well as ones by the recently arrived and the up-and-coming. Profiled in the *New Yorker* in 2015, real estate mogul Aby Rosen was alarmingly frank about his approach to connoisseurship:

> Of his own art collection (Warhol, Basquiat, Koons, Hirst), he said "I'm surprisingly very unattached to those things. I love them, but if you walk into my house and say, "Can I buy it?" Absolutely. It's worth X, you can walk out with it.[72]

Perhaps what this reveals more than anything else is the commodity exchange approach to connoisseurship. Mr. Rosen knows from day to day

what his works of art will fetch in the market, and the potential returns on his investment would appear to trump his love for them.

By now an exasperated reader is saying, "I'm never going to buy art so why does this matter to me?" Well, it should matter, because whether you are conscious of it or not, equating price with quality has so infiltrated the art world that a great deal of work by living artists that is presented to us by museums and galleries as being important or revolutionary or even just new is, in fact, merely expensive. When a painting by a lesser-known artist under the age of thirty-five sells for more than a million dollars at Christie's or Sotheby's, everyone sits up and pays attention—the collectors, the dealers, and museum curators.

There are many living artists whose work has sold publicly for more than $5 million and privately for more than $10 million. Some I like, some I don't, and just a few, a very few, might have permanent spots in the museums of the future. However, there are no artists selling in this price category that are ignored or marginalized by the mainstream art world. In fact, it is virtually impossible for a living artist to be considered important if their work has not sold at auction for impressive amounts, and art that is sold for very high prices becomes, in our monetized wisdom, ipso facto, the best. Surely it only makes sense that artists like Jeff Koons, Damien Hirst, and Gerhard Richter are the best artists of their generation because their work has sold for the highest auction prices. Well, would you judge that the extremely wealthy best-selling author Dan Brown ranks with Leo Tolstoy and Charles Dickens? Put that way, the price/quality axis starts to wobble.

In our culture of highly developed branding and marketing, popularity and price in art are virtually indistinguishable. The art market rewards popularity with high prices, but often both the popularity and the prices are short lived. Today's connoisseur (you) need pay no attention to either popularity or price. It is perfectly acceptable to enjoy what everyone else seems to be talking about but only if it sincerely moves you, not because it is on everyone else's radar. Honesty is a key element in connoisseurship. If you are captivated by a work of art that is no longer in fashion (or perhaps one not yet in fashion or one that never will be in fashion), stay with it, enjoy it, and tell your friends you like it. You might be doing them a favor.

Nevertheless, in today's world, the dollar defines the quality of art, and the fall of the auctioneer's hammer is more powerful than all the critics, curators, and dealers combined. But hey, if you aren't buying, why not ignore all that and become your own connoisseur?

Me? A Connoisseur?

In today's world, a connoisseur of art is not someone who claims to know what is real and what is fake, what is good and what is bad, or what is going up or down in value. Today a connoisseur is someone like you with the curiosity and energy to seek out works of art that give you repeated satisfaction whenever you see them, irrespective of anyone else's opinion. Moreover, you train yourself as a connoisseur by the act of seeing works of art as often as possible. This constant exercise oils the mechanism that produces confident choices.

Real-life, real-time comparison, much more than information, leads to connoisseurship. In any room of a museum or gallery, keep asking yourself, "What do I like the best?" You do not need to know why. You do not need to agree with the majority, you do not need to be "right." You need to be honest, and to be honest you have to see, and to see you have to look hard. And compare. Of course, it's fun to be with someone who agrees or disagrees, so long as you can agree to disagree.

When it comes to modern art, the all-star team is not yet finalized, and the Hall of Fame is always up for revision. Leonardo's *Mona Lisa* was heralded in its time and then languished for two hundred years before enjoying its current adulation. Who knows, it may fade again and be replaced by Warhol's *Campbell's Soup I* (1968) or Picasso's *Guernica* (1937). Don't worry that the works that pop your cork may not be anyone else's hits, either of today or tomorrow.

As a connoisseur-in-training, your job is to compare a work of art with something that looks similar and decide which has the strongest impact on you. Forget what your spouse (or friend) thinks, and forget art history (that takes too long); just decide for yourself. Do you find a painting of a generously proportioned, full-bodied naked woman by Lucian Freud

more moving/intriguing/frightening/arousing/disgusting/beautiful than an equally large female nude by his contemporary Jenny Saville or by his predecessor Pierre-Auguste Renoir? If the decision comes quickly, ask yourself what one says to you that the other does not. How about, "I like Freud's thick paint; it's sticky and suggestive"; or, "Frankly, Renoir's nudes are prettier and I like pretty." When different artists tackle the same subject, discriminating is more straightforward. Marilyn Monroe has become a Mona Lisa for modern artists from Willem de Kooning to Andy Warhol and even Richard Serra. Which artist's Marilyn is your favorite?

Most visits you make to a gallery or museum are going to afford you the opportunity to see a number of works by the same artist, which is a great way of training your eye and your ability to make spontaneous and intuitive choices. Museums love to mount retrospective exhibitions that review the entire career of a well-known artist. Not long ago there was a wonderful Wassily Kandinsky show at the Milwaukee Art Museum from the collection of the Centre Georges Pompidou in Paris. My wife, daughter, and I had the place almost to ourselves one weekday morning, and we experienced the joy of seeing great works side by side.

After starting out together, we each soon found ourselves in different rooms spending time with different pictures, and, of course, we had a spirited conversation afterward about which ones we thought were "the best." Our individual choices were informed by the fact that we had a good selection of top-quality works to enjoy.

Visiting a gallery giving an artist a first solo exhibition is also a fine way to hone your seeing skills. The works of an artist not yet with a "name" and track record offer a perfect opportunity for you to compare and contrast and make your own judgments with no fear of being influenced by market prices or the critical opinions of others (though you may have to tune out some honeyed words if a dealer thinks you might be a buyer).

If you are up for some graduate work in this diploma-free program, go back to the retrospective or to the emerging artist's solo show two or three weeks later, just to find out if the works you liked the most the first time around still "do it" for you. I rarely reread a novel or see a movie twice (by choice), but when it comes to art, I cannot get enough of objects I have

fallen in love with, and when they are in my vicinity, I return again and again to them. I cannot go to Chicago without visiting de Kooning's *Excavation* (1950) at the Art Institute of Chicago, and I swear I see further into it and more of it every time.

But It's In a Museum, So It Must Be Good!

I would like to take you through the storage rooms of virtually any museum older than fifty years and show you the "great treasures" gathering dust on dimly lit shelves and sliding racks, works that were once proudly exhibited and may never again hang in public spaces. Museums that own art (as opposed to institutions devoted solely to exhibitions) acquire by purchase and by donation. Its acquisition reflects the taste of the time when the work is purchased or accepted as a gift.

Museums are organic and constantly evolving. A distinguished museum like the Metropolitan Museum of Art in New York or the National Gallery in London may have a top 20–30 percent of its collection permanently on view from generation to generation, works of art that have been blessed by history, are popular with visitors, and are sustained by their inherent quality. Directors or curators of the future may well decide to consign some of these works to the basement if their popularity is waning, or for any number of less compelling reasons. Many works regularly on view as part of the permanent collection of the Museum of Modern Art in New York when I first saw them in 1964 would be unfamiliar to today's visitors, although, because I am a nostalgic old fogy, I gravitate back to the works that I first laid eyes on when I was seventeen that are still available for me to enjoy today.

In the early years of the twentieth century, many major works by Victorian painters once considered great, like John Frederick Herring, Sr., Frederic, Lord Leighton, and Lawrence Alma-Tadema, found themselves in museum storage, some to be resurrected temporarily for thematic exhibitions, but never again restored to permanent glory.

Sir Nicholas Penny, director of London's National Gallery, observes:

> There seems to be a belief that the reputations of artists in museums will never be challenged. This is a valuable myth for the market. It may be that once a certain amount of public money has been invested in art it will be valued forever. But I doubt it.[73]

We should be mindful of the "market" in this context. Wealthy contemporary art collectors invest in artists, not single artworks, and aim to reinforce their investment in an artist's body of work by donating individual pieces by that artist to a museum. Major museums do not accept works uncritically, but curators, as much as any of the rest of us in the art world, cannot help but be influenced by the collective positive opinion of a specific artist, even if it is wholly or partially the product of a branding strategy.

Sir Penny is convinced that the jury is still out for much of what passes for important (currently fashionable) contemporary art, but nevertheless understands that the museum has an obligation to present new art: "We are actually very keen that we do not collect such work. But, equally, we are very keen to exhibit it."[74] By exhibiting it, he gives you and me the opportunity to see modern art in the same building, and sometimes cheek by jowl with works by Rembrandt, Raphael, Titian, and Leonardo. This is a wonderful opportunity for us and a great challenge for today's artists. Can a work by Roy Lichtenstein hang next to one by Cézanne? Is it as deeply expressive? As rich in nuance? Does it hold our attention as long? Possibly yes. When we see a painted bronze sculpture of Kate Moss by Marc Quinn next to Auguste Rodin's marble *Danaïd*, is the Quinn elevated or diminished?

One of the most unfortunate consequences of art branding is that while we allow a star actor or actress to make a perfectly awful movie from time to time, we have a tendency to fawn over every single object produced by Picasso or Pollock or Warhol, even though, in their fairly long, hardworking lives, each produced a fair number of mediocre works of art. The strongest Cubist painting by Juan Gris is far better than many not-so-successful Cubist paintings by Picasso, but the name "Picasso" alone is enough to ensure the public's greater attention.

Once again, your job as a connoisseur is to ignore the branding and just see the work itself. Your local museum might be advertising itself with big names, but the top-quality works available for you to view might in fact be by artists with less name recognition. You will only find them by seeing the paintings, not by reading the labels. In their constant effort to boost attendance, museums compete by promoting their current exhibitions, and these may well bring wonderful works of art to your town or city, but in so doing, these museums often neglect to advertise their permanent collections, which can include treasures worth visiting and revisiting, as well as works by local artists in danger of being taken for granted in their own communities. The next time you visit a special exhibition at any museum, take time to wander around the permanent collection. By the same token, if you are a tourist visiting famous works of art in an overseas museum, take the time to meander through the less crowded galleries and try to make at least one interesting find of any kind of art of any period.

Remember, you are part of the current of history that elevates works of art. Your opinion matters.

Trusting Your Eye

Findlay's Theory of Relativity

Findlay's Theory of Relativity states that one's natural ability to make confident personal judgments about art is in direct proportion to time spent seeing and comparing real works of art that bear visual similarities to each other. I emphasize visual similarities. Forget artist, date, or nationality, and definitely forget isms.

If you follow my advice, the tastes you have now may well change and possibly expand. If you have no definite tastes, I guarantee you will enjoy discovering them. If you take a serious interest in the work of a specific artist, or a type of art, and look at everything you can see of that type of art or by that artist (and avoid Googling or reading about them); and if you allow your preferences to rise to the surface, unbiased by the opinion of others, then you will develop a personal hierarchy of taste. This may not

be so different from that of the majority. However, you will have judged the quality of that work for yourself and will have reached on your own the conclusion that others also have reached, that the work is, simply, the best of the best. Conversely, you might find yourself greatly moved by a work that most others are ignoring. That does not make you wrong.

When we are actively engaged in seeing works of art and comparing one with another, it is not easy to ignore other people's opinions, whether heard or read. The way that a curator installs an exhibition will often affect our opinion of the art, even if the curator's opinion is not obviously stated by the ubiquitous wall labels.

Audio guides preselect and reinforce an established opinion about which works deserve most of your attention. Likewise, gallery lecturers tend to choose the popular works to discuss, the ones for which they have a well-rehearsed, entertaining talk. I mentioned in Chapter One that the same standard-bearers are reproduced over and over in art history surveys, and this clouds our objectivity. When we run into one of those in a museum, our recognition of it elevates the piece above its neighbors, although the reason that specific work is reproduced so frequently may have less to do with any particular quality of the work itself than with photography of it being available, and affordable, for reproduction. Our brain absorbs and stores much more about what we see than we think we can remember. I make no claims to be an infallible lie detector when it comes to fakes, but after a lifetime of enjoying several hundred paintings by Henri Matisse, my eyes register a "wrong" one long before I am able to articulate the exact reasons I think it problematic. Many other art dealers have the same experience in their various fields. They sense problems right away and that intuition provokes the research or testing that may prove the eye to have been correct.

When you have the opportunity to see a solo exhibition of an artist whose work attracts you, ideally a retrospective that covers many works from different periods of their career, I urge you to try an unconventional approach. Curators tend to install such exhibitions chronologically to impose a neat linear perspective on the artist's output. They also like to produce time lines, in which works of art are paralleled with a narrative of the artist's

life, thus creating a comprehensible "explanation" of the work. An example of this was an exhibition at the Tate Modern, London, in 2010 called *Joan Miró: The Ladder of Escape*, which included many magnificent works, all of them, according to the signage, inspired by the artist's commitment to social ideals, as if Joan Miró's activity in the studio were a by-product of his politics.

To subvert this type of curatorial storytelling, walk through the exhibition slowly, from start to finish, look at all the walls and pause only to take note of works that beckon you. When you get to the end of the exhibition, which usually will present works made late or at least later in the artist's life, look around the gallery to see which works pique your interest. Late work can be good, bad, or indifferent, depending on the artist. My theory is that if the artist lived a long, full life, late works can be among the most interesting because the artist may have had nothing to prove and could reach for the stars.

As you walk back toward the beginning of the exhibition, look for the works that caught your eye as you first passed through and spend some minutes with each one. Remain focused on the ones you like, remembering that you don't have to see everything—there will be no exam. When you reach the start of the show, go back once more through the galleries and pick the two or three (or more) works that *really* speak to you and look at them again, intensely. By this point, it should become obvious to you not only what you like but, to a degree, and perhaps not in words, why you like it. I promise you this process will not take any more time than if you shuffle along on the audio guide conveyor belt with the other visitors. Following my way, instead of learning about the politics or the love life of the artist, you can enjoy what he or she made expressly for you.

What matters for you, as a connoisseur, is that you can absorb, compare, and make choices based on your fully informed senses. This is how we form our taste. Which work of art rings your bell? That is what matters, but to arrive at an opinion, to be delighted, you have to see all of the works "live." Two paintings that seem similar when juxtaposed at the same size on a glossy printed page may, in fact, look totally different when they appear together on a wall.

I get a great deal of stimulation from exhibitions of artworks collected by an individual or a couple, especially if the collection was assembled over a long period. A great example may be seen at the Barnes Foundation in Philadelphia, where the collection of the fascinating and eccentric Albert C. Barnes may be viewed, still shown more or less in the same highly eclectic manner that he installed it at the original home of his foundation in the Merion suburb of Philadelphia.

Barnes's taste ranged widely and his installation follows no neat rules of style or chronology. Masterpieces by Paul Gauguin and Vincent van Gogh are hung next to works by early-twentieth-century American artists like Horace Pippin and Charles Demuth. A masterpiece by Georges Seurat hangs above a masterpiece by Cézanne, and you may find, sandwiched between a Matisse work and a Renoir work, an eighteenth-century German door knocker, as well as jewelry, antiquities, textiles, and Middle Eastern and Native American artifacts—all the result of a collecting career extending from 1910 to 1951. Colors collide and patterns emerge as our eyes quickly adjust to the apparent confusion, and not only do we enjoy the similarities and differences between paintings from different times and cultures, but we instinctively make personal choices and judgments. I find this far more exciting than a plodding soup-to-nuts academic exhibition that proposes to "tell a story."

This method can be used to navigate almost any major museum. The Metropolitan Museum of Art in New York, for example, is justifiably proud of its Jacques and Natasha Gelman Collection, a tribute to the couple's amazing collection of twentieth-century paintings. After visiting these galleries, you might visit the stunningly beautiful galleries devoted to Islamic art that include carpets, textiles, and ceramics; then conclude your visit with a stroll through the glorious sculptures of the Greek and Roman galleries. What a feast! You can let your eyes think for you. The works of art you will have viewed may be of different "species" from an art historical point of view, but all masterpieces have the power to move us if we allow ourselves to engage and react emotionally. Practicing engagement and trusting the sincerity of your reactions breeds the confidence

of connoisseurship. Whether or not all, many, or none others share the tastes that you develop is immaterial. You cannot be wrong.

If I were to say that one's judgment improves the more one is exposed to modern art, I would imply that there is an accepted canon of quality. To some degree, the jury is out (the jury being history). The most popular art today might well be consigned to what Leon Trotsky called "the dust-bins of history." The great art of the past that we now revere (and enjoy) has endured beyond the times and places when it was first made and seen because some aspects of it continue to speak eloquently to us today. As for the art of our own era, you and I know only what we like and dislike; we have no crystal ball; and if you are making no investment except your time, you need not be concerned by what may or may not interest your great-great-grandchildren.

Although my judgments about what is "good" and "bad" art may differ from yours, perhaps radically, your opinions are just as valid as mine so long as they are based on the evidence of your feelings, experienced when honestly engaging with art for a decent length of time.

Many art theorists scorn the use of words as blunt as "good" and "bad" about modern art, but I can't help it. Bad modern art is everything that strikes me as lazy, low-energy, offhand, or flippant, no matter how seemingly radical or innovative (and I do like radical and innovative), such as the work of Pavel Tchelitchew, who made a huge but short-lived splash in the mid-twentieth century with skillful but shallow (just my opinion) works. Strangely, some of the most successful emerging artists are the most conservative, producing conventional abstract or figurative easel paintings, which to me differ little in appearance from works made by pioneering artists up to fifty years ago. The patrons snapping up the new (but possibly not improved) versions either don't know or don't care about the antecedents, which in any case lack the glamour, hype, and "now" narrative that (briefly) makes the lazy daubs of a frowning shirtless twenty-something into a tangible asset. Artists pushing the envelope often work in ways that do not lend themselves so easily to investment, such as Heman Chong, whose work encompasses storytelling, installations, and video as well as

painting, printmaking, and objects. A lot of his practice has no investment potential and is subsidized by institutions.

Chong's *God Bless Diana* (2000–4) functioned as a stand-alone postcard store, on the grounds of a museum, which was stocked with 550 different postcards of images of urban life, selected and grouped by the artist. Each card is considered a work of art and is available for purchase at modest cost. The press release for the exhibition indicated that Chong was presenting "the world as the artist's studio, and his audience as fellow travelers." At first we might wonder how we could possibly relate this type of artwork to any other—what happens to Findlay's Theory of Relativity with something so new, so radical, so far out? To what can we compare it? Well, since Chong is duplicating an activity familiar to most of us (buying postcards in a museum shop), do we feel the same as if we were doing it in real life?

Wait a minute, we are doing it in real life. But this is a work of art. Or is it?

Many of the most interesting and amazing works of modern art are created outside of the market system (a system fueled by auction price search

engines promoting the theory of financial relativity), and we can experience them without being influenced by what (presumably sane) people will pay for them. Some, like Robert Smithson's *Spiral Jetty* (1970) or Walter De Maria's *Lightning Field* (1977), harness environmental phenomena and deserve to be compared with other features of Mother Nature, tamed or untamed, rather than with anything seen in or outside a museum. On a much more discreet scale, but for forty years, Charles Simonds has been creating tiny structures made predominantly of clay, placing them inconspicuously in cities around the world as dwelling places for a mythical race of Little People. If you find one, there is no label, no audio guide, no waiting in line to buy a ticket, no gallery talk, nothing for you to do but take it in and perhaps make a note to stop by that street again.

To really enjoy modern art takes time and practice, like riding a bike or swimming, but once you get it, the pleasure is forever. We do, however, have to overcome a cultural bias in favor of expert opinion. There are many aspects of our daily lives—financial and medical, perhaps, or, in my case, cooking and driving—that require us to defer to those we deem experts. When it comes to modern art, I say, do it yourself. You do not need to listen or read (except this book, of course!), you only need to see. Entering the world of modern art requires the same two main ingredients as riding a bike and swimming (not to mention cooking and driving): skill and confidence.

I have outlined the skills; what you need to bring is the confidence. Some of us remember that moment when we rode our bicycle all the way to the bottom of the road, came to a stop, and realized that our Mom or Dad was not holding the back of the seat but was standing proudly at the top of the driveway. The equivalent of that moment in the process of learning to see art happens in a museum or gallery when you, after having spent twenty minutes with a work by an artist (living or not) you have never heard of, say to yourself, "This is terrific! I really like it." Then your friend (who took art history) arrives, takes a quick look around, wrinkles her nose, and says, "Oh god, this stuff is awful, let's go next door and see the (insert artist name) show everyone is talking about." But you surprise her (and yourself) by saying, "Take another look, I like this a lot. See this one over here . . . ?"

It does not matter that the artist in the next gallery goes on being famous and "your" artist never makes it out of the art market starting gate. What matters is that you are exercising your critical judgment, and not only are you confident that you are right (you know you like the work), but you are confident enough to grab your friend's elbow and persuade her to look twice.

Looking Critically at Art We Think We Know

When we are drawn to a work in a museum, we may recognize the artist. As an eager student of my method, you may have avoided looking at the wall signage beside this work, but you nevertheless can tell that it is a painting by Francis Bacon.

Immediately some fragments of information about Bacon crowd your mind—he was English (or Irish?); he drank; he was gay. Something by him just sold for more than a hundred million dollars. Your memory hints he is famous for painting portraits and popes, so you think that perhaps what you are seeing isn't a typical Bacon work. Half true or not, none of that information floating around in your head is doing anything except distracting you from what Mr. Bacon labored (perhaps long and hard) to deliver for the attention of your senses.

There was an excellent exhibition at the Museum of Modern Art in New York in 1996 called *Picasso and Portraiture*. I was invited to the opening and made an effort to get there early so I could actually see some of the works before the chatter started. After passing through the first couple of galleries, I glimpsed through the entrance of a gallery ahead and saw six or seven people staring intently at a wall that was outside my field of vision. I was intrigued to know what great masterpiece they were all staring at with such silent attention.

When I made it to that gallery, I was surprised to see they had not been looking at a painting by Picasso, but had been staring at a wall of text and photographs detailing the chronology of the artist's various wives and mistresses. For many of us, in or out of the art world, information is easier to take in than visual experience.

Can you stand in front of a painting that you know is by Picasso and engage with just the painting? Can you imagine caring only about what you see, not who created what you see? When we say to ourselves "that is a Picasso" or "that is a Magritte," we are already tipping the balance away from enjoying the work toward taking pride in our education or knowledge. After all, Picasso did not wake up one morning and say to himself, "I am going to paint a Picasso." He got up with an image in his head and ideas about how to put that down in whatever medium came to hand, and the result is an object you and I can fully engage with and enjoy for what it is in and of itself, totally detached from its many possible classifications.

One irony of a figurative artist becoming famous is that the subjects they choose to paint often become famous as well, even though for the artist they may simply have been useful subjects. All his life, Picasso painted portraits of women, but did he do this to immortalize them as individuals or because they both inspired him and were at his beck and call? Sometimes he painted what appear to be composite portraits, particularly when he had overlapping love interests, and art historians (and art dealers, I must confess) take pride in deconstructing these and theorizing about which part fits which woman. Does it matter? Do I have to know how a great building was made to enjoy its beauty?

The British painter Lucian Freud's principal subjects were men and women of his acquaintance, many of them distinguished only because they were briefly lying or sitting in front of him. Some were family members, some close friends, but others were encountered casually and never saw him again after having been paid to sit. We see these people through Freud's eyes. He presents us with visual excitement and drama that completely transcend any of the sitter's biographical details. While Picasso rarely titled his works, Freud (like James McNeill Whistler) used impersonal titles such as *Man in Blue Tie* rather than *Brigadier Andrew Henry Parker Bowles* OBE.

To engage critically with art that we think we know, we must try to forget the facts, and the best way to do so is to examine the art slowly and for quite a few minutes, describing it to ourselves, with or without words.

Allow ourselves to see the lines, the colors, and the shapes, and once we have engaged with what we are seeing, we can concentrate on what that conjures within us.

One of the hardest things to forget is having been told that you are in the presence of a masterpiece, or of a poor example, or a typical, or atypical, one. What if you know that it has been crowned as being "iconic" and you don't like it? Bravo! This is how you become your own connoisseur, having gained the courage to disagree with received opinions, particularly those you would have heard if you wimped out and used the audio guide.

Looking Critically at Art We Don't Know

Museums chase big-money donors, and a lot of big-money donors chase the next new thing in art, so it is increasingly the case that museums are exhibiting the next new thing. When a critic accused the Museum of Modern Art in New York of becoming "a business-driven carnival," its director defended its willingness to embrace art "that is increasingly interactive and pop-culture infused."[75] An example might be the actress Tilda Swinton displayed inside a large glass vitrine, appearing to be asleep. Titled *The Maybe* (2013), this piece is attributed to sculptor Cornelia Parker, although it is described as being "conceived" by Swinton herself.

Encountering such a work in a museum, some visitors might be afraid to dislike it because that might mean being unhip, and others may be afraid to like it because it might not be art. How should one approach new, strange, are-you-sure-that's-art art? Exactly the same way I ask you to approach more obviously conventional painting, drawing, or sculpture—slowly and carefully. Art writer Jed Perl skewers "laissez-faire aesthetics," which he defines as the belief that "any experience that anyone has with a work of art is equal to any other," which, he says, leads to an "anything goes" aesthetic on the part of the artist (and/or "conceiver") and very slack critical judgment by the public. Perl suggests that the contemplation of art should be "intimate, incremental, and solitary."[76] Try that when you are three-deep in a crowd around a movie star in a box or squeezed between

underpaid naked performers at the same Museum of Modern Art when viewing the 2010 exhibition of the performance artist Marina Abramović.

I believe that we should treat all art the same way. Just because some artists are experimenting with new mediums does not mean we should abandon our natural instinct for critical judgment. With *Ulysses* and *Finnegans Wake*, James Joyce revolutionized English literature, but we still read them as we read any book, from start to finish, word by word. As for art becoming "increasingly interactive," I believe *all* art is interactive; it does not exist without acting upon us and us acting upon it. When we encounter what appears new and strange in a gallery or museum, the temptation to seek information is very strong indeed. Resist the label! Engage and interact.

Perhaps the greatest waste of our time is when we glance at a work in a museum and we think we know who did it. I have observed others (and myself, I have to admit) doing this. A couple approaches a painting and the man whispers "Pollock" to his female companion who looks at him admiringly. Then she reads the label and shakes her head. He looks angry, shrugs, and walks to the next painting. Opportunity lost.

Let's be honest, if we recognize the artist, we want to read the label to find out if we are "right," and if we don't recognize the artist, we are convinced that we need at least to know the artist's name in order to look at the work.

Sally Smith
Untitled, 2014
Acrylic on canvas
71½ × 89⅜ in.
(181.5 × 227 cm)

A big painting of a red circle on a black ground catches our eye and we wander over to it. We read the label. It tells us a young American artist whom we never heard of recently made the work. We look back at the painting. Is there more to think about now that we have some information? Do we wonder what a young American woman might be "trying to say," as art educators often put it? Suddenly a young man with a badge on a lanyard pushes in front of us with a mumbled apology, peels off the label, and replaces it with another.

Jiro Yosihara
Red Circle on Black,
1965
Acrylic on canvas
71½ × 89⅜ in.
(181.5 × 227 cm)
Hyōgo Prefectural
Museum of Art,
Kobe, Japan

So, is the painting different now? Does it look "Japanese," perhaps? More important? Older? Possibly not. We really don't need the label, unless to tell a friend what it was we liked so much or to look for more work by an artist we have discovered for ourselves. If we don't recognize the artist, we are a step further towards having a genuinely personal opinion about the work. But it is not only the label that can influence our opinion but also the venue and context. The status of the museum or gallery we are visiting may enhance or reduce the perceived importance of what we are looking at. If we are wandering around an auction house or an art fair, a sales estimate or price may also exert a strong influence, particularly if we equate expensive art with great art.

Let's say you see something that intrigues you at first, but after staring at it for a while, it engages you less and less. The name on the label means nothing, so you move on. The next day, to your chagrin, you read that the artist is going to have an exhibition at a well-known museum and has been reviewed favorably in the *Wall Street Journal*. Were you wrong? Heck no! Are you right and the *Wall Street Journal* wrong? Neither. There is simply a fundamental disagreement about a highly subjective issue. There are plenty of people who do not like Mark Rothko's work—perhaps you are one of them—and they have looked at it long and hard. I do not share their opinion, but they are entitled to it.

I have looked carefully at paintings by Rothko and I do not like them.
Fair enough.

I have looked carefully at paintings by Rothko; I do not like them, and he is a bad artist.
I respectfully disagree, for me he is not only a good artist but a great artist.

I have looked carefully at paintings by Rothko; I do not like them, he is an uninteresting artist, and he will probably be forgotten in fifty years.
In my opinion unlikely but not impossible, and besides, I am enjoying this particular work a lot today and so are many other people and that is, frankly, all that matters.

If you are an octogenarian, you might have wandered into the Betty Parsons Gallery on East Fifty-Seventh Street in New York City in March 1948 to find an exhibition of the forty-five-year-old Mark Rothko's new paintings. You might have been more impressed than the *New York Times* reviewer Sam Hunter, whose four-sentence review dismissed the work as "an impasse of empty formlessness, an art solely of transitions without beginning, middle or end."[77] Or perhaps you read the review and decided to skip the show. There were none of today's "tells" to gold-star Rothko's work at that time. Reviews were mixed. Betty Parsons was a young woman of private means in a business dominated by older men. In those bygone days before artworks became luxury goods, the relatively modest prices

would have given a visitor, had they enquired, no clue that the artist was destined for world record stardom in the financial stakes.

In fact, it is very difficult to encounter "unknown artists" today unless we are pioneers taking studio detours off the eight-lane art world highway. The marketing system employed by auction houses, art fairs, and even galleries is geared to ensure that if you haven't heard of the next wunderkind, you are late to the game. An artist who is new to the general public is anointed an "emerging" artist, but having selected a likely candidate (sociable and photogenic doesn't hurt), the system likes to ensure that such an artist emerges with plenty of fanfare, which may include but is not limited to blog posts, spreads in glossy magazines, and pre-exhibition purchases by celebrity collectors. To achieve the goal that no mere civilians (non-buyers) get to see the work in a neutral atmosphere, the air must be heavily scented with positive hype.

Let's move away from the gilded salons of New York, London, Paris, and Beijing. You find yourself in a small local art gallery in a midsize city at an exhibition of "new talent." What are the rules? No different than if you are at the Metropolitan Museum of Art. First, take your time. Glance around and wait for one or another object to come to you. If one does, go and look at it for a few minutes. The less you know about the artist the better, and that includes age, gender, race, and nationality. And pay no attention to what the artist says about their own work. Yes, I mean it.

The Artist Speaks: Should We Listen?

If we engage with the work of an artist carefully and decide we dislike it or are indifferent to it, what the artist may wish to tell us about the work is irrelevant. If we enjoy the work, on the other hand, and the artist, by way of press release or interviews, publicizes his opinion about his work, surely we need to read that to find out if we are enjoying it for the right reasons, i.e., are we getting what the artist tells us she or he is giving?

No—the artist's view is totally irrelevant. Why? Because good artists tell us what they want with their art, not with press releases or interviews. (OK, there probably is some conceptual or performance artist somewhere

whose work consists of press releases and interviews, but you are on your own with that one.) I have been lucky to know a number of very talented artists over a fairly long period of time and with one or two of them I have in fact discussed specific works by them at different points in time, often decades apart. They do not always say the same thing about a given work. An artist's statement about a painting she has just finished may be quite different from what she says about the same painting twenty or thirty years later. This does not mean she is untruthful. It means that she has a subjective opinion about her own creations and, being subjective, that opinion may change as she changes. What does not change is the artwork.

Many artists produce statements out of dire necessity for grant applications or because their galleries insist on a text for a catalogue. Artists who enjoy writing about their own art may be illuminating, but we should be particularly wary of an artist who claims to have developed new, all-encompassing life theories such as the highly successful Takashi Murakami, who has apparently invented "superflat" art:

> The world of the future might be like Japan is today—Superflat. Society, customs, art, culture: all are extremely two-dimensional . . . Superflat is an original concept that links the past with the present and the future.[78]

There are also artists eloquent about art itself while making no claims for their own. The father of abstraction, Wassily Kandinsky, once said:

> The true work of art is born from the Artist: a mysterious, enigmatic, and mystical creation. It detaches itself from him, it acquires an autonomous life, becomes a personality, an independent subject, animated with spiritual breath, the living subject of a real existence of being.[79]

Kandinsky divorces the work of art from its maker so that we can absorb a painting by itself, for example, as something independent, made by Kandinsky but not "a Kandinsky," a work we can enjoy on its own terms— unbranded, so to speak. Artists' statements about their processes are the least helpful for me, perhaps because I am only interested in the finished product.

There is a crop of relatively young artists today who enjoy boasting about their lack of skill and reliance on technology. Wade Guyton eschews brush and paint in favor of ink-jet printers and flatbed scanners, yet to me his work just seems flat (superflat?) and stale. "I hated art as a kid," Guyton has said, boasting about winning a school competition by submitting a drawing done by his father: "That's why I don't draw now and why I use the printer (laughs) . . . I got so bored. It was too much work. I could just type into the computer and the printer did a better job."[80]

Wise artists are able to satisfy their fans' hunger for words with statements so gnomic they are as open to any interpretation as their art: "Take an object. Do something to it. Do something else to it," said Jasper Johns. However, artists lacking skill and imagination can leave us hungry for information that will help us understand what we see. If we engage a work and that hunger remains, the failure is in the work, not us.

The work of an accomplished artist is the only story that matters. There should be no need of meanings and explanations from the artist (or anyone else, for that matter). This does not mean that we will absorb everything about the work instantly—far from it. Deep engagement may be required and will be well rewarded.

I Don't Know Much About Art But I Know What I Like

To be honest, I have never quite understood this statement. I suspect that "but I know what I like" is meant as a rallying cry for those who dismiss modern art as either fraudulent or intentionally abstruse, as opposed to notionally more palatable images such as sunsets and kittens (and let me go on record that I am not against either unless painted on black velvet).

Knowing what we like is very important. In fact, the purpose of this book is to inspire confidence in your own taste. When someone tells me they "don't know much about art," I suspect they are implying that they "don't have the time and inclination to get to know art"; or worse, they are insinuating that "knowing about modern art is an elitist affectation."

Of course, if you have read this far, you realize that the villain in the original statement is the word "know," and while there are many versions of this anonymous quote, they all include the words "know about art." Let's think for a minute. Why do we rarely, if ever hear:

> I don't know much about music but I know what I like.
> I don't know much about movies but I know what I like.
> I don't know much about writing but I know what I like.

In our culture it is possible to read books, listen to music, and go to the movies, and, without the benefit of reading a text or taking a course, feel comfortable if not confident about one's taste. This comfort level often includes being able to talk about what we like with others who share our tastes and to argue with those who do not. I devour every book by John Banville as it appears, but I have no desire to study his work in an educational setting, as I am sure some people do. I like John Coltrane and Thelonious Monk, but I have not the remotest grasp of their technical innovations. If I can simply enjoy *Giant Steps* by Trane (see, I am even comfortable using his nickname), why can't I simply enjoy more or less contemporaneous paintings by Jackson Pollock and Clyfford Still in the same way? I don't need a jazz critic to tell me that I prefer one track to another any more than you need an art critic (or a museum curator) to tell you that one painting by Pollock is more important (to whom?) than another. Going into a museum and only looking at the paintings that have audio guide symbols on their wall labels is like buying an album and only playing the tracks that the person who wrote the liner notes asterisked.

We can be a discerning audience for modern literature, music, film, opera, dance, theater, and everything in between without knowing anything about them other than perhaps the names of the authors and performers. Modern art is no different, I promise. If you enjoy being a philistine and don't want to join those of us with pointy heads, you could say: "I don't know much about modern art, but I look at it carefully and I know what I like."

How Do I Know If What I Like
Is Any Good?

The answer is you don't and it doesn't matter unless you are a buyer. Of course, we all like to pick the Oscar winner, so if you fall in love with the work of an unknown young artist who later becomes the darling of the art world or even, heaven knows, the subject of a retrospective at the Museum of Modern Art, you will have the great satisfaction that many other people eventually came to share your taste. Of course, in another twenty years that artist may be old hat, held in contempt, almost forgotten. Will that mean you were wrong?

Diversion: I had a wonderful friend and client named Elaine Dannheisser, who bought challenging new art in the 1970s and 1980s the old-fashioned way (she bought what she liked). She could never forget that I had suggested she consider the work of German artist Joseph Beuys before he was well known in the United States. If we met at a party, she never failed to mention that "Michael told me to buy Beuys, I should have listened. . . ." In fact, she did eventually listen, but when we first met she simply didn't like his work. That does not mean she made a mistake. In 1997 she gave her collection of contemporary art to the Museum of Modern Art in New York; at the time, it was described as "one of the largest and most significant gifts of art in the museum's history," and it included works by Beuys to join his *Sled* (1969), which I sold to the museum in 1970.[81]

In the context of good art and bad art, with regard to my definition of connoisseurship, you can only be "wrong" if you let the opinion of others trump the conclusions, albeit highly subjective, that you reach as a result of your own careful and genuine engagement with works of art. By all means, listen to the buzz, learn what is hot and what is not, and go see what everyone is talking about. But have the self-confidence and clarity of the child who knew the Emperor was naked, even if you don't shout it from the back of a crowded gallery.

I firmly believe that even in a world of contemporary art defined by theorists as post-post-postmodern, we can and, in fact, must be able to use the

words "good" and "bad" as well as "brilliant" and "mediocre." Judgments on quality should not be sidelined by questioning an artwork's adherence to some abstract principle of philosophy or the current state of political correctness.

I have to admit that it is not always easy to resist the hype that elevates and supports the work of some of today's most popular living artists, especially when their names and imagery are drummed into the public consciousness with the same professionalism and persistence that drives Lady Gaga's publicity machine. At the beginning of the book, I mentioned Jeff Koons's crowd-pleasing show at the Whitney Museum of American Art in New York in 2014, which was accompanied by an avalanche of mostly positive commentary. Jed Perl, though, took exception to the gale force that might sweep "average museumgoers" into thinking something must be wrong with them if they did not like works that Perl himself found sadly lacking:

> Must it be appreciated simply because it exists (and sells for so much money)? And where does this leave the average museumgoer, whoever that mythical being might be, who has been told even before walking through the doors of the Whitney that whatever scruples he or she has are suspect?[82]

Although I disagree that "the average museumgoer" is a mythical being, I am one hundred percent with Perl for challenging the hype that disenfranchises our personal judgment. Art is good if it moves you. Art is not good (for you) if it leaves you cold. If someone else's opinion or the high esteem of the marketplace can make you hot about a work of art or an artist, then you have failed these lessons and should go back to the beginning of this book.

Familiarity Breeds Good Judgment

It amazes me that so many people I know who are movers and shakers in the art world spend so little time looking at works of art. Sounds crazy, but it is absolutely true. Many of us feel it is important to be seen (at openings,

dinner parties, art fairs, and auctions) but fail to understand the importance of *seeing* what we sell, buy, curate, and support.

In almost any community with people of means, there are those who are attracted by the social cachet of attending special events at museums and galleries, but I find it all but impossible to practice any of the principles in this book with a glass of wine in my hand in a crowd of people, with many of whom I am obliged to chat. At most openings I have ever attended someone always says, "Of course, we have to come back and really see the show," but how often do they?

Although I spent sixteen years working at Christie's, I still cannot quite grasp why major evening auctions are mostly packed with people *who never buy or sell anything.* They are the watchers. They spend up to two hours watching a smattering of people they may or may not recognize bidding "in the room," and even more auction house employees bidding "on the telephone" on behalf of anonymous collectors around the world. A few large works are on the walls of the salesroom during the auction, others come up on a turntable next to the auctioneer, seen clearly only by the people in the front rows. Most of the artworks are absent and sold "as viewed" and remain unseen as their fate is decided.[83]

To be fair, bidders and some of the watchers have seen the works prior to the sale during the very brief preview exhibition period and so have had the chance to form their opinions, but do they need to be present at the sale? They could follow the auction in real time (and also bid) on the Internet from anywhere, even the comfort of their home, and some journalists at the auctions tweet results in real time as well as guesses as to the buyers and sellers. OK, I'll admit it can be compelling to be present when one hundred million dollars is being spent, even if you have no idea who is spending it and barely glimpse what they are spending it on.

What if instead of becoming a regular on the party-and-auction-and-art-fair circuit, you simply want to be a museum- and gallery-going art lover, curious about modern art and enthusiastic about art being made today? What do you do after having read this book? Simple, you spend as much time as possible in museums and galleries. If there are none where you live, then plan domestic or international travel accordingly, and when

planning ahead to visit museums in larger cities, do not neglect to seek out commercial galleries there as well, because that is where you may see interesting and challenging work by artists you do not know.

If you are lucky enough to live in or near a city that does have a museum of contemporary art, or a space that regularly shows contemporary art, I urge you to go often and challenge yourself by aiming for some of the artworks you think hold no interest for you. And if there are galleries in your town that present recent art, you do not have to be a buyer to become a frequent visitor. Let your eyes do the thinking, not your brain, and you will find your taste changing, possibly broadening, and your judgments becoming more firmly based on visual experience rather than the opinions of others or your own prejudices.

A work of art is different every time we see it, not because it changes but because we change, and the extent to which it "speaks" to us is not only a function of how eloquent it may be but also how well we are listening. The more frequently we look at it, the more will be revealed, and each episode of looking adds a patina of interest and enjoyment, so the effect is cumulative. There are works of art I have revisited throughout my life, and as I have changed so has my perception of the work. Some, like Pollock's *One: Number 31, 1950* (1950), deliver the same thrill every time, and others like *Map* (1961) by Jasper Johns, always seem to have something new to tell me.

Should I Learn Artspeak?

I was once asked what I saw in Pop Art at a dinner party, and I replied (as my wife famously recalls), "Challenging painterly abstraction, it is essentially a Marxist-based critique of Western post-World War II power systems." I was chagrined and chastened by a man across the table, who said to his partner, "Do people really talk like that?"

I guess some people do, including me, but I would have been better off saying, "I like it but you don't have to." End of story. You can enjoy art without talking about it, and certainly without using words like "cognition," "specificity," and "subject-effect," or even "painterly abstraction."

"I like the way this stuff makes me feel" was said to me by an eminent art historian when I was showing her work by the French-Canadian artist Jean-Paul Riopelle. It is not a particularly eloquent statement, but it is accurate and effective and one that you do not need a PhD in art history to either say or understand.

I do a fair amount of reading about art, including exhibition catalogue essays, so I guess I am bilingual. I can do artspeak if I have to, but frankly, among art dealers and collectors (and even artists), the language commonly used in talking about art is fairly basic, grunts and hand gestures included and expletives not always deleted.

Many people's inhibitions about modern art are partially fueled by being uneasy about their ability to talk about it without revealing ignorance. Consider the following: twenty undergraduate students in the general population of a Midwestern university (not studying art or art history) were divided into two groups of ten. Each student in each group was shown two posters and asked to choose one to hang for at least six months where they lived. One poster showed an image of kittens peeking out of socks hung on a clothesline, and the other was a reproduction of a painting by Claude Monet.

Ten of the students were told beforehand that they would be required to give a reason for making their choice. The other ten were simply given the choice. The majority of the students who were required to give a reason chose the kittens. The majority of those who did not have to justify their choice chose Monet. After the six months were up, most of the students who had chosen the kittens said they regretted their choice. Those who had chosen the Monet did not.

Clinically accurate or not, my interpretation of this experiment is that while we are comfortable using our day-to-day language about music and books, we think of art as being in a category that requires special language skills. Books and plays are language-based art forms but, like music and dance, works of modern art, even ones that incorporate words, mostly do not reveal themselves verbally. Any attempt by us to interpret them with language will always fall short, and so we should not beat ourselves up because we are not steeped in the arcane terminology used by

some art critics, philosophers, historians, and curators, most of which is unlikely to survive as long as the art does, other than as arcane footnotes in tiny type.

If you have looked long enough at a work of art, are confident that you have engaged with it, and feel like making a comment to your companion, it is important to be subjective and sincere, regardless of what you know or suspect is their opinion. How about:

I love it, it makes me feel blissful.
It creeps me out but I think I like it anyway.
I just want to stare at it for a long time.
This leaves me stone cold.

Debating or arguing with your companion about the meaning of an object can be a cul-de-sac. It is more fun to discuss what it makes you feel, and if what you feel is owed to the work or what you bring to it or to a bit of both. You do not need decasyllabic words for this. We might consider the graceful admonition that concludes John Keats's "Ode on a Grecian Urn:"

Beauty is truth, truth beauty,—that is all
Ye know on earth, and all ye need to know.[84]

OPPOSITE
Willem de Kooning
Woman, I, 1950–52
Oil on canvas
75 ⅞ × 58 in.
(192.7 × 147.3 cm)
The Museum of
Modern Art, New York.
Purchase

Like the word "love," "beauty" is given so much work that it is well-nigh exhausted. When it comes to art of the past, we still are comfortable applying words like "beauty," but when we are stirred by Willem de Kooning's *Woman, I* (1950–52), we hesitate to call it beautiful; although, while the image of the female is not conventionally appealing, the painting, as a painting, is a thing of great beauty (to me, anyway). Does that make sense?

Keats's idea about beauty and truth helps me get closer to the mark when I am thinking about modern art. If you reach the level of engagement that I am encouraging in this book, when you find yourself *not* liking a work of art, it may be due to some dishonesty on the part of the artist. Great works of art tell the truth. That truth may not be conventionally beautiful (sorry, Mr. Keats), but the clarity of feeling it engenders is beautiful.

Two well-known contemporary abstract artists are Brice Marden and Gerhard Richter. Richter also paints figurative works, Marden only

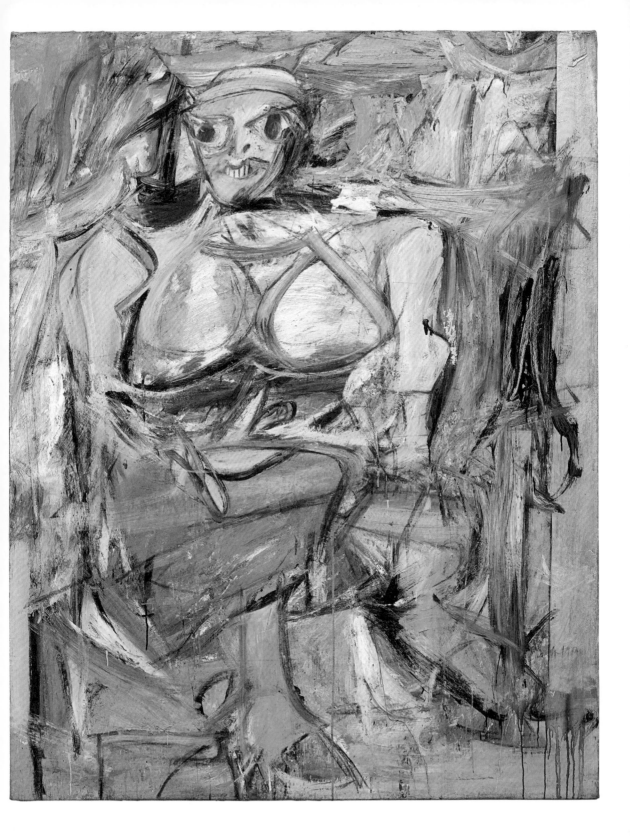

abstract ones. In general, I find Marden's work to be "truthful," that is, I am convinced that the marks he makes on his canvases (of which some are more successful than others) come from some spiritual depth. He is sharing this with us; he is not performing.

Richter, on the other hand, makes handsome abstract paintings that strike me as performances, demonstrations of his talented hand-eye coordination rather than expressions of his spirit. A great deal has been said and written, in high-flown language, about the work of each of these artists, pro and con. When I see the painting by Marden, I can only say I like it because it tells me the truth about itself. I don't like the Richter as much because to me it seems evasive. I have been told that is precisely the point because Richter, born and educated in East Germany during the Cold War, is questioning the very idea of "truth" in painting. Perhaps. But what I see is a painting that seems afraid to look (back) at me in an honest way, and no biographical or art critical bells and whistles are going to change my

emotional response. Despite being a hardheaded Scotsman, I am not a died-in-the-wool literalist, and I can enjoy gamesmanship and paradox in modern art, but at the end of the day we should not need to know the backstory (or indeed any *story*) in order to *see* what we are looking at.

The longer you have spent with a work of art, the more you will have to say about it. In our increasingly fast-paced lives, particularly those driven by social networking, "like" and "don't like" appear to suffice. But while one-click snap judgment may work for dating sites and YouTube videos of puppies, I suggest that real-life, real-time dialogue with those who share your art outings is more rewarding. You and your friend may be looking at the same painting for the same length of time, but, in fact, you are each

Gerhard Richter
Clouds, 1982
Oil on canvas
Two panels:
79 × 102⅝ in.
(200.7 × 260.7 cm)
The Museum of
Modern Art, New York.
Acquired through the
James Thrall Soby
Bequest and purchase

seeing a different work because of what you are bringing to it. Even if your responses are very different, each one is valid.

Let's say you and a friend visit the Museum of Modern Art in New York and enjoy ten minutes in front of *The Chariot* (1950) by Alberto Giacometti.

After spending time engaging with the work, you might feel:

Alberto Giacometti
The Chariot, 1950
Painted bronze on
wood base
Overall: 57 × 26 × 26⅛ in.
(144.8 × 65.8 × 66.2 cm);
Base: 9¾ × 4½ × 9¼ in.
(24.8 × 11.5 × 23.5 cm)
The Museum of Modern
Art, New York. Purchase

Elated Blissful Radiant Excited Serene Amused Ecstatic Mellow Happy Connected Calm Intrigued Uplifted Lighthearted Harmonious

Your friend, on the other hand, might feel:

Perplexed Distressed Bored Anxious Disoriented Unhappy Dismayed Shocked Threatened Nauseated Agitated Enraged Cold Disdainful Uncomfortable

The more powerful the work of art, the more intense our responses will be. The range of expression in modern art is extremely wide—an object that reduces some to tears might invoke laughter in others. The compulsively neat among us may be drawn to the rational serial imagery of Minimalist artists like Donald Judd and Agnes Martin, while those of us with boundary issues might revel in the bombastic splashiness of Franz Kline and Lee Krasner.

When talking about art, cultivating an ability to express our feelings is much more productive than nailing classifications. Talking about art adds to the experience—I know, I spend half my life doing just that. But first we have to have the experience, otherwise we literally do not really know what we are talking about. Let's open our eyes before we open our mouths.

Comparisons Are Not Always Invidious

Occasionally there are exhibitions devoted to just one series or type of work by an artist, and spending quality time in the show is an especially effective way to increase our confidence in our own responses. In 2015 I saw an exhibition at the Metropolitan Museum of Art entirely devoted to twenty-four of the twenty-seven known portraits by Cézanne of his wife, Hortense. Lined up next to each other in galleries that boast comfortable sofas, the portraits were a great treat. I knew some very well and others not at all. How did they differ from nother?

Hortense was similarly posed and expressionless in every painting, yet I engaged with each one in very different ways and with varying degrees of intensity. My feelings about some of the works with which I was already

familiar changed when I saw them in this context. In fact, one privately owned work that I had seen a few times in its owner's home and had never cared for, perhaps because it was not well lit, blazed from the wall, and I could hardly believe it was the same work. Being able to compare similar great works intelligently juxtaposed is a unique treat.

We do not have to wait for special exhibitions to enjoy such experiences. There are permanent installations we can visit and revisit that not only effortlessly train our eyes but are stunning experiences. Not all are in big cities. Two hours north of New York City is an amazing museum called Dia:Beacon where, among many other wonderful permanent installations

of contemporary art, you will find an immense gallery exhibiting 102 paintings of shadows by Andy Warhol.

The installation is a breathtaking experience, and I have seen visitors look stunned when they step into the gallery. Many stay for more than an hour. This is not your textbook Warhol. If you could take one home, which would it be? Compare and contrast.

For a very different experience, if you happen to be near Aspen, Colorado, pull off Route 85 and visit the Powers Art Center, a small, beautifully designed museum devoted to limited-edition works on paper by Jasper Johns. These range from 1960 to 2012, a lifetime's worth of work by a master

Paul Cézanne
Madame Cézanne in a Red Dress, 1888–90
Oil on canvas
45 ⅞ × 35 ¼ in.
(116.5 × 89.5 cm)
The Metropolitan Museum of Art, New York. The Mr. and Mrs. Henry Ittleson Jr. Purchase Fund, 1962

printmaker, shown in a comfortable atmosphere. While you are in Colorado, you might polish your eyes still more at the Clyfford Still Museum in Denver, where in quiet rooms of just the right size, you will have the opportunity to compare and contrast colorful, craggy, monumental paintings, each with its own voice and personality.

A surprising number of modern artists have museums devoted solely to their work. In Europe, you can visit Picasso museums in Paris and Málaga and Barcelona in Spain (and while in Barcelona, visit the Fundació Joan Miró). At London's Tate Modern, you can sit and be enveloped by Rothko's Seagram murals in a room that draws me back year after year with an almost magnetic force. Closer to (my) home is the Andy Warhol Museum in Pittsburgh. Texas is chock full of artist museums. At the Menil Collection in Houston, the stand-alone Cy Twombly Gallery is a must-see, but only after you have visited the Rothko Chapel (see page 231) across the small park. The Chinati Foundation in the old cowboy town of Marfa, is a campus of site-specific outdoor sculptures and buildings devoted to individual artists, including Donald Judd, Dan Flavin, and John Chamberlain.

It is not unusual for collectors to tell me they want a "signature" work by a particular artist. What they really want is a work similar to a well-known one (often in a museum), a standard-bearer that is reproduced over and over again to represent that artist. But there is often more to an artist than their signature work. With Rothko, for example, his journey toward abstraction began with figurative works, some with scenes in the New York City subway; and then, like his peer Jackson Pollock, he was influenced by Surrealism and made paintings peopled by dream creatures. In the subsequent period he painted his major symphonies, the works we call "Rothkos," large canvases of rectangular clouds of saturated color that appear to hover in space, before he moved well beyond them to the subdued, dark, harder-edged but extremely powerful late works. Each Rothko "style" delivers in different ways. He experimented with different languages, but his accent was strong and distinctive and compelling throughout. Familiarity may draw us to the "signature" Rothkos when we visit a museum, but as with many hardworking, long-lived great artists, all of his work rewards our attention.

PAGES 214–15

Andy Warhol
Shadows, 1978–79
Acrylic on 102 canvases
76 × 52 in.
(193 × 132 cm) (each)
Installation view,
Dia Art Foundation,
New York

OPPOSITE

Amedeo Modigliani
Cypresses and Houses at Cagnes (Cyprès et maisons à Cagnes), 1919
Oil on canvas
24 × 18⅛ in. (61 × 46 cm)
Barnes Foundation,
Philadelphia. BF259

Philip Guston
Painting, 1954
Oil on canvas
63¼ × 60⅛ in.
(160.6 × 152.7 cm)
The Museum of Modern
Art, New York. Philip
Johnson Fund

Even artists with relatively short careers can produce great works often deemed atypical or not their "real style." Amedeo Modigliani is justifiably admired as a modern master of distinctively elongated nudes and portraits, mostly female. But consider this Modigliani landscape.

The trees are just as sensuous and willowy as his portraits, and for me, paintings such as this one can have an even stronger emotional impact than Modigliani's best-known works, but I don't want to put my feelings in your head; you must have your own.

Some artists abruptly change their style, creating camps of admirers divided by taste and opinion. Philip Guston was of the same generation as Still and Rothko, and he was a great painter of lyrical abstract works often dominated by pinks and grays. In the late 1960s, he suddenly (or so

it seemed) switched to painting grotesque cartoonlike figures and still lifes. Along with most of his fans at the time, I was shocked and found it very difficult to approach the new work, not necessarily because of what was depicted (after all, I liked Peter Saul's work, somewhat in the same vein), but because it seemed to have no relation to his previous work. It was not until I attended the Whitney Museum's 1981 Guston retrospective that I saw the fascinating steps Guston took to get from one style to another, and I found myself enjoying both equally but in different ways.

So the next time you see a painting, sneak a look at the label and think, "That doesn't look like a Picasso/Pollock/Warhol/Whatever," STOP THINKING, and just look at the artwork. And look a little longer. Let go of the need to identify. What are you seeing? Are your senses stimulated? If so, what are you feeling? And perhaps find a bench nearby and sit and spend another minute or two with that work that doesn't look like a work by . . . what was that name again?

Philip Guston
Couple in Bed, 1977
Oil on canvas
81⅛ × 94⅝ in.
(206.2 × 240.3 cm)
The Art Institute of
Chicago. Through prior
bequest of Frances W.
Pick, and memorial gift
from her daughter,
Mary P. Hines, 1989.435

GETTING PERSONAL

⌄

Art alone makes life possible.

—

JOSEPH BEUYS

Learning Backward

As soon as I could read, I picked up *Punch*, a British humor magazine, and avidly devoured the cartoons. I am fairly certain this image was my first introduction to modern art:

This and similar cartoons told me that people found modern art either baffling or ridiculous (usually both). Quite likely the cartoonists themselves were ambivalent, yet they rendered the image deftly enough that I was intrigued to see the original for myself. When I did see my first mobile by Alexander Calder, I was well prepared by *Punch* and, luckily, untrammeled by the opinion of a parent or a teacher.

At that age, around six or seven, I was sure that anything in a museum was not only unquestionably "art," but *important* art. It was a long time before I learned that museum basements are filled with also-rans, artworks once (perhaps briefly) displayed before the public, only to be relegated to

Cartoon, 1951
Punch magazine

the limbo of huge movable racks where they may remain unseen, decade after decade. Earlier I described my youthful epiphany when seeing Henri Matisse's *Nude Study in Blue* for the first time, and though I became a determined museumgoer at an early age, I did not study art history in the classroom; I studied it on the job.

I began my career in the 1960s, exhibiting and selling contemporary art, most of it done by artists not much older than myself, and I was drawn both to Pop Art and to hard-edge abstract art, both of which were to me exciting and new and no more in need of being "understood" than Charlie Mingus or Allen Ginsberg. It soon became clear to me that most art dealers, unlike those of today, did not make a very good living if they sold only art by young artists, and I quickly became acquainted with the "secondary market," works of art that had at least one owner since they left the artist's studio. This required knowing about a wide range of late-nineteenth- and twentieth-century art, from that of Impressionists like Claude Monet and Camille Pissarro to works by Matisse, Pablo Picasso, Georges Braque, and Salvador Dalí, right up to already celebrated but then still living masters like Barnett Newman, Mark Rothko, and Willem de Kooning. My taste developed by engaging with their work, perhaps in a fairly random way—what came into the gallery where I worked, what I saw in other galleries, and, of course, art presented in the many museum shows I attended.

In 1984, I was recruited to head the Impressionist and Modern Art Department at Christie's, and after agreeing, I suffered a brief panic attack because, while I had looked at a lot of art, I had read very little about it, so I spent a couple of weeks absorbing *The History of Impressionism* by John Rewald. Two months later, I found myself merrily paraphrasing him (or is it called something else?) in notes for an auction catalogue. By the time I retired from Christie's sixteen years later, I had seen thousands of Impressionist and modern works of art, many good, some bad, a few fake, and a fair amount that were simply dreadful. Also, while at Christie's in the 1980s, I had the opportunity to see a much wider range of art—Old Masters, early American, Japanese, and Chinese—and although my colleagues and I were always under the gun, getting this or that auction together, there were times I could wander around after-hours at my leisure.

The older I get the further back I go. A few years ago I woke up to the glories of Renaissance gold-ground artists like Giotto di Bondone. On a recent visit to my hometown of Wimbledon, London, I realized I had simply come full circle. Stopping in the Sacred Heart Church for the first time in almost sixty years, I saw with instant familiarity the gold-ground Giotto-esque *Stations of the Cross* that I had stared at Sunday after Sunday while waiting to put my large copper penny in the collection plate.

Spotting New Talent, Then and Now

In the 1960s and 1970s, I was always on the lookout for new talent, and I spent a great deal of time visiting studios. Quite often one or another artist friend (or collector or writer) had suggested an artist to visit, and I had little idea of what I was going to see. In those days, artists went from gallery to gallery and left their slides for review—35mm color transparencies that were just as misleading as images on today's websites. I often visited studios on the basis of these slides, sometimes not having met the artist until I was looking at their work.

There are a few first visits I recall vividly. In some cases I took on the artists, and in the fullness of time their work has come to be widely appreciated—Sean Scully, Hannah Wilke, and John Baldessari, in particular. Scully had just moved to New York from London and was living in a bare loft, which must have had white walls, but I recall everything else being black, including his paintings, and although the atmosphere was gloomy and melancholy (and the artist said very little), I was excited by the work. Wilke was at the time living with the then much better-known Pop artist Claes Oldenburg. She worked in a small corner of his studio and was making beautiful unglazed, ceramic table sculptures, seemingly abstract but remarkably like vaginas. I was immediately struck by their quiet power.

There were other occasions when I was shocked and surprised by work but in the moment could not decide if it was extremely good or simply awful. One artist in particular, whose name I have mercifully forgotten, nailed together horizontal slats of painted wood of various lengths that he found on the street to make rectangular "paintings." They were poorly

Jordan Wolfson
Female Figure, 2014
Mixed media
90½ × 72 × 29 in.
(229.9 × 182.9 × 73.7 cm)

constructed and the juxtapositions of size and color seemed completely arbitrary, and after a second visit I decided they were terrible. I was supposed to be a professional, seeing new art day in and day out, and even I could not trust my instincts. In fact, "instinct" has nothing to do with seeing art; it is part of our luggage best left in storage. What I needed to do was simply go back and look again, and look hard.

In a similar vein, but with a different response, I recently encountered the work of a young New York artist, Jordan Wolfson. Urged by a friend

to see an installation by him, and knowing only that it was to be entered by no more than two people at a time, I walked into a brightly lit, white-walled room at the far end of which was a large mirror. In front of it, facing the mirror, appeared a scantily clad blonde woman poised to dance.

She is, in fact, a robot. She dances in a lifelike manner to well-known songs, she speaks (in the artist's voice), and she makes eye contact. She is strange and chilling and utterly compelling. Wonderful or terrible? Perhaps both. The experience was hard to shake. I began to be convinced that I had never seen anything like it before, and it suddenly came to me that in 1965 I helped to organize an exhibition of cybernetic sculpture by the Chilean artist Enrique Castro-Cid, who made extraordinary "robot" sculptures with movement and sound.

Best of the Best

In *The Value of Art*, I made up an art-for-art's-sake fable about an art genie, who could give you any work of art in the world you wanted but you could only enjoy it by yourself, you could not sell it or show it to anyone else. My challenge to the reader was to choose such a work to be enjoyed purely for its own sake, not to be shared with others or boasted about, and certainly not considered as an investment. I did not realize that I was setting myself up for having to answer the same question from interviewers.

Before I answer the question, I must explain that I have been a fickle art lover in the course of my lifetime. Works that have mesmerized me for years, if not decades, include Barnett Newman's *Stations of the Cross: Lema Sabachtani* (1958–66) in the collection of the National Gallery of Art, Washington, DC, and Picasso's *Les Demoiselles d'Avignon* (1907) in the collection of the Museum of Modern Art, New York. I seem to be drawn to the epic and monumental; I enjoy being overwhelmed and subsumed by a work of art. Today, then, my choice is Bridget Riley's *Veld*, which I was privileged to see shortly after it was completed in 1971, and most recently in 2014.

I have spent hours in front of *Veld* and feel a loss when I have to leave it. It is capable of sweeping me away to a place of harmony and peace, yet it

is pulsing with motion. I feel as if I were witnessing the heartbeat of the universe. It is in the National Gallery of Australia in Canberra, and if you find yourself there, spend some quality time with another great achievement of the twentieth century, Jackson Pollock's *Blue Poles (Number 11, 1952)* (1952); both are worth the trip (from anywhere).

Bridget Riley
Veld, 1971
Synthetic polymer
on canvas
55 ⅛ × 124 ⅝ in.
(140 × 316.5 cm)
National Gallery of
Australia, Canberra

My most recent encounter with *Veld*, and my reluctance to leave it, led me to think about similar encounters throughout my life with art, and I decided there were three particularly powerful ones worth sharing. Perhaps I enjoy being overwhelmed because what they have in common is that each one is more art "place" than art object. I have placed them in the order in which I encountered them:

Joseph Beuys, *Block Beuys, Room 2* (1949–69)

I was twenty-three in 1968, a year of political upheaval both in America and Europe. The art world, much smaller than it is today, was by no means immune to the turmoil. The speeches for the June 27 opening of documenta 4, one in a series of influential exhibitions of international art initiated in

1955 in the small town of Kassel, Germany, were drowned out by protestors waving red flags, demanding a more democratic selection process.

This was strictly an exhibition, not an art fair, and no commerce was being transacted, although of course there were many dealers there supporting their artists, most of whom were under forty. Many were enjoying their first international exposure. For me, it was very exciting. I worked for a New York gallery that represented some of the new generation of British painters, including Bridget Riley, Allen Jones, and Richard Smith, and the sculptors Phillip King and William Tucker. They were exhibiting alongside their American contemporaries Carl Andre, Walter De Maria, Roy Lichtenstein, and Andy Warhol, as well as young Europeans Günther Uecker, Dieter Roth, and Martial Raysse.

The atmosphere was vibrant with experimentation, and almost everything seemed very new and daring. In an open field near the exhibition site, the Bulgarian-American artist Christo and his collaborator and wife, Jeanne-Claude, installed a 280-foot-high, condom-shaped inflated balloon, and its tumescence (or lack thereof) added tension to the daily events.

One's sense of discovery was not diluted by marketing or even signage, and at one point I found myself alone in an exhibition area that at first seemed to contain only building materials or the elements of an installation yet to be completed. There were shoulder-high piles of large gray felt rectangles with copper plates on top of them, steel T-bars leaning against a wall, two large copper tables, a dangerous-looking electrical device on the floor emitting sparks that was connected to two glass cylinders, and a huge open wooden closet with two rows of five compartments, each filled with industrial, mechanical, and domestic detritus. There were German newspapers taped into squares, each bearing a red cross, a walking stick, and much more.

It slowly dawned on me that it was an installation by an artist and that each separate object or set of objects seemed to relate to each other. I stayed there by myself for a long time, wandering back and forth, steering clear of the sparks, absolutely enthralled. I had seen nothing like it, and it evoked a host of complicated, and to some extent contradictory, feelings. Despite its novelty, it conveyed the sense of always having been

PAGES 228–29
Joseph Beuys
Block Beuys, Room 2,
1949–69
Hessisches
Landesmuseum,
Darmstadt, Germany
(installed 1970)

there. Nevertheless, I felt an expression of great sadness, which I somehow associated with the Second World War (still very real to my generation). I did not want to leave.

I soon found out that the artist was Joseph Beuys and that what I had witnessed was an installation made specifically for documenta 4 (you can see it today in the Hessisches Landesmuseum in Darmstadt, Germany). I was captivated by his work, and through a young German dealer I met that summer, I bought three pieces by Beuys and showed them in New York that fall.

My fascination and enthusiasm for Beuys increased a few years later when the artist spent a week alone with a coyote in the gallery below mine on Spring Street in SoHo. Beuys only communicated with the wild dog during that time and they lived in an enclosed but visible space. He called the work *I Like America and America Likes Me* (1974). I visited daily, mesmerized by the harmonious relationship that evolved into a performance. It was strangely beautiful and at the same time risky and unpredictable— qualities I like about modern art.

Mark Rothko, Rothko Chapel (1971)

Three years after my startling encounter with Beuys's installations in Germany, I was fortunate enough to be invited by Jean and Dominique de Menil to the opening of the Rothko Chapel on the grounds of what is now the Menil Collection in Houston, which is one of the best places in the world to really see modern art. The other is the Fondation Beyeler in Basel, Switzerland. Both buildings were designed by Renzo Piano with maximum respect for the contemplation of art and a minimum of architectural egotism.

The de Menils commissioned Rothko to make a series of works for a small nondenominational chapel, which the artist himself designed with the architect Philip Johnson. I arrived before the opening ceremonies and was allowed to be alone with the works for fifteen or twenty minutes. There is no artificial lighting, the paintings are seen only in natural light, admitted indirectly from above. It takes at least five minutes for the deep

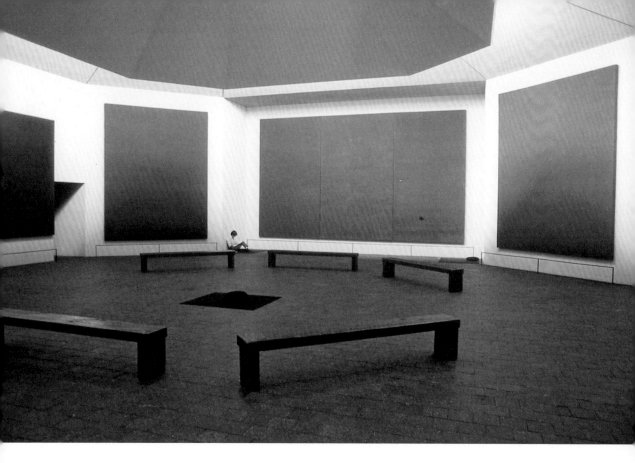

colors of the fourteen monumental canvases to emerge. To say that I was overcome with emotion would be an understatement. Remembering the visit much later, a phrase in a poem by T. S. Eliot came to me: "At the still point of the turning world."

It was thirty years before I returned to the Rothko Chapel. Thirty years to get used to Rothko, perhaps even to get tired or bored of Rothko. But when I stood in that octagonal room again, this time among a dozen or so other visitors, the impact on me was, if anything, even greater.

James Rosenquist, *Celebrating the Fiftieth Anniversary of the Signing of the Universal Declaration of Human Rights by Eleanor Roosevelt* (1998)

In the summer of 1998, James Rosenquist was asked by the French government to create a monumental work for the ceiling of the Palais de Chaillot (a public building in Paris housing a number of museums) to

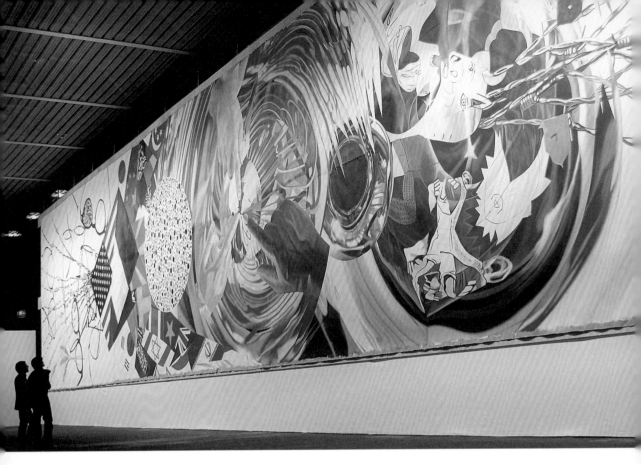

James Rosenquist
Celebrating the Fiftieth
Anniversary of the Signing
of the Universal Declaration
of Human Rights by Eleanor
Roosevelt, 1998
Oil and acrylic on linen
24 × 133 ft. (7.3 × 40.5 m)
On view at Art Basel
Unlimited, Switzerland
(2006)

commemorate the fiftieth anniversary of the adoption of the Universal
Declaration of Human Rights, drafted by a committee headed by Eleanor
Roosevelt on December 10, 1948. The work had to be finished for the cer-
emonies in December. Rosenquist, known for his monumental painting
F-111 that stunned its first viewers (including myself) when it was com-
pleted in 1965, was the right artist for the job.

As is often the case with art commissioned by government bodies, the
project floundered. Though Rosenquist completed the painting on sched-
ule, a Herculean task since the canvas measured 24 feet in height and 133
feet wide and was done by hand (unlike some of Rosenquist's younger fol-
lowers who program ink-jet printers to cover large expanses of canvas),
the Paris construction industry was sadly not as efficient, and the resto-
ration of the building was delayed by many years. The giant work, rolled
up and in sections, was kept by the artist.

A reproduction of the painting was included in the catalogue for a retro-
spective exhibition organized by the Solomon R. Guggenheim Museum in

2003, but the work itself was too large to be included in that show. Almost no one had ever seen it. Acquavella Galleries decided to remedy this and arranged for the work to be installed at the Art Basel fair in Switzerland in June 2006. To prepare for the presentation, I was with the artist when the huge canvas sections were taken out of storage and unrolled on the floor of a warehouse.

This in itself was a revelation, but nothing like the experience of seeing it take shape on a custom-built stretcher three stories high and half a block in length. By and large, modern artists have shied away from direct confrontation with the humanity of politics. Not Rosenquist. For five days, thousands of visitors marveled at this compelling panorama of modern history. Sadly, that was also the last public viewing of this amazing work of art. It was completely destroyed in a fire that ravaged the artist's Florida studio in 2009.

I share these profoundly moving experiences not to point specifically to these particular works but to emphasize the possibility of one having deep encounters with art. There is a tendency among people who make their living in the art world to lose their vulnerability. I have tried not to let that happen to me, and I can still be stunned into silence by masterpieces of modern art, ones well known and others perhaps as yet unacknowledged.

I enjoy talking about what moves me, and I like dragging people to see things that I like, but I don't expect them to have exactly my taste, and I don't think my taste is necessarily better than theirs. What is important for you is to take the time to find the art that speaks to you, engage with it fully, allow it to affect your feelings, and enjoy sharing your taste and experiences. Look, see, watch, engage, *feel*, and . . . enjoy!

FURTHER READING

Throughout this book, I have railed against reading about art, but in the end, I've shared my thoughts with you in a book. I would hope it might be the last book about modern art you ever read, the only one you *need* to read, but I recognize that might not be the case. I cannot stop you (or myself, for that matter) from reading in the mainstream media when modern art becomes news, typically when connected to money, forgery, and theft, or when a movie star sleeps in a glass box in a museum. That kind of reading is fundamentally harmless.

Art journalism and criticism are another matter. Modern art is so varied and provides the basis for so much interpretation that for decades it has generated a vast industry of academic inquiry both inside and outside the great seats of learning. Different approaches use the English language in different ways, and I would encourage you to dive in only if you have studied postmodern philosophy at the graduate level. My advice is, if there are more than two eight-syllable words in the first sentence, stop reading.

In the United States, good, clear writing about modern art is still to be found in a few general-circulation publications like the *New Yorker* (Peter Schjeldahl) and the *New Republic* (Jed Perl). I recommend the following highly readable biographies of modern artists such as *de Kooning—An American Master* by Mark Stevens and Annalyn Swan; John Richardson's monumental and endlessly fascinating four-volume *A Life of Picasso*; and *Salvador Dali* by Meryle Secrest. You might also look at *Holy Terror: Andy Warhol Close Up* by Bob Colacello; Hilary Spurling's two-volume biography of Matisse; *Mark Rothko: A Biography* by James E. B. Breslin; and *Chuck Close: Life* by Christopher Finch. One of the few outstanding autobiographies by a modern artist is *Painting Below Zero* by James Rosenquist.

Tempering my admonition not to believe everything artists say about their own work, I recommend *The Language of Sculpture* by William Tucker; you might also dip into *The Eye's Mind: Bridget Riley—Collected Writings 1965–2009*; and be amused by *Not Nothing*, the selected writings by Ray Johnson. I enjoy good novels about art and artists, particularly *To the Lighthouse* by Virginia Woolf; *Theft: A Love Story* by Peter Carey; *The Vivisector* by Patrick White; and *The Horse's Mouth* by Joyce Cary.

NOTES

1 Susan Sontag, *A Susan Sontag Reader* (New York: Farrar, Straus & Giroux, 1982), 95.

2 Rachel Donadio, "Masterworks vs. the Masses," *New York Times*, July 28, 2014, http://www.nytimes.com/2014/07/29/arts/design/european-museums-straining-under-weight-of-popularity.html (accessed July 29, 2014).

3 Ibid.

4 Ibid.

5 Zadie Smith, "North West London Blues," *New York Review of Books*, July 12, 2012, http://www.nybooks.com/articles/2012/07/12/north-west-london-blues/ (accessed October 30, 2016).

6 Blake Gopnik, "The Rush to the Box Office," *Art Newspaper*, no. 245 (April 2013): 16.

7 Maxwell Lincoln Anderson, "Metrics of Success in Art Museums," paper commissioned by Getty Leadership Institute, Los Angeles, 2004, 4.

8 Ibid., 9.

9 Holland Cotter, "That Head Turner's Back, With an Old-School Posse," *New York Times*, October 20, 2013, http://www.nytimes.com/2013/10/21/arts/design/that-head-turners-back-with-an-old-school-posse.html (accessed December 2, 2013).

10 Ben Lerner, "Damage Control: The Modern Art World's Tyranny of Price," *Harper's Magazine*, December 2013, 46.

11 Drake Baer, "Malcolm Gladwell Explains What Everyone Gets Wrong About His Famous '10,000 Hour Rule,'" *Business Insider*, June 2, 2014, http://www.businessinsider.com/malcolm-gladwell-explains-the-10000-hour-rule-2014-6 (accessed June 8, 2015).

12 Ellen J. Langer, *Mindfulness* (Reading, MA: Addison-Wesley, 1989), 35.

13 Ibid.

14 Joan Miró and Margit Rowell, *Joan Miró: Selected Writings and Interviews* (Boston: G.K. Hall, 1986), 82.

15 Langer, *Mindfulness*, 117.

16 James Elkins, *The Object Stares Back: On the Nature of Seeing* (New York: Simon & Schuster, 1996), 63.

17 Sheena S. Iyengar and Mark R. Lepper, "Rethinking the Value of Choice: A Cultural Perspective on Intrinsic Motivation," *Journal of Personality and Social Psychology* 76, no. 3 (1999), 349–366.

18 Elkins, *The Object Stares Back*, 63.

19 *Oxford Dictionaries Online*, s.v. "Essence," accessed February 2, 2017, https://en.oxforddictionaries.com/definition/essence.

20 John B. Nici, *Famous Works of Art—And How They Got That Way* (Lanham, MD: Rowman & Littlefield, 2015), 138.

21 Ed Ruscha, interview by Paul Holdengräber, March 6, 2013, transcript, LIVE from the New York Public Library, Celeste Bartos Forum, New York Public Library, New York, https://www.nypl.org/sites/default/files/transcript_3.doc (accessed December 4, 2017).

22 Langer, *Mindfulness*, 22.

23 Ibid.

24 Roland Penrose, *Picasso, His Life and Work* (Berkeley: University of California Press, 1981), 307.

25 Carol Vogel, "British Cede Le Brun Portrait to the Met," Insider Art, *New York Times*, May 15, 2014, https://www.nytimes.com/2014/05/16/arts/design/british-cede-le-brun-portrait-to-the-met.html (accessed May 17, 2014).

26 David Robson, "What's in a Name? The Words Behind Thought," *New Scientist*, September 1, 2010, https://www.newscientist.com/article/mg20727761-500-whats-in-a-name-the-words-behind-thought/ (accessed September 11, 2015).

27 Christine Kenneally, "When Language Can Hold the Answer," *New York Times*, April 22, 2008, http://www.nytimes.com/2008/04/22/science/22lang.html (accessed April 22, 2008).

28 Dietrich Blumer, "The Illness of Vincent van Gogh," *American Journal of Psychiatry* 159, no. 4 (April 2002): 522.

29 Paul Wolf, "Creativity and Chronic Disease: Vincent van Gogh (1853–1890)," *Western Journal of Medicine* 175, no. 5 (November 2001): 348.

30 Colin McGinn, "What Can Your Neurons Tell You?" *New York Review of Books*, July 11, 2013, 49.

31 V.S. Ramachandran and William Hirstein, "The Science of Art: A Neurological Theory of Aesthetic Experience," *Journal of Consciousness Studies* 6, no. 6–7 (1999): 15.

32 Ibid., 18.

33 Ann Lukits, "Our Brains Are Made for Enjoying Art," *Wall Street Journal*, June 16, 2014, http://www.wsj.com/articles/our-brains-are-made-for-enjoying-art-1402958948 (accessed June 23, 2014).

34 "Researchers Debunk Myth of 'Right-Brain' and 'Left-Brain' Personality Traits," *University of Utah Health Care*, August 14, 2013, http://healthcare.utah.edu/publicaffairs/news/current/08-14-2013_brain_personality_traits.php (accessed November 15, 2016).

35 Nicolas Rothen and Beat Meier, "Higher Prevalence of Synaesthesia in Art Students," *Perception* 39 (2010), 718–720.

36 Daria Martin, "Mirror-Touch: Empathy, Spectatorship, and Synaesthesia," *Tate* (blog), February 7, 2014, http://www.tate.org.uk/context-comment/video/mirror-touch-synaesthesia-social-video-recording (accessed June 25, 2014).

37 Susan Jacoby, "Keep the Gates of Paradise Open," *New York Times*, November 2, 2013, http://www.nytimes.com/2013/11/03/opinion/sunday/keep-the-gates-of-paradise-open.html (accessed November 4, 2016).

38 Ibid.

39 Daniel J. Levitin, *The Organized Mind: Thinking Straight in the Age of Information Overload* (New York: Dutton, 2014), 169–171.

40 Martin Bailey, "To Ban or Not to Ban Photography," *The Art Newspaper* no. 255 (March 2014): 28.

41 Ibid.

42 Robert S. Nelson, "The Slide Lecture, or the Work of Art 'History' in the Age of Mechanical Reproduction," *Critical Inquiry* 26, no. 3 (Spring 2000): 415.

43 Patrick Keough, "Thoughts on Teaching Art Appreciation and History," *KeO BLoG*, April 17, 2008 https://keoughp.wordpress.com/2008/04/17/thoughts-on-teaching-art-appreciation-and-history/ (accessed July 31, 2013).

44 Mark Doty, *Still Life with Oysters and Lemon* (Boston: Beacon Press, 2001), 70.

45 J.M. Coetzee, "The Making of Samuel Beckett," *New York Review of Books*, April 30, 2009, http://www.nybooks.com/articles/2009/04/30/the-making-of-samuel-beckett/ (accessed November 5, 2016).

46 Vincent van Gogh to Theo van Gogh and Jo van Gogh-Bonger, July 10, 1890, *Vincent van Gogh: The Letters*, http://www.vangoghletters.org/vg/letters/let898/letter.html (accessed November 15, 2017).

47 Ibid.

48 Paul Schmelzer and Scott Stulen, "The Nine Lives of the Internet Cat Festival," *Walker Magazine*, August 28, 2013, http://www.walkerart.org/magazine/2013/nine-lives-internet-cat-video-festival (accessed October 18, 2016).

49 Roger Fry, "Paul Cézanne by Ambroise Vollard: Paris, 1915," *Burlington Magazine* 31, no. 173 (August 1917): 53.

50 Julian Bell, "A 'Treacherous' Art Scene?" *New York Review of Books*, November 21, 2013, http://www.nybooks.com/articles/2013/11/21/treacherous-art-scene/ (accessed December 2, 2016).

51 Nelson, "The Slide Lecture, or the Work of Art 'History' in the Age of Mechanical Reproduction," 419.

52 Ibid.

53 Margaret Talbot, "Pixel Perfect," *New Yorker*, April 28, 2014, 37.

54 Calvin Tomkins, "No More Boring Art," *New Yorker*, October 18, 2010, 48.

55 Donna Tartt, *The Goldfinch* (New York: Little, Brown, 2013), 19–24.

56 Michael Duffy, "Reading in Slow Motion," April 8, 2009, http://mikejohnduff.blogspot.ca/2009/04/reading-in-slow-motion.html (accessed November 15, 2016).

57 Gary Wills, "William James: In the Maelstrom of American Modernism," *New York Review of Books*, July 19, 2007, 46.

58 William Wordsworth, *Lines Composed a Few Miles above Tintern Abbey, On Revisiting the Banks of the Wye During a Tour*, July 13, 1798, poetryfoundation.org, https://www.poetryfoundation.org/poems-and-poets/poems/detail/45527 (accessed October 30, 2016).

59 "Mindfulness in the Age of Complexity," *Harvard Business Review*, March 2014, https://hbr.org/2014/03/mindfulness-in-the-age-of-complexity (accessed October 15, 2016).

60 Wang Wei and David Hinton, *The Selected Poems of Wang Wei* (New York: New Directions, 2006), xvii.

61 Elkins, *The Object Stares Back*, 23.

62 David Steindl-Rast, "Want to be Happy? Be Grateful," *TED*, June 2013, https://www.ted.com/talks/david_steindl_rast_want_to_be_happy_be_grateful?language=en (accessed December 18, 2016).

63 Doty, *Still Life with Oysters and Lemon*, 4.

64 Edward Mendelson, "The Secret Auden," *New York Review of Books*, March 20, 2014, http://www.nybooks.com/articles/2014/03/20/secret-auden/ (accessed November 1, 2016).

65 Calvin Tomkins, *Marcel Duchamp: The Afternoon Interviews* (New York: Badlands Unlimited, 2013), 31.

66 Gabrielle Selz, *Unstill Life: A Daughter's Memoir of Art and Love in the Age of Abstraction* (New York: W.W. Norton, 2014), 57.

67 "Excerpts from a 1979 Marcia Tucker Interview with Jack Tworkov," in *Jack Tworkov: Paintings, 1950–1978*, exh. cat. (Glasgow: Third Eye Center, 1979).

68 Aljean Harmetz, "Museums Reviving 'Picasso' Film, A Failure in '57," *New York Times*, February 11, 1986, http://www.nytimes.com/1986/02/11/movies/museums-reviving-picasso-film-a-failure-in-57.html (accessed December 31, 2013).

69 Arthur Conan Doyle, "The Adventure of the Cardboard Box," *The Adventures of Sherlock Holmes* 16, *The Strand Magazine* 5 (January–June 1893): 67.

70 Eric Fernie, *Art History and its Methods* (London: Phaidon Press, 1995), 103–115, http://w3.gril.univ-tlse2.fr/Proimago/pictsemio/morelli.htm (accessed December 5, 2016).

71 Roger Ebert, "One Woman or Two," *RogerEbert.com*, March 2, 1987, http://www.rogerebert.com/reviews/one-woman-or-two-1987 (accessed November 1, 2016).

72 Emma Allen, "Landlord," *New Yorker*, June 29, 2015, http://www.newyorker.com/magazine/2015/06/29/landlord-beaux-arts-on-the-bowery (accessed December 15, 2016).

73 Charlotte Higgins, "National Gallery Director Writes Off Video, Conceptual Art, Performance Art," *Guardian*, October 15, 2012, https://www.theguardian.com/culture/charlottehigginsblog/2012/oct/15/nicholas-penny-video-art (accessed November 15, 2016).

74 Nicholas Penny, "'People Have Fooled Themselves,'" *Art Newspaper*, no. 240 (November 2012): 22.

75 Randy Kennedy, "MoMA's Expansion and Director Draw Critics," *New York Times*, April 21, 2014, https://www.nytimes.com/2014/04/21/arts/momas-expansion-and-director-draw-critics.html (accessed November 15, 2016).

76 Jed Perl, "Laissez-Faire Aesthetics; What Money is Doing to Art, or how the Artworld Lost its Mind," *New Republic*, February 4, 2007, https://newrepublic.com/article/63174/laissez-faire-aesthetics-what-money-doing-art-or-how-the-artworld-lost-its-mind (accessed November 15, 2016).

77 Sam Hunter, "Diverse Modernism," *New York Times*, May 16, 1948, sec. 2, 8.

78 Ryoko M. Nakamura, "Vision of a 'Superflat' Future," *Japan Times*, April 13, 2005, http://www.japantimes.co.jp/culture/2005/04/13/arts/vision-of-a-superflat-future/#.WFmGobYrIyk (accessed December 1, 2016).

79 Robert L. Solso, *Cognition and the Visual Arts* (Cambridge, MA: MIT Press, 1996), 57.

80 David Armstrong, "Wade Guyton," *Interview Magazine*, June 8, 2009, http://www.interviewmagazine.com/art/wade-guyton/ (accessed December 1, 2016).

81 "The Museum of Modern Art Receives Major Gift of Contemporary Art from Elaine Dannheisser," The Museum of Modern Art, April 16, 1996, https://www.moma.org/momaorg/shared/pdfs/docs/press_archives/7426/releases/MOMA_1996_0021_21.pdf?2010 (accessed December 15, 2016).

82 Jed Perl, "The Cult of Jeff Koons," *New York Review of Books*, September 25, 2014, http://www.nybooks.com/articles/2014/09/25/cult-jeff-koons/ (accessed December 1, 2016).

83 Carol Vogel, "Rush for Deals Before Top Art Goes to Auction," *New York Times*, May 4, 2014, https://www.nytimes.com/2014/05/05/arts/rush-for-deals-before-top-art-goes-to-auction.html (accessed December 15, 2016).

84 Thomas Pfau and Robert F. Gleckner, *Lessons of Romanticism: A Critical Companion* (Durham, NC: Duke University Press, 1998), 122.

INDEX

Page numbers in italics indicate illustrations.

ILLUSTRATION CREDITS

Page 9: © The Museum of Modern Art, New York. Photo by Jennifer Hickey © 2017. Pollock-Krasner Foundation/Artists Rights Society (ARS), New York. **Pages 10–11:** Tate, London / Art Resource, NY / © Salvador Dalí, Fundació Gala-Salvador Dalí, Artists Rights Society (ARS), New York 2016. **Page 28:** Illustration by Martha Vaughan. **Page 31:** Iain Masterton / Alamy Stock Photo. **Page 38:** © The Metropolitan Museum of Art / © 2016 Artists Rights Society (ARS), New York. **Page 41:** The Solomon R. Guggenheim Foundation / Art Resource, NY / © Successió Miró / Artists Rights Society (ARS), New York / ADAGP, Paris 2016. **Page 44, 212, 213:** © The Metropolitan Museum of Art. **Page 45:** Digital Image © The Museum of Modern Art/ Licensed by SCALA / Art Resource, NY / Art © Estate of Larry Rivers/Licensed by VAGA, New York, NY. **Page 47:** Digital Image © The Museum of Modern Art/Licensed by SCALA / Art Resource, NY / © 2016 The Jacob and Gwendolyn Knight Lawrence Foundation, Seattle / Artists Rights Society (ARS), New York. **Page 58:** Photo © Christie's Images / Bridgeman Images / Courtesy the Artist and Victoria Miro, London / Copyright: © Chris Ofili. **Page 64:** © The Israel Museum, Jerusalem / Israel Antiquities Authority / Bridgeman Images. **Page 65:** © John Chamberlain. All rights reserved / The Solomon R. Guggenheim Foundation / Art Resource, NY / © 2017 Fairweather & Fairweather LTD / Artists Rights Society (ARS), New York. **Page 67:** The Philadelphia Museum of Art / Art Resource, NY. **Page 68:** Digital Image © 2017 Museum Associates / LACMA. Licensed by Art Resource, NY / © 2016 Estate of Pablo Picasso / Artists Rights Society (ARS), New York. **Page 71:** Digital Image © The Museum of Modern Art/Licensed by SCALA / Art Resource, NY / © Artists Rights Society (ARS), New York / ADAGP, Paris. **Page 76:** Digital Image © The Museum of Modern Art/Licensed by SCALA / Art Resource, NY / © 2016 Succession H. Matisse / Artists Rights Society (ARS), New York. **Page 82:** Digital Image © The Museum of Modern Art/Licensed by SCALA / Art Resource, NY / © 2016 Estate of Pablo Picasso / Artists Rights Society (ARS), New York. **Page 85:** Bridgeman Images. **Page 94:** Erich Lessing / Art Resource, NY. **Page 97:** David Sipress The New Yorker Collection/The Cartoon Bank. **Page 105:** Art Resource, NY. **Page 116:** Courtesy National Gallery of Art, Washington. **Page 117:** Art © Estate of Duane Hanson/Licensed by VAGA, New York, NY / Photograph Courtesy of Sotheby's, Inc. © 2017. **Page 119:** © Sean Scully. **Page 127:** © Mark di Suvero, courtesy of the artist and Spacetime C.C. Photograph by Jerry L. Thompson, © Storm King Art Center, Mountainville, New York. **Page 129:** Wolfgang Volz / © 2005 Christo and Jeanne-Claude. **Page 131:** Digital Image © The Museum of Modern Art/ Licensed by SCALA / Art Resource, NY / © 2016 Frank Stella / Artists Rights Society (ARS), New York. **Page 136:** Scala / Art Resource, NY. **Page 140, 141:** Image courtesy of the author. **Page 151:** Digital Image © The Museum of Modern Art/Licensed by SCALA / Art Resource, NY. **Page 153:** Digital Image © The Museum of Modern Art/Licensed by SCALA / Art Resource, NY / © 1998 Kate Rothko Prizel & Christopher Rothko / Artists Rights Society (ARS), New York. **Page 155:** Digital Image © The Museum of Modern Art/Licensed by SCALA / Art Resource, NY / © 2016 Artists Rights Society (ARS), New York / ADAGP, Paris. **Pages 156–157:** Photo: Bruce M. White / © The Estate of Jean-Michel Basquiat / ADAGP, Paris / ARS, New York 2016. **Page 162:** Art © Wayne Thiebaud/Licensed by VAGA, New York, NY. **Page 166:** © El Anatsui / Photo: Nathaniel Willson. **Page 182:** © RMN-Grand Palais / Art Resource, NY. **Page 182:** Courtesy of Mary Boone Gallery, New York. **Page 188:** Courtesy of Wilkinson Gallery, Rossi & Rossi and FOST Gallery. **Page 191:** Digital Image © The Museum of Modern Art/Licensed by SCALA / Art Resource, NY / © The Estate of Francis Bacon. All rights reserved. / DACS, London / ARS, NY 2016. **Page 195:** © Yoshihara Shinichiro. **Page 207:** Digital Image © The Museum of Modern Art/Licensed by SCALA / Art Resource, NY / © 2016 The Willem de Kooning Foundation / Artists Rights Society (ARS), New York. **Page 208:** Photograph by Cathy Carver / © 2016 Brice Marden / Artists Rights Society (ARS), New York. **Page 209:** © Gerhard Richter 2017 (1309). **Page 210:** Digital Image © The Museum of Modern Art/Licensed by SCALA / Art Resource, NY / © 2016 Alberto Giacometti Estate/Licensed by VAGA and ARS, New York, NY. **Pages 214–215:** © The Andy Warhol Foundation for the Visual Arts, Inc./Artists Rights Society (ARS), New York. Photo: Bill Jacobson Studio, New York. Courtesy Dia Art Foundation, New York. **Page 217:** Image © 2016 The Barnes Foundation. **Page 218:** Digital Image © The Museum of Modern Art/Licensed by SCALA / Art Resource, NY / © The Estate of Philip Guston. **Page 219:** The Art Institute of Chicago / Art Resource, NY / © The Estate of Philip Guston. **Page 221:** Punch Ltd. **Page 224:** Photo by John Smith. Courtesy of the artist and David Zwirner, New York. **Page 226:** © Bridget Riley 2016. All rights reserved, courtesy Karsten Schubert, London / Bridgeman Images. **Pages 228–229:** © 2016 Artists Rights Society (ARS), New York / VG Bild-Kunst, Bonn. **Page 231:** Nicolas Sapieha / Art Resource, NY / © 1998 Kate Rothko Prizel & Christopher Rothko / Artists Rights Society (ARS), New York. **Page 232:** © 2017 James Rosenquist/Licensed by VAGA, New York. Used by permission. All rights reserved.

PRESTEL PUBLISHING LTD.
14-17 Wells Street, London W1T 3PD

PRESTEL PUBLISHING
900 Broadway, Suite 603, New York, NY 10003

Library of Congress Cataloging-in-Publication Data
Names: Findlay, Michael, author.
Title: Seeing slowly : looking at modern art / Michael Findlay.
Description: New York : Prestel Publishing, 2017. | Includes bibliographical references.
Identifiers: LCCN 2017011979 | ISBN 9783791383835 (hardcover)
Subjects: LCSH: Art, Modern—19th century—Appreciation. | Art, Modern—20th century—Appreciation.
Classification: LCC N6490 .F534 2017 | DDC 709.03/4—dc23
LC record available at https://lccn.loc.gov/2017011979

A CIP catalogue record for this book is available from the British Library.

Editorial direction: Holly La Due · Copyediting: John Son · Proofreading: Susan Richmond
Index: Kathleen Preciado · Endnotes: Efren Olivares
Design: Mark Melnick · Picture research: John Long · Production: Luke Chase

Verlagsgruppe Random House FSC® N001967
Printed on the FSC®-certified paper Golden Sun woodfree FSC

Printed in China

ISBN 978-3-7913-8383-5

www.prestel.com